PERFORMING PUBLIC HISTORY

Performing Public History explores history-telling as a performance across a wide range of media, including theatre and film, historical re-enactments and living history performances, operas, and video games.

Taking historians as storytellers, this book illustrates how the choices they make shape historical meaning. While historians may strive to be objective when they research and write the past, they inevitably draw on their imagination, emotions, and creativity, aligning them with others who make history in public. The book explores issues such as the nature of archives, realism, fact and fiction, accuracy and authenticity, and actants and audiences. It draws on case studies from all parts of the world, offering global perspectives that invite a rethinking about what history is, and how and why we do it. Sharing work by graduate students, the author also offers an appendix of classroom exercises that instructors will find valuable.

Written accessibly for students, this volume offers a succinct account of the discipline of history, the field of public history, and how performance is a useful concept for thinking about history work.

David Dean is Distinguished Research Professor and Professor Emeritus in the Department of History at Carleton University, Canada. He has published widely in the field of public history, including *A Companion to Public History* (2018). He is the co-editor of *International Public History*, the journal of the International Federation for Public History.

Global Perspectives on Public History
Edited by Dr. Kristin O'Brassill-Kulfan, *Rutgers University*

This series explores the work of public historians and the contested histories they engage with around the world. Authored by both scholars and practitioners, volumes focus on cases where complex histories and diverse audiences meet and examine public representations of history. The series aims to link professional discussions of different historical methodologies with broader dialogues around commemoration, preservation, heritage, and interpretation in diverse geographical, cultural, social, and economic contexts. The co-existence of both global and regionally specific volumes in the series highlight the wide range of innovative new projects and approaches on offer. These books will provide students, researchers, and practitioners with new case studies and helpful analytical tools to confront the (mis)representations of history they encounter in their work and as members of twenty first century communities.

Public History in Ireland
Difficult Histories
Edited by Leonie Hannan and Olwen Purdue

History in Public Space
Edited by Joanna Wojdon and Dorota Wiśniewska

Performing Public History
Case Studies in Historical Storytelling
David Dean

PERFORMING PUBLIC HISTORY

Case Studies in Historical Storytelling

David Dean

NEW YORK AND LONDON

Designed cover image: Indonesia, Java, Yogyakarta, Kraton palace complex, music pavilion, wayang golek puppets. John Elk III / Alamy Stock Photo

First published 2025
by Routledge
605 Third Avenue, New York, NY 10158

and by Routledge
4 Park Square, Milton Park, Abingdon, Oxon, OX14 4RN

Routledge is an imprint of the Taylor & Francis Group, an informa business

© 2025 David Dean

The right of David Dean to be identified as author of this work has been asserted in accordance with sections 77 and 78 of the Copyright, Designs and Patents Act 1988.

All rights reserved. No part of this book may be reprinted or reproduced or utilised in any form or by any electronic, mechanical, or other means, now known or hereafter invented, including photocopying and recording, or in any information storage or retrieval system, without permission in writing from the publishers.

Trademark notice: Product or corporate names may be trademarks or registered trademarks, and are used only for identification and explanation without intent to infringe.

ISBN: 978-1-032-01288-9 (hbk)
ISBN: 978-0-367-77536-0 (pbk)
ISBN: 978-1-003-17802-6 (ebk)

DOI: 10.4324/9781003178026

Typeset in Sabon
by Apex CoVantage, LLC

To Janet

CONTENTS

Acknowledgements *viii*
List of Figures *xi*

 Prologue: Performing History Publicly 1
1 History, Public History, Performance 7
2 The Truth About Archives 30
3 Performing the Real 54
4 Feeling the Past 79
5 Authentic Performances 102
6 "The Cat Ate My Bannock" and Other Stories 124
 Epilogue: Performing Public History 144

Appendix: Classroom Activities *151*
Bibliography *167*
Index *180*

ACKNOWLEDGEMENTS

This book has been long in gestation, and there are many people to thank. Rick Duthie read the entire manuscript and I am very grateful for his astute observations and suggestions. Kresno Brahmantyo, Mary Owusu, Stephen Sesser, and Kira Smith generously offered valuable feedback on specific chapters.

Carleton University has always provided a rich intellectual and nurturing environment. I've learnt much from Tonya Davidson, Jennifer Evans, Shawn Graham, Chinnaiah Jangam, Sonya Lipsett-Rivera, Paul Litt, Laura Madokoro, Daniel McNeil, Del Muise, and Michael Windover to name just a few, and one of the greatest pleasures of my academic career has been to work so closely with James Opp and John Walsh. Another has been to co-edit the journal *International Public History* with Andreas Etges. He and other colleagues on the steering committee of the International Federation for Public History have contributed much to my thinking through some of the key arguments of the book.

I have benefitted hugely from presenting at conferences of the International Federation for Public History, the National Council on Public History, the Canadian Historical Association, the Canadian Association for Theatre Research, and Performance Studies International, as well as two conferences that were collaborations with colleagues at the University of Ottawa's Theatre Studies department, especially Yana Meerzon. Thanks also to those who gave me the opportunity to share ideas with seminar participants in India (Indira Chowdhury), Indonesia (Kresno Brahmantyo), Japan (Michihiro Okamoto), South Africa (Noor Nieftagodien), and Turkey (Rüya Kalintaş).

I owe much to Peter Hinton and Paula Danckert and to everyone who worked with English Theatre at the National Arts Centre between 2006 and 2012, a heartfelt thanks. Peter, along with Vanessa Agnew, Maxime Durand, Lisa Peschel, and Bruno Ramirez, lectured in an influential series on Performing History funded by Carleton History Department's Shannon Donation. I am grateful to Maxime, and to Rachel Alderman, Megan Piercey Monafu, and Ruth Stewart-Verger for sharing their performance activities with me and my students, and giving me permission to publish them here. The Social Sciences and Humanities Research Council of Canada funded research into performing history through drama in museums (2014–2016), staging the past in opera (2016–2018), and performing identity through art and food in diasporic communities (2018–2020). Thanks to Kresno Brahmantyo for taking me to see Wayang Orang Bharata perform in Jakarta, to Mary Owusu for alerting me to Dani Kouyaté's film *Keita!*, and to my brother, Andy Dean, who introduced me to Larkin Poe.

It is impossible to exaggerate how much the book has been shaped by students I supervised, co-supervised, or examined who chose performance as the culminating work for their honours and graduate degrees and who took my graduate seminar on narrativity and performance in public history. I especially want to thank those who gave me permission to share their work in Chapter 6: Kathryn Boschmann, Liane Chiblow, Sinead Cox, Meranda Gallupe-Paton, Dany Guay-Belanger, Rowen Germain, Suki Lee, Amy MacDonald, Sara Nixon, David Siebert, and Allison Smith.

Thanks also to Ashlee Beattie, Candice McCavitt, and Elizabeth Paradis for being there at the beginning; to Katelyn McGirr who introduced me to the work of Nick Sousanis; to Laurel Rowe and Amie Wright for teaching me about graphic novels; to Chantal Brousseau, Danielle Mahon, and Cristina Wood from whom I learned so much about performing history digitally; to Dany Guay-Belanger for helping me work through games and gaming culture; and to Arpita Bajpeyi, Sinead Cox, Marie-Anne Gagnon, and Christina Parsons who took everything to a whole new level with *Staging Our Histories*.

I would like to thank those who gave me permission to use images and visuals: the Pastados Presentes Project Archive at LABHOI/UFF (Figure 2.1); Ubisoft Entertainment (Figure 3.1); the Wereldmuseum, Amsterdam (Figure 3.2); Sanjoy Ganguly and Jana Sanskriti (Figure 4.1); Radhika Hettiarachchi and Hema Shironi (Figure 4.2); Adam Brisbine, Little Fang Media (Figure 5.1); David Siebert (Figure 6.1); Charles Games (Figure 7.1); and Sam Hester and the Department of History, Carleton University (Figure 7.2).

I would like to acknowledge Taylor and Francis (https://www.tandfonline.com/) for granting me permission to re-purpose my discussion of King Lear

from David Dean, "Negotiating accuracy and authenticity in an Aboriginal *King Lear*," *Rethinking History* 21.2 (2017), 255–273, https://doi.org/10.1080/13642529.2017.1282725, and the discussion on living history from David Dean, "Living History," in *The Routledge Handbook of Reenactment Studies* eds. Vanessa Agnew, Jonathan Lam, and Juliane Tomann (Routledge, 2020), 120–124 in the same chapter; to Springer Nature for permission to re-use part of Daniel McNeil, Yana Meerzon, and David Dean, "Introduction," in *Migration and Stereotypes in Performance and Culture* ed. Yana Meerzon, David Dean, and Daniel McNeil (Palgrave, 2020), https://doi.org/10.1007/978-3-030-39915-3, also in Chapter 5; and to Oxford University Press for permission to draw on Thomas Cauvin, Joan Cummins, David Dean, and Andreas Etges, " 'Follow the North Star: A Participatory Museum Experience,' Connor Prairie, Fishers, Ind.," *Journal of American History* 105.3 (2018), 630–636, https://doi.org/10.1093/jahist/jay281 in Chapter 4.

It has been such a pleasure working with everyone at Routledge. Allison Sambucini guided the manuscript through to publication with patience and skill. Thanks also to Kimberley Smith who commissioned the book, the series editor Kristin O'Brassill-Kulfan, and the production team led by Sathyasri Kalyanasundaram.

Personal perspectives need to be acknowledged as these are subjectivities that have shaped this book. I am white, straight, enabled, and identify as male. A first-generation Canadian of British heritage, I am a settler who lives and works on the traditional, unceded territory of the Anishnaabek/Omàmiwininiwag, and recognize the ongoing legacies of colonialism's genocidal policies. While I am grateful for the opportunity to share with readers what I have to offer in this book, especially with regard to ways of knowing and doing history that are different from those I was born into and have practised for much of my academic life, I am deeply aware that being able to do so comes from a position of privilege.

Janet Siltanen has provided encouragement and support throughout all of my meanderings in history, public history, and performance. The dedication of a book seems small recompense.

FIGURES

2.1	D. Terezinha blesses the bonfire at the Quilombo São José festival (2005)	47
3.1	Raphaël Lacoste, "London Mood"	63
3.2	Wayang Figures of Prince Diponegoro and General De Kock	73
4.1	Jana Sanskriti, *Shonar Meye* (Golden Girl)	91
4.2	Hema Shironi, "Buried Alive Stories." Embroidery, 2020	96
5.1	Mohammed and Salar in *The Jungle* at the Curran, San Francisco, United States, 2019	110
6.1	David Siebert, "Unruly Remains"	130
6.2	Master of arts in public history students from Carleton University engage with the Dome Mine door in the Ingenium Conservation Lab, Canada Science and Technology	139
7.1	*Svoboda 1945: Liberation*, Charles Games, 2021	145
7.2	Sam Hester, "Theatrical Pasts"	149

PROLOGUE

Performing History Publicly

In her essay entitled *Possession*, American playwright Suzan-Lori Parks reflects on how she stages the past. "A play is a blueprint of an event" she writes, "a way of creating and rewriting history through the medium of literature." For Parks, theatre is the perfect place to recover erased African American pasts. As a playwright, she feels her task is to uncover bones that sing about the past, the present, and the future, and then, "through literature and the special strange relationship between theatre and real-life," turn their song into something that "*actually happens*." Theatre offers her the opportunity to write history anew: "I'm working theatre like an incubator to create 'new' historical events. I'm re-membering and staging historical events which, through their happening on stage, are ripe for inclusion in the canon of history."[1]

Parks has gifted me words that capture much of what this book is about. It speaks to my experience as a historian who was privileged to work with theatre professionals for a time and then to share what I experienced with honours undergraduate and graduate students. My journey began as an academically trained historian of early modern Britain who became a public historian working collaboratively with others outside the academy, a historian trained in the Western tradition who has come to recognize the relationships between positivist theory, empirical practice, and the colonialist project as he encounters other ways of doing and making history.

Western historiography is often said to begin with the ancient Greeks Herodotus and Thucydides who disagreed about what history was and how best to do it. Their differences can be traced in the centuries that followed well into our own day with debates about whether history is an art

DOI: 10.4324/9781003178026-1

or a science. The history wars of the late twentieth and early twenty-first centuries attest to anxieties about truth-telling, fake histories, fact, and fiction. Historians have always wrestled with the role of the imagination in historical thinking and the value of speculation in historical writing. The relationship between the real and the performed (in writing, imaging, sounding, embodying, digitizing) is comprehended in the word "authentic." Defined as "not false or imitation," Merriam-Webster considered it to be a synonym for "real" and "actual" when they declared authentic to be the 2023 word of the year.[2] Yet the relationship between the real that happened and its performance in the present is much more nuanced and complex than the venerable dictionary would have it.

Blueprints, Parks' chosen metaphor for this relationship, are accurate reproductions of an image printed on light-sensitive sheets. Invented by Sir John Herschel in 1842, blueprints were used to ensure exactitude in engineering and construction works for many decades until displaced by photocopying processes. But unlike those later forms of reproduction, blueprints were negatives of the original image, so-called because of the white lines that showed up on a blue background. Not quite an exact replica then, but an image of it. And in the broader, looser use of the word to refer to any sort of plan, a sign that something has existed that is now being used to create something new. The blueprint then is not quite the same as the original and what is produced from the blueprint is in fact a new original used to create something real, off the page. The relationship between the original and what is produced from it is at the heart of the historical endeavour and fundamental to the historians' task. It is a major theme of this book.

Historians have their own blueprints. As might be well-known, they distinguish between primary sources and secondary sources, the latter being written out of the former. One of the first things we teach undergraduates is how to analyse and interpret primary sources (ones that are as close to the original event as possible). Then, as they progress, we teach them how to evaluate secondary sources, usually ones that focus on the same event or problem. Understanding how historians variously interpret evidence – primary sources – is called historiography. When honours students or graduate students come to do original research, one of the requirements is that they situate themselves within existing historiography so that they are saying something new in their work. What makes their contribution to knowledge original is sometimes a new approach, or applying a new theory or a new methodology, but often it is because their work draws on a primary source or sources that have been under-used, ignored, or newly discovered. Indeed, finding a source that no one else has ever considered is the historian's holy grail, a precious to be fiercely guarded until the discoverer makes its value public.

The relationship then between the original primary source and the secondary source is crucial to the historians' craft in ways that correspond to how Parks describes her work as a playwright. We too draw on the traces of the past that have survived (which we call primary sources) to create something new (the secondary source). We too dig for bones, and over the centuries, we have developed techniques and strategies for reading, listening, seeing, and interpreting them. We hope in our work to bring those bones to life, to give them a voice, and to restore something of *their* present-day experience to our own. And we do so because we hope that our writing of the past will improve our lives in the present and shape a better future. The historians' writing of the past is also, as Parks observes about the theatre, "an incubator for the creation of historical events."

Tania Branigan, for many years the Guardian's correspondent in China, observes in her moving and troubling study of the afterlives of the Cultural Revolution in China that:

> facts are – or should be – sacred, to journalists and historians at least, but facts are not the whole truth; which we select and how we understand and weave them together – that matters too. We think of remembering as retrieval, but in fact it is an act of creation.[3]

For historians, these acts of creation mean, as Hayden White, Greg Dening, and others have observed, there is an affective element to historical narratives that sometimes blurs the distinction between non-fiction and fiction.

Historians and journalists, the latter perhaps more self-consciously than the former, know that their writing of and about the past carries great responsibility and raises ethical questions. What gives us the right to speak on behalf of the dead? Who gave us the right to tell stories that perhaps the dead never wanted to be told? Who are we to reach conclusions about causes and consequences, motives, and reactions? And how do we know that our restoration work bears some truth that the dead would recognize, perhaps even agree with?

There is no easy answer to these questions, but historians have girded themselves with the armour of generally agreed-upon practices and methodologies to justify their work and validate their truth claims. Interpreting sources with thoughtfulness, care, and rigour is part of this. So too is the obligation to situate oneself within historiography. Equally important is being open and transparent about the relationship between the history we write – our creative work – and the sources we have used to give it ballast. While not every historian will explain their positionality in their writing, they are all exceptionally careful about referencing sources, citing them

with exactitude so that others can find them, examine them for themselves, and come to their own conclusions, perhaps even to write their own (alternative) histories from them. There is indeed a special and strange relationship between the sources left to us of lives lived and the histories that we write about them. At the heart of this relationship is how we go about negotiating the gap between past and present or, to put it another way, how we navigate historical distance.

Mediating the distance between a past that happened and the writing of those events in the historian's present has been a significant theoretical and methodological challenge, one that has been met variously by historians and those engaged in representing the past from at least the early modern period to our own time. Referring "to a position of detached observation made possible by the passage of time," historical distance is generally assumed to achieve both detachment and improved understanding.[4] The confidence that comes with this assumption, and the linearity that underpins it, is troubled when consideration is given to the role of affect, emotions, and the senses in historical representations and by understanding the ways in which genres and media are deployed by their creators.[5] This too is a major theme of the book.

If, as is so often said, the past is a foreign country and they do things differently there, then navigating historical distance might be said to be an act of translation.[6] Embodying the past through performance is also a form of translation, an "act of transfer," to borrow from performance studies scholar Diana Taylor, that characterizes the transforming of the fixed knowledge of an archive into a more ephemeral repertoire.[7] As in the best translations, something of the original ghosts the new creation. There is a haunting in our productions of the past, a haunting of space, of time, of those who lived the lives whose stories we tell. Our representations – our re-presentations – of the past, even of those we are familiar with, seem always to carry a sense of the uncanny. This is a book then about how we speak about the dead and how they, in turn, have shaped our stories about them, never quite letting go.

Plan of the Book

Performing Public History speaks to my journey as someone who began his academic career in the 1980s trained in the British empiricist tradition within the academic discipline of history with a focus on early modern England and who ended up four decades later as a public historian who researches, teaches, and occasionally participates in the creation of historical representations in non-print media. The first chapter is a reflection on these three elements: the discipline of history, the field of public history,

and performance. The first section considers the nature of the discipline of history from the perspective of someone who saw how others perceive the historian's craft while working as a historical consultant to a theatre company and a presenter to gatherings of scholars and practitioners in theatre and performance studies. The second section identifies some of the key elements that characterize the still-emerging field of public history, notably its engagement with publics and how it embraces non-traditional forms of historical representation. The final section offers a brief account of what performance is and why I think it is a useful way of thinking about historical representation in the public world. Rather than succinct introductions or overviews, the three sections are intended to offer points of reference and engagement for the discussions that follow in the rest of the book.

The second chapter considers the work of archivists and curators in preserving the past, argues for a broadening in the definition of both archives and museums, and asks questions about the truths found in such storehouses of the past and the histories we write out of them. Close readings of a German feature film and an American theatre production are offered, which illustrate the tensions between written histories and oral histories and raise questions about the privileging of some sources over others and the relationship between memory and history. Discussions about tangible and intangible archives reference examples from Guatemala, India, Senegal, and Brazil.

The third chapter explores how the real is performed across a range of media. It plays with Roland Barthes' notion of "reality effects" and offers case studies of how the real is conveyed in film, theatre, and video games. Particular attention is paid to the concept of documentary, in both film and theatre. The chapter also discusses forms of historical performance in the global south where the binary of real and unreal is unsettled, taking as a primary example Indonesian *wayang kulit* shadow puppetry.

Chapter 4, "Feeling the Past," considers the importance of affect, emotions, and the senses in historical representations. Case studies investigate music and affect in an extensive discussion of the Canadian opera *Louis Riel* and the affective political theatre of the Bengali-based company Jana Sanskriti that travels throughout India performing especially in villages, work inspired by Augusto Boal's Theatre of the Oppressed. The chapter includes a discussion of emotions stimulated by soundscapes.

The fifth chapter explores the possibility that representations of the past can capture a degree of authenticity even though they may not adhere strictly to their sources. I argue that when the record fails, historians must use their imagination to fill the silences and use speculation to offer possibilities rather than certainties, testing the boundary between what is known and what might have been. As well as an Indigenous adaptation

of Shakespeare, readers will encounter a case study of a British-French film production about the Paris Commune and the relationship between lived lives and performed lives in living history performances and historical re-enactments.

The book's sixth chapter reveals how students taking a graduate seminar in narrativity and performance in public history wrestled with the issues raised in the first five chapters. The epilogue reviews the book's themes through an account of playing the historical video game, *Svoboda 1945 Liberation*. The Appendix offers examples of classroom-based activities that encourage discussion and debate as well as offering hands-on experience of the relationship between history, public history, and performance.

Notes

1. Suzan-Lori Parks, *The America Play and Other Works* (New York: Theatre Communications Group, 1995), 5.
2. Merriam-Webster, "Word of the Year 2023." https://www.merriam-webster.com/wordplay/word-of-the-year.
3. Tania Branigan, *Red Memory: The Afterlives of China's Cultural Revolution* (New York: W.W. Norton, 2023), 220.
4. Mark Salber Phillips, *On Historical Distance* (New Haven and London: Yale University Press, 2013), 13–14.
5. Mark Salber Phillips, Barbara Caine, and Julia Adeney Thomas, eds., *Rethinking Historical Distance* (Houndmills, Basingstoke, Hants: Palgrave Macmillan, 2013).
6. Often attributed to David Lowenthal, *The Past is a Foreign Country* (Cambridge: Cambridge University Press, 1985), the phrase is from the novel by L. P. Hartley, *The Go-Between* (London: Hamish Hamilton, 1953), 1.
7. Diana Taylor, *The Archive and the Repertoire: Performing Cultural Memory in the Americas* (Durham, NC and London: Duke University Press, 2003).

1
HISTORY, PUBLIC HISTORY, PERFORMANCE

I approached the stage door at Ottawa's National Arts Centre with a mixture of excitement and trepidation. I was on my way to join the English Theatre Company's first rehearsal of *Macbeth*. Today was a "meet and greet," but tomorrow I would be sharing with the actors and creative team all that I knew about the play, its author, and the period in which it was written. I planned to talk about culture and politics in the early seventeenth century and about the remarkable stage play world of Shakespeare's time. But mostly I wanted to talk about witches.

Witches are central to the play. Two of its most memorable scenes are their encounters with Macbeth. In Act One, Scene Three, they entice him with the promise that he will be king, launching his bloody ascendancy to power. In Act Four, Scene One, they ridicule him for thinking he can avoid his dreadful fate, turning the plot towards his downfall and death. The witches invite us to contemplate the role of the supernatural in the natural world. It was very topical at the time of the play's writing because the new English monarch, James I, had been active in the prosecution of witches in his native Scotland and had even written a book about the supernatural called *Demonology*. For Shakespeare's contemporaries, the play spoke directly to a lively debate about witches, whether they really existed or whether they were a fanciful notion for those who sought opportunity, power, revenge, or an excuse for the exercise of patriarchal authority over women. The play also addressed another question that troubled many at the time: to what degree are human beings responsible for their actions or can evil acts be put down solely to the devil's work? Over the years, I had

done a lot of research and teaching on early modern witchcraft and I was anxious to share.

The next day, I passed by the table of drinks and treats, posted schedules and sign-up sheets, and entered the rehearsal space which was set out like a seminar or meeting room with a rectangle of tables and chairs. The surrounding walls were crammed with photocopies of images from Shakespeare's world but, curiously I thought, also people dressed in mid-twentieth-century military uniforms. Energized by the passion in the room, I spoke for some two hours and answered challenging questions, responding to astute observations. Director Peter Hinton thanked me and then dropped a bombshell: there were to be no witches in our *Macbeth*.

This, to me, was like an espresso without the caffeine, pavlova without the meringue, it just couldn't be and, more revealing, I thought it shouldn't be. While I was used to, and open to, re-situating Shakespeare from his own early modern world to other times and places, and to challenging audiences by changing a character's gender, race, sexuality, ability, and language to raise new questions about what was, after all, a work of fiction, I was not used to such a dramatic alteration to the original. *Macbeth* without witches was simply a step too far.

Admittedly, the witches in *Macbeth* are very hard to stage for a modern audience. I know from teaching early modern witchcraft to twenty-first-century students that one of my first tasks is to convince them to take witches seriously. Besides the very few who are Wiccan, most students' experience of witches comes from Halloween costumes, Harry Potter, or any number of television shows and films. Not surprisingly, they struggle to see witches like early moderns did, as powerful yet vulnerable members of their communities with dangerous links to the supernatural. One solution is to focus on the providential aspect for, as Harold Bloom points out, the witches "place nothing in his [Macbeth's] mind that is not already there."[1] The witches then are a means to reveal the devilry within us and turn it into action. Director Peter Hinton and dramaturge Paula Danckert chose to set the play in the mid-twentieth century, with competing forces of fascism and democracy replacing warring medieval Scottish factions. *Macbeth*'s witches, played by young actors, became child evacuees fleeing bombs and destruction. No cauldrons. No bubbles. But lots of trouble.

It was transformative, for the play and for me as a historian, because it succeeded in capturing the opportunity and danger posed by early modern witches and convincingly represent this to a modern audience. In western culture, at least, children speak blunt truth ("out of the mouths of babes"). They can be charming and delightful but a split second later become angry, manipulative, and vindictive, much the same as how early modern

writers imagined and depicted witches. Sitting in the audience watching the child-actors pour all their scorn and disdain onto Macbeth in Act Four, Scene One, while retaining all their innocence and susceptibility, I became aware that perhaps for the first time (having seen many productions of the play) those sitting around me were experiencing something authentic about Shakespeare's time, in other words, they *got* early modern witches without them being witches at all.

For the historian this was, to say the least, rather unsettling. A conscious decision to deviate from an original source in re-presenting it to an audience had captured a greater degree of authenticity about the period in which it was written than I think would have been possible if there had been strict adherence to the original. As a historian, I had always assumed that treating sources with a commitment to rendering them accurately would ensure an authentic representation. Now I knew differently.

Over the next six years, I had the privilege of working alongside English Theatre's creative team as company historian. Working on productions such as *Mother Courage*, *A Christmas Carol*, *Romeo and Juliet*, *King Lear*, and *Vimy*, led me to ask questions about what historians do, and how, and why we do it. Working with theatre professionals who were as equally committed to sharing what we know or think we know about the past with others as was I, the professionally trained historian, led me to reconsider the historian's craft as I had learnt it, and taught it, as a historian of early modern Britain. As a participant observer, I witnessed and experienced a new way of doing history that was embodied, affective, sensory, emotional, and immersive.

Moving history off the page and onto the stage led to new research projects and new engagements with scholars and practitioners in theatre studies and performance studies. In my work as a public historian, I gravitated away from contested pasts in museums to performed histories, presenting papers and writing articles on theatre, film, opera, and living history sites. I organized a lecture series on performing the past in film, theatre, video games, re-enactments, and through recreations of a performance archive. My undergraduate teaching on history and film shifted from critiquing representation to engaging with how history is written in and on film.

I also began teaching a graduate seminar called "Narrativity and Performance in Public History" where the final form of assessment was not a traditional paper but an original performance in whatever form and on whatever topic the student chose. Week in and week out, the seminar contributed much to my thinking about performing public history and performing history publicly. Each semester culminated in inspiring performances that moved and impressed, that posed new questions, or that raised new possibilities about the past and how we tell the histories that are

important to us. This book owes much to them, and to those who chose to write their theses and major research essays in performative modes.

My personal "performative turn" raised questions about the relationship between the past and the writing of the past, about sources and their narrativizing, and about authors and their publics.[2] It encouraged me to acknowledge the importance of historical representations across a much wider range of media than the written articles and books that are the usual fare of the academic historian. It necessarily led to exploring media, from augmented reality to feature film, graphic novels to operas, puppetry to video games, in and on their own terms rather than as inadequate versions of "proper" forms of history. It led me to place greater value on affect, emotion, and the senses; on embodiment and movement; and on enacting and staging. It required exploring work in other disciplines, notably theatre and performance studies. The decision to have no witches in our production of *Macbeth* was the catalyst that opened up new spaces for thinking about history, public history, and performance.

History

In 1902, John Bury, a historian of the Roman Empire, became Regius Professor of Modern History at the University of Cambridge. Whereas his predecessor, Lord Acton, was well known for writing history with a literary flourish, Bury had a very different approach. The title of his inaugural lecture, "The Science of History," signalled the change. History, Bury asserted, "though she may supply material for literary art or philosophical speculation, she is herself simply a science, no less and no more."[3] The lecture provoked an immediate response from the Cambridge-trained historian G. M. Trevelyan. While acknowledging the importance of the scientific function which was, as he put it, "the day-labour that every historian must well and truly perform," Trevelyan insisted that there was a second function: the imaginative or speculative. This involved playing with the facts, selecting and organizing them to enable the historian to make suppositions, reach conclusions, and propose generalizations. This, in turn, was followed by a third function, the literary: "the exposition of the results of science and imagination in a form that will attract and educate."[4]

Although rarely articulated with such clarity at a particular historical moment, whether history is a science or an art or both, and what that implies theoretically and methodologically had been characteristic of the discipline long before this exchange between Bury and Trevelyan and ever since. It underlies the criticism that Thucydides (who died around 404 BCE) apparently levied against his predecessor Herodotus (died 425 BCE), namely that he lacked rigour in his approach to sources, accepting the

credibility of stories he heard but could not verify.[5] It characterizes the 1988 debate between Natalie Zemon Davis, who insisted on the need to speculate (openly and carefully) when the sources fail us, and Robert Finlay, who insisted that too much deviation from the sources amounted to "invention."[6] More recently, Saidiya Hartman's practice of "critical fabulation" has been met with scepticism by some historians.[7]

When Bury insisted history was a science "no less, and no more," he was reflecting a generation of historical work that was positivist, empiricist, and rigorous in its methodology. This emergence owed much to the German historian Leopold von Ranke, who died in 1886. Ranke famously said that the purpose of the historian was to capture the past *wie es eigentlich gewesen ist* – "as it essentially happened" – although it has more often been translated as "as it really happened" or "as it actually happened."[8] While for Ranke the historian's task was to move beyond the facts to establish what lay behind them to expose universal truths, a position known in philosophy as idealism, it was his practice that made the most impact on the discipline.[9] Ranke's emphasis on the seminar method of teaching in which historians presented their work to the rigorous interrogation of their peers, his reverence for the original sources, particularly written documents located in archives, and his insistence on extensive and proper citation so that others could critically engage with the interpretations and arguments proposed remain hallmarks of historical practice and training to this day.[10]

Doing history in this way tended to privilege written documents over other types of sources (visual, material, intangible) because that is what archives generally held. Since most archives were associated with governments ranging from small municipalities to nation states, the histories written from them tended to be focused on politics, governance, and diplomacy and reflect the perceptions and prejudices of political elites.[11] Sifting through the records with a view to teasing out the truths they have to reveal came to be the unique and privileged task of the professionally trained historian. This training required, and enabled, historians to distinguish and distance history from stories (tales, myths, memories) unverifiable by reference to the sources.

The Rankean method found fertile ground across Europe, with French positivists and English empiricists, historians who assumed that what they uncovered about the past could be accurately reflected in their historical writing. Setting aside Ranke's idealist philosophy, they formalized his practice. Careful interpretation of primary sources (those of the time being investigated or as close to that time as possible), offered up for the examination of fellow historians in prose that was devoid of any literary flourishes, was the name of the game. Historians had to resist offering

speculations that could not be defended by referring to those sources, to do otherwise was to stray into fiction writing, or philosophical surmise, unfounded and ungrounded in the past reality that the sources revealed. This was what history became in what Ernst Breisach calls historiography's "Golden Age," when

> historians counselled kings, were leaders in the unification of Germany and Italy, gave a prime minister and a president to France, provided identities to new and old nations, inspired the young American nation in its mastery of a continent, endowed revolutions with the authority of the past, and ascended to the rank of scientists. Above all, they convinced most scholars that everything must be understood in terms of development; in short, historically.[12]

This way of practising the historian's craft was exported to Europe's colonies, to the European colonial settler states, and to other countries where it was adapted or adopted and often displaced vernacular traditions of history writing. It became the dominant way of doing history, of thinking about history, and it still carries much weight in academic history departments.

For many outside academia this is also what history is: an account of what the historian has uncovered in the archive, repetitive at its driest, revelatory, and instructive at its best. When non-historians seek out the past as written by historians, they expect to find a story grounded in factual detail, ordered logically through a linear sequence. They anticipate narratives of cause and consequence, of risings and fallings, triumphs and declines, stories with a beginning, a middle, and an end. History written as tragedy or comedy, revolving around a turning point, a significant decision or turn of events. History doesn't change, the saying goes, although historians might interpret it differently or discover something new about it.

Historians, then, are trained and equipped to read, analyse, and interpret sources that are obscure and opaque to most, even if they were able to get access to them. We are expected to know about the past – any past, most pasts – and to be repositories of information. In my time with English Theatre, two examples from the several weeks of rehearsals of *Romeo and Juliet* come to mind. At one point, we were staging the friar going to rest on his bed. Would it be a simple affair of a mat on a bare floor, or would it be a posher version, perhaps raised off the floor? During blocking one actor, performing the role of a servant, said they were so angry with their master while rehearsing a scene that they wanted to hit them. Would that be acceptable? I was seen as an expert in both Elizabethan cultural and social practices and late medieval Italian life depending on whether I chose

to answer from the context of Shakespeare's own lived experience or that of the one he imagined and conjured up for the play.

This was not an unfair position to be put into because as a historian I *could* give answers. I replied that, for the friar's bed, it depended on how the actor (and director, and dramaturge) saw the friar. Were they a devout and strict adherent to the Franciscan rule or had circumstances softened them to allow for a little luxury? And, on the servant, did they feel that circumstances had generated such a strong feeling of injustice that they lost control and violated the Elizabethan homily on obedience which they would have heard many times? I could reach into the archives and pull-out examples of friars who got into trouble for being too lax, or who were accused of sowing discord in the community by judging others according to their own extreme asceticism. I could bring out (the very few) court records which evidenced a servant hitting their master. I was an expert witness to the past, invested with the authority to judge the rightness of how it might be represented and re-presented on stage. Yet if what was wanted was certainty – a clear yes or no answer – all I could offer were possibilities and playabilities informed by my knowledge of the archive and historiography.

Public History

Historians writing in the western tradition have always done history in public. For sure, their audiences may be rather small. By the sixteenth and seventeenth centuries, Herodotus and Thucydides had been translated and consumed by enough literate elites in Europe that their works were referenced by political and military writers, in parliamentary speeches, and in stage plays. European historians writing in the sixteenth and seventeenth centuries had their audiences too, ones that were ever-increasing in number as literacy rates rose and books became more readily available with the printing revolution.

Those writing the past during and in the aftermath of the Enlightenment enjoyed sizeable publics, often writing with a literary flourish and insisting on what was called "sentiment," the need for their work to stimulate the senses and the imagination of their readers.[13] Genres of fact and fiction were blurred. Sir Walter Scott's historical fictional novels were firmly grounded in research, not just archival and library research, but drawing on objects, landscapes, and oral histories. Conversely, Thomas Carlyle's historical works were written in a way to deliberately provoke responses from readers by offering strong opinions and using emotional language.

These historians attracted many readers. They were writing history for a larger public, their works were often accompanied by dramatic illustrations, which resonated with the genre of historical painting that really took

off at the same time. Historians played a vital role in the romantic movement. Representations of the past commanded much public interest in novels, plays, pageants, paintings, and performances. In Italy of the 1830s, the opera composer Gaetano Donizetti found value in telling stories drawn from Tudor Britain.[14] Historical themes, reinforcing claims to ancient pasts or deliberate evoking of shared (sometimes invented) traditions, became part of the strategy of governance, for example through coins and postage stamps. Historians enjoyed their "Golden Age," not just as statesmen and what today we would call influencers but also in popular culture and with the public at large.

Doing history in public is one definition of public history. As Ludmilla Jordanova has remarked, "Among other things, public history is *popular* history."[15] This was something valued by Trevelyan who worried that Bury's insistence on history being a science would exclude many of those who read and enjoyed history, not to mention those amateur historians who produced it. History for the people, by the people, of the people was something not to be sneered at, or distanced from, but this was in the end the consequence of the professionalization of the discipline from the late nineteenth century onwards. For many academic historians to write for a popular audience was to dumb down the past, to offer generalizations that resisted good historical interpretation, to tell histories that might compel and entertain, but lacked intellectual rigour and were not accurate representations of what really happened or what might have happened or what essentially happened. While not all did, most professionally trained historians working in the academy (universities and colleges) withdrew from addressing larger publics writing almost exclusively for other professionally trained historians and students in training even though outside academia many historians were doing public history work.[16] What had been a very public discipline became a rather private one.

In the 1970s and 1980s, university-based historians across the globe, but particularly in North America, recognized that while teaching history undoubtedly served to educate citizens, most doctoral students would be unlikely to find academic positions. In 1978, deciding whether to pursue a doctorate or not, many told me (as I tell my students today) that the motivation for doing so must come from an intellectual curiosity, not from hopes of being a professor. There were simply no, or very few, teaching and research jobs at universities. There were, however, many openings for historians in other institutions such as archives, museums, heritage sites, or professional research firms.

One of the manifestations of this realization was the creation of dozens of new degree programmes, particularly in the United States, designed to train students to work in such institutions, often giving them hands-on

experience through placements and internships. Recognizing this rapidly growing field of history led to the founding of a journal, *The Public Historian* (1978) and an association, the National Council on Public History (NCPH, incorporated 1980).[17] By the end of the 1980s, it seemed that a new approach to the study of the past was emerging. Sometimes called applied history – the application of historical knowledge in the present day for practical purposes – it became known, particularly in North America, as public history. Doing history in public, or popular history, had become a formalized, recognized, distinctive field of the discipline.

What characterized this field? It was, first and foremost, of course, history. It shared all the characteristics and attributes of other types of history: the critical interpretation of the sources left by the past and the dissemination of that interpretation to others. Academic public historians, no less than any type of historian, were, and still are, trained in the empiricist tradition. Yet the qualifier public is of deep significance. It goes beyond a simple correlation with popular history as Jordanova recognized when she prefaced her sentence with "Among other things. . . ."[18]

First, histories written by public historians are intended for larger audiences than specialists: they are intended for the public and are about the public. Second, and increasingly over time, the histories written by public historians came to be histories written in collaboration with others who are not trained historians: public history with the public. Third, public historians recognize the value of histories written and produced by the public without, necessarily, any involvement with professionally trained historians. The "pop" histories written by history buffs and amateur historians may be flawed, but public historians value them not only for how they might stimulate interest in history and the past or demonstrate the role of history in our everyday lives but also for what they might contribute to historical knowledge and understanding.

Popular Uses of History in American Life was the title of a seminal work in the field of public history by Roy Rosenzweig and David Thelen.[19] They carried out an extensive survey of how and where Americans engaged with the past, noting a collective experience as well as distinguishing those who identified as white, Afro-American, Latino, and Sioux. Besides uncovering the many ways in which people engage with the past in their everyday lives – reading historical novels, working through family photo albums, participating in history-focused events, collecting objects from the past and so on – the study also revealed which of those activities were thought to be the most trustworthy. The survey on which their study was based encouraged later investigations in Australia and Canada which looked even more deeply into how such activities contributed to historical awareness, consciousness, and understanding.[20]

The many ways in which publics engage with the past are the focus for the work of public historians. Indeed, when asked to explain what it is that they do public historians often identify their field by talking about the sites of historical representations that occupy their attention. They say they study the past as represented in – and history "written" in – museum exhibits, films, television, video games, graphic novels, podcasts, web sites, re-enactments, and so on. Public historians not only value historical representations in non-traditional forms but engage in creating history through these media. This makes them the most visible of historians who perform history making in the present. The formalization and growth of the field took place at a time when in the larger discipline, privileging political and constitutional history was being challenged by the new social history, women's history, Black history, LGBTQIA+ history, cultural history, the history of the everyday, and postmodern history, to name only some of the exciting shifts of those decades within academic and popular history. Many public historians were participants in or were influenced by these new approaches.

Public historians then, compared to other types of historians, especially acknowledge, encourage, and value the participatory role of publics in history making. Furthermore, they are more likely to work collaboratively with publics, even co-produce histories with non-historians, and this forces them to confront their own subjectivities, challenge their assumptions about expertise and authority, and to think deeply about accountability. These are not always comfortable relationships and historians are even more challenged by histories produced without their involvement. Some may be excellent, deeply researched and thoughtfully written, and others are relatively harmless even though they may be superficial or uncritical, miss complexity, or prioritize entertainment value over historical veracity. Some, however, are deeply troubling because they commemorate or celebrate dark histories or deliberately misuse the past to support agendas in the present. Historians can choose to ignore, ridicule, and dismiss such representations or decide to critically engage with them, producing alternative, better histories. Whatever action they take, historical representations produced by non-historians invite questions central to the field. What makes a historian a public historian? Is it their training as historians or that they do history in the public sphere, or both? Do the histories produced by non-historians count as public history? Do those who make them become public historians as a consequence of their history work even though they have no training in the discipline?

Affective history which focuses on feelings and their embodiment in practice, and sensory history, which pays attention to sound, sight, smell, taste, and touch, are central to public history practice. Starting from the

position that all human activities are performed as embodied representations whether we think of the practices of everyday life or the more formal framings as in theatre, music, film, and dance, performance and performativity have become valuable ways of thinking about public history. Moreover, embodying history through performance embraces forms of representation that predate the field's formalization and institutionalization in North America and Europe and have been global phenomena for centuries. As Greg Dening put it, "History – the past transformed into words or paint or dance or play – is always [and one might add, has always been] a performance."[21]

Performance

If history is always a performance, then it follows that historians are performers. My performances of the past may be more obviously performative in the lecture hall or seminar room, but it is also present when I'm researching, thinking, and writing about the past. In his 1959 work *The Presentation of the Self in Everyday Life*, Erving Goffman defined performance "as all the activity of a given participant on a given occasion which serves to influence in a way any of the other participants . . . we may refer to those who contribute as the audience, observers, or co-participants."[22] Performance plays a vital role in our understanding of the world around us and in our positioning ourselves within it. In this, the past, and history, have a role to play. Reading through the various national surveys about how publics engage with the past one is struck by how important it is in the everyday lives of so many people. Making something of, and telling stories about, the past is important to them. It is part of their identity, which makes them human, and they perform history making through visiting, watching, reading, collecting, re-creating, walking, and talking.

There is, then, the original, the past that is the subject and focus of such activities and the secondary performances of them in the present. There is a double-ness in history making that has been seen by performance studies scholars as being central to their field. In *Performance: A Critical Introduction*, Marvin Carlson approves Richard Bauman's insistence that "all performance involves a consciousness of doubleness, through which the actual execution of an action is placed in mental comparison with a potential, an ideal, or a remembered original model."[23] For Richard Schechner, this remembered original means that performances are "behaviours previously behaved" or "twice-behaved behaviours."[24] Rehearsing these "restored behaviours" involves a "performative bundle" that is multidirectional: "the future – the project coming into existence through the process of rehearsal – determines the past: what will be kept from earlier rehearsals

or from the 'source materials.'"²⁵ Schechner famously illustrated this with reference to English actor Sir Laurence Olivier's performance of Shakespeare's *Hamlet*:

> Olivier is not Hamlet, but he is also not not Hamlet. The reverse is also true: in this production of the play, Hamlet is not Olivier, but he is also not not Olivier. Within this field or frame of double negativity, choice and virtuality remain activated.²⁶

Performances are the ways in which something is passed along to others whether this be through writing, theatre, music, dance, cooking, re-enactments, or rituals. They are, in Diana Taylor's words, "vital acts of transfer" characterized by "once again-ness" in which the role of the performers, as well as audiences, is key.²⁷

German playwright Bertolt Brecht was of the view that there had to be a dialectical relationship between the actor and the role they were playing, reinforced through staging. The actor – through various means including verbal observations, gestures, or song – engages with the role they are performing or the performance itself, but also with the audience. Often in Brechtian productions, this was made quite explicit, breaking down the "fourth wall" between audience and actor by employing strategies such as having actors sitting in the audience or inviting audience members to comment during the performance. This enabled Brecht to make productions set in the past, like *Mother Courage* (set in the seventeenth century's Thirty Years' War) speak loudly to his own mid-twentieth-century Europe. It asked audiences of our English Theatre's production of the play to relate it to Canadian participation in the war in Afghanistan which we insisted upon by adopting various Brechtian techniques such as including contemporary references through sound and image.

Brecht is especially credited with the concept of epic theatre. This is not a matter of scale (as in epic feature historical films like Stanley Kubrick's *Spartacus*) but refers to how audiences react to, and can be made to work with, theatrical productions. Audiences are not there to suspend their own reality, but to engage with it through theatre. He demonstrated this concept through *Street Scene*. An eyewitness to a traffic accident offers their view on what happened, but those hearing this may disagree, having seen it differently or, having not seen it at all, still have opinions about it. The eyewitness may act out the role of the driver or the role of the victim, but those watching will still form their own views and positions, and theatrical strategies must be employed – lighting, music, verbal interventions – to ensure the audience is not lulled into passivity by being so immersed in the imagined reality on stage that they forget that they are watching a play

and that the play has things to say about their own lived reality.[28] Brazilian director Augusto Boal, author of the influential 1974 work *Theatre of the Oppressed*, adopted Brechtian strategies to realize theatre's potential to create social change. He coined the term "spect-actors" where audiences are active agents in creating meaning in, and of, performances rather than passive consumers.[29]

Freddie Rokem builds on Brecht's concept of epic theatre to think through the implications of doubleness (the actor being Hamlet but not Hamlet). He proposes that actors (in theatrical productions re-presenting the past) become "hyper-historians," witnessing the "real" past they are re-performing in their own present for an audience.[30] This bringing of the real and the imagined together through theatrical energies means that performers become witnesses presenting testimony for the spectator. The actors, in working with the text and the performance elements, create the text a second time, which is both familiar and yet foreign; acting "both transmits and transforms social energies from that past on the present-day stage."[31]

Rokem is writing about theatre, performances that are based (usually) on scripts conveying plot, storylines, and characters acted out on stage. There are other performances though, such as embodied and movement-based street art, to which living history performances and re-enactments, parades, pilgrimages, walking tours, and so forth could be added; this is the focus of scholars working in performance, rather than theatre, studies. Schechner, building on Brecht and Boal, identifies seven functions of performance – to entertain, to beautify, to change and mark identity, to make and foster community, to heal, to teach or persuade, and to deal with the sacred and profane. It might be said that these correspond also to the functions of performativity – the construction of social realities such as gender as developed by Judith Butler.[32] If all social realities are constructed, whatever purpose they are put to, then it follows that everyday performances are acts of showing and doing. Diana Taylor offers a distinction between the "archive" – which exists but is always interpreted anew – and the repertoire – which is embodied and ephemeral but always referential. Her notion of scenario as a methodology in performance studies has been influential and also speaks to public history work.

Taylor sees the scenario as comprising narration and plot, milieux, and corporeal behaviour. Scenarios, she argues, are "meaning-making paradigms that structure social environments, behaviours, and potential outcomes."[33] She suggests that scenario draws from the repertoire and the archive by addressing scene and embodiment: "by encapsulating both the setup and the action/behaviours [scenarios] are formulaic structures that predispose certain outcomes and yet allow for reversal, parody, and

change."³⁴ Multifaceted, and insisting that we play roles "as participants, spectators, or witnesses," the scenario is not a copy but "constitutes once-againness," a concept with which historians are deeply familiar.³⁵ Greg Dening was one historian who recognized the synergies between theatre work and history writing. In his 1993 article "The Theatricality of History Making and the Paradoxes of Acting," he urged historians to be as reflective about the process of writing the past as are those staging it.³⁶ One consequence of re-engaging with the ways we do history, and do history publicly, drawing on insights from performance studies, is that it encourages us to see, as well as do, things differently.

Ways of Seeing and Doing

Performance studies scholar Dwight Conquergood distinguishes two ways of knowing and understanding. "Empirical observation and critical analysis from a distanced perspective: 'knowing that' and 'knowing about'" dominates the academy. This top-down view is "shadowed by another way of knowing that is grounded in active, intimate, hands-on participation and personal connection: 'knowing how' and 'knowing who.'" This "ground-level" knowledge is gained through the practice and experience of doing.³⁷ The first is like the empiricist approach to the study of the past, an act of archival excavation that rests on a distanced view, akin to scientists using microscopes and telescopes. Both instruments enable the viewer to see things that are too small or too far way to see with the naked eye, to see them straight on through the interplay of light, mirrors, and lenses. This way of perceiving the world, of making sense of it, assumes that what is reflected down the tube to the human eye accurately represents the object under observation, in much the same way as the historian's observation of sources reflects the realities of the past. History writing, then, simply needs to be grounded in those sources to be able to be seen as accurate representations of past reality and through a process of citation (and criticism) these representations are validated as authentic. It is a way of seeing rightly, of getting the story straight.

This was a view expressed during a seminar attended by humanities scholar Hans Kellner who notes it earned a repost from the historian Stephen Bann that on the contrary, the point was "to get the story *crooked*."³⁸ The implications of this response were brought home to Kellner while he was repairing his opera glasses. Kellner discovered that by turning a few screws he could bring the lenses back into alignment so that the glasses would work properly, focusing straightly, but he realized the value of seeing things crookedly: "To see the text straight is to see *through* it – that is, not to see it at all except as a device to facilitate knowledge of reality."³⁹

Real understanding came from seeing things differently, in parts and fragments, that could be put together in one way, or another, or not at all. He demonstrates what reading crookedly means by examining a passage from nineteenth-century French historian Jules Michelet's *Le Moyen Age*, analysing the narrative offered by the historian rather than seeking out facts and arguments validated (or not) by the sources cited by them. Displacing the direct relationship between source and its narrative representation by the historian, Michelet troubled the priority given to the primary source and its secondary derivative, opening up the possibility that history – the writing of the past – resided more in the latter than in the former.

In his meditative graphic novel, *Unflattening*, Nick Sousanis also asks that we rethink about how we see (and know) through looking. Perspective lies between our eyes, when we bring what we see through each eye into alignment in the in-betweenness above our noses, but "there is difference between the view each produces – thus there is no single, 'correct' view."[40] The telescope enabled us to "probe deeper and peer still further," its lenses expanded understanding but also restricted "vision to a narrow range of the spectrum . . . leading us to mistake the view of them for reality."[41] Sousanis argues that we need to embrace alternatives to a singular, flattened perception of the world, shifting from our own one-dimensional view to a more multidimensional one. He even posits that we embrace the senses as a way of knowing, evoking how a dog navigates at night-time though elevated (compared to humans) awareness through sound and smell. And what of knowing through imagining? In an image of two hands reaching towards each other and interlocking their fingers with a vortex behind them, Sousanis invites us to visually engage with the question: "Is it not imagination that allows us to encounter the Other as disclosed through the image of that Other's face?"[42]

Historians seek to understand the other that is the past, but using one's imagination runs against the grain of the empiricist, scientific tradition. If the imagination is allowed to run riot, not held in check by the sources, what distinguishes history from myth, fact from fiction? A few decades after the Bury-Trevelyan controversy, another historian of the Roman Empire, and idealist philosopher of history, R.G. Collingwood, tackled Bury's insistence that history is a science "no less, and no more," head on. Collingwood sympathized with Bury's desire to establish the scientific nature of what the historian does but pointed out that the events about which the historian writes "are not deliberately produced by historians under laboratory conditions in order to be studied with scientific precision. Nor are they even observed by historians in the sense in which events are observed by natural scientists."[43] Collingwood argued that, even if their practice denies it, historians inevitably draw on their imagination as they read and interpret.[44]

Elizabeth Kostova makes the same point from the perspective of a writer of fiction. In *The Historian: A Novel*, which I happened to stumble across when passing one of the little libraries that populates my neighbourhood, Kostova blurs many genres for it is part mystery, part thriller, and part fantasy, contained within a historical fiction novel about a young woman who discovers an archive that leads her down many paths seeking to uncover the history of Vlad the Impaler. Readers encounter an explanation of the research methods behind the story: archival and written sources as well as interviews. "There is a final resource to which I've resorted when necessary," Kostova writes, "the imagination." She has used this, she says "with judicious care, imagining for my reader only what I already know is very likely, and even then only when an informed speculation can set these documents into their proper context."[45]

History does not stand outside its object – the past. As Stein Helgeby observes, for Collingwood, it "is an activity, or act, which involves the historian in performing other actions." This means that "knowing the action means performing the action again . . . by understanding the past he has become different to what he was before."[46] Collingwood acknowledged that the historian's method consists of (source) selection, construction, and criticism, but then asked "how does the historian discern the thoughts which he is trying to discover?" His answer was that there "is only one way in which it can be done: by re-thinking them . . . [history] is the re-enactment of past thought in the historian's own mind."[47] Since our knowledge of the past is always mediated not experienced, the historian necessarily uses their imagination in order to make sense of the past in much the same way as a novelist does. There are, though, crucial differences: the novelist is free of three rules of historical practice: "The historian's picture must be localized in time and space"; it "must be consistent with itself"; and most importantly, it "stands in a peculiar relation to something called evidence."[48]

Collingwood argued that the *idea* of history has to be given content and historians fulfil this obligation "by using the present as evidence for its own past. Every present has a past of its own, and any imaginative reconstruction of the past aims at reconstructing the past of this present, the present in which the act of imagination is going on, as here and now perceived."[49] In using their imaginations to reconstruct the present of the past they are seeking to understand, the historian, situated in their own present, cannot help but draw on the pasts that shaped their world, pasts which happened after that which they are investigating. What happens next is vital. Does the historian insist that their professional training enables them to set aside these later pasts, and their own present, to achieve a degree of objectivity and distance? Or do they acknowledge, engage with, and even make use of their own positionality and subjectivity?

One historian who has done precisely this is Minoru Hokari who went to Australia intending to uncover the oral traditions and oral histories of the Gurindji of Daguragu and Kalkarindji in the Northern Territory and came away with an entirely new perspective and understanding of the theory and practice of history. Hokari soon discovered that assigning veracity to histories told by referring to evidence was almost entirely irrelevant; the trustworthiness of a story depended much more on locations and sites, the credibility of the storyteller, and the storyteller's connections with others. "A person who has more knowledge and connection to other people and places may assert more authenticity over more stories than others," Hokari writes, and because "there is no authentic centre that guarantees the validity of information, knowledge naturally acquires many variations through the process of networking." Contradictory stories thus co-exist happily: "the Gurindji people's historical knowledge accepts many different versions of events."[50]

For Hokari, as it should for us, this raised serious questions about western historiography. If credibility rests more on the power of place and that of the storyteller as a social being, then what do we do with a practice where it rests ultimately on a bedrock of evidentiary sources? What happens if we are open to questioning the privileging of primary sources over secondary ones, and the assumption that with time and distance, history writing becomes more objective and therefore more authoritative? These linear and straight ways of thinking are somewhat closed compared to the Gurindji whose knowledge system was more open "because wherever and to whomever stories belong, they are pooled, and multiple variations are preferred . . . pooled stories are always chosen and used according to the context of the story being told."[51] Perhaps, though, there is more fluidity in ways of writing history in the West than is generally acknowledged, more genre-bending, and more open-ness to alternative ways of representing the past that ultimately also challenge complacency about "essentials" in the doing, making, and writing of history.[52] The work of C.L.R. James is a case in point.

History as Drama

"There is no drama like the drama of history."[53] So wrote C.L.R. James in his ground-breaking work, *The Black Jacobins*, originally published in 1938 and later revised for publication in 1963. James's remarkable statement comes towards the end of the final chapter on the war of independence which led to the death of Toussaint L'Ouverture, the heroic leader of one of the most successful slave revolts in history. James begins the chapter by setting out the story as a tragedy, but not the common trope where an

individual faces uncontrollable forces; "the tragic flaw," James argues, was within Toussaint himself, his fall and death the consequence of "a total miscalculation of the constituent events."[54]

There is no doubt of the significance of *The Black Jacobins*. Its themes of Black agency and achievement were revolutionary for the historiography of its day and inspired Black and anti-colonial activism in the decades that followed. In his foreword to the 1980 edition, James speaks of his motivation:

> I was tired of reading and hearing about Africans being persecuted and oppressed in Africa, in the Middle Passage, in the USA and all over the Caribbean. I made up my mind that I would write a book in which Africans or people of African descent instead of constantly being the object of others people's exploitation and ferocity would themselves be taking action on a grand scale and shaping other people to their own needs.[55]

In an interview with Bill Schwartz, leading British intellectual Stuart Hall succinctly captured the importance of *The Black Jacobins*: it was the first work "to centre slavery in world history."[56] The product of deep research, the book was very much shaped by James's anti-colonial activism, his Marxism, and the activist labour movement across the Caribbean in the 1930s. Perhaps less well known is that the themes of *The Black Jacobins* first saw light of day as a play, *Toussaint Louverture*. It was performed in 1936 in London with Paul Robeson (who had been courted for Sergei Eisenstein's projected film about the Haitian Revolution) in the starring role.[57] *The Black Jacobins* was then decidedly dramatic history. "It's not fiction, it's not story-telling," Hall comments, "but the excitement of *The Black Jacobins* lies in its dramaturgical sweep."[58]

While historians today readily acknowledge that history is storytelling (some might even playfully use the word *hi*storytelling to signal the factual basis of their narrativizing the past), the tensions between history written as monograph and history written as drama remains.[59] The interdependence between James's play-writing and history writing has been charted impressively by Rachel Douglas; her deep reading of James's texts and the contexts in which they were written reveals that this was a life-long project taking many turns and directions, a constant process of re-engagement and re-writing.[60] *Toussaint Louverture* was written while James was researching for his book. The play as performed was very much shaped by Robeson which in turn influenced *The Black Jacobins*.[61] The book's tragic element is given, on Douglas's reading, an even stronger emphasis in the re-writing that took place between the editions of 1938 and 1963. Besides linking the Haitian Revolution to the Cuban, the 1963 publication introduced

new influential figures into the narrative of revolution, gave more emphasis to the role of the crowd and to larger forces of change inspired by historians associated with the economic, social, and "history from below" approaches that were gaining ground in the 1950s and 1960s. The 1967 play also reflects these changes, while also drawing – dramaturgically speaking – from epic theatre and Boal's Theatre of the Oppressed. The life-long synergy between James's creative writing and his non-creative writing, the evident crossovers that are multi-directional and many-layered, demonstrates not only that there are no hard-and-fast boundaries between writing history as drama and writing history as monograph but that the academic writing of the past is always a creative act. The slipperiness of disciplinary boundaries became acutely visible at a particular moment in the settler colonial history of Aotearoa New Zealand.

A Historian on the Beach

As the tall-masted ship rounded the point and entered the bay cheers broke out at one end of the beach. At the other, women began to wail. "Seemingly from nowhere," Joanna Kidman wrote,

> I hear a shuddering cry and realise it's coming from me – an involuntary howl of rage and grief for all the generations of dislocation, dispossession and diaspora. It's for the taking of land and whakapapa [genealogy] and for my own whānau [extended family] lost in the tides of those histories.[62]

Kidman was witnessing a historical re-enactment of Captain James Cook's arrival in Aotearoa New Zealand staged 250 years after the event. The famous explorer's landing at Tūranganui-a-Kiwa (Gisborne) in October 1769 was marked with bloodshed, nine Māori men and boys were killed by the *Endeavour*'s crew over three days.

For many pakeha (whites) attending the event, this was an occasion to celebrate a key foundational event in settler history, to wonder at the achievements of voyaging across the globe in what for many was a surprisingly small ship, to appreciate its beauty. For them, while the re-enactment and commemoration closed historical distance, they did not overcome it. By contrast, for the Māori in attendance, historical distance was violently collapsed, overpowered, and eliminated by anger and grief.

For some pakeha, the protests and outpourings of emotion were misplaced and unwarranted; even if they acknowledged wrongdoing and suffering, they thought it was time for Māori to "Get over it" and "Let it go. Move on."[63] But what does letting it go mean? Forgetting? Forgiving? And

then moving on as if nothing had happened? For Māori leaders, the government's insistence that the event should still take place despite an earlier apology by the British High Commissioner for what had occurred was evidence that such statements were empty gestures, devoid of real meaning and consequence.

The arrival of Cook's ship therefore took on an energy and a life of its own. This was no re-presentation of a past original, it was an original newly made, an event with its own history, contexts, and archive. For Marise Lent, the event forced Māori to "re-live" the original trauma, a powerful reminder that "[o]ur indigenous rights have been breached over and over again."[64] While many pakeha, including the Minister for Crown-Māori relations, insisted on the value of the commemoration as an opportunity for Māori "to share their true story, to tell of their loss," the notion of shared trauma is strikingly absent from these discourses.[65] Foregrounding Māori experience, giving Indigenous peoples a chance to tell their side of the story, relieves settlers from the responsibility of acknowledging the benefits they received through colonialism's destruction of Indigenous cultures. Even if more commemorative than celebratory – a claim often made in defence of such events – re-staging the arrival of the *Endeavour* failed as a curated opportunity to encourage and empower settler society to come to terms with their own privileged, and blood-soaked, histories.

Kidman concludes with a moving account of the re-narrativization of Te Maro, rangatira (chief) of the Ngāti Oneone, that takes the form of a tall circular sculpture. A renowned horticulturalist and scientist, he was murdered on that fatal day in October 1769. It is a gathering place for Māori to celebrate his life and his legacy. From its vantage point on Kaiti Hill, Kidman looks down at the "puny" *Endeavour*, along with Te Maro who now gets to tell his own story, displacing the one that marks him merely as one of the victims of Cook's murderous acts. Thus, to truly move on requires a commitment to change the narrative, to re-write the history, to change our performances of it, whatever form these performances might take. Our writings of the past – including academic history writing – are created and curated, performances as much for ourselves as for our audiences. To be able to do so comes not only from a position of privilege but also of power as we seek to reshape narratives by getting our stories, or our take on things, across. This means, as Kidman's experience of the re-enactment of Cook's arrival in Aotearoa New Zealand demonstrates, that scholars need to embrace their own positionality and the performativity in their history work. Only by so doing can we truly engage with the present-ness of the past and the past-ness of the present.

Notes

1 Harold Bloom, *Shakespeare: The Invention of the Human* (New York: Riverhead Books, 1998), 532.
2 Doris Bachmann-Medick, *Cultural Turns: New Orientations in the Study of Culture* (Berlin: De Gruyter, 2016), 73–102; Peter Burke, "Performing History: The Importance of Occasions," *Rethinking History* 9, no. 1 (2005), 35–52.
3 Fritz Stern, *The Varieties of History: From Voltaire to the Present* (2nd ed., New York: Vintage, 1973), 223.
4 Stern, *Varieties*, 239.
5 Thucydides did not mention Herodotus by name, but historians have assumed this who had in mind when he promised readers that unlike previous historians, he was committed to finding out the truth, Marek Węcowski, "Friends or Foes? Herodotus in Thucydides' Preface," in *The Children of Herodotus: Greek and Roman Historiography and Related Genres*, ed. Jakub Pigoń (Newcastle upon Tyne: Cambridge Scholars Publishing), 40–41.
6 Robert Finlay, "The Refashioning of Martin Guerre," *American Historical Review* 93, no. 3 (1988), 533–71 and Natalie Zemon Davis, "On the Lame," *American Historical Review* 93, no. 3 (1988), 572–603.
7 Alexis Okeowo, "How Saidiya Hartman Retells the History of Black Life," *New Yorker*, October 19, 2020.
8 Felix Gilbert, *History: Politics or Culture? Reflections on Ranke and Burckhardt* (Princeton: Princeton University Press, 1990), 32–45.
9 Peter Novick, *That Noble Dream: The 'Objectivity Question' and the American Historical Profession* (Cambridge: Cambridge University Press, 1988).
10 See, for example, from Geoffrey Elton, *The Practice of History* (London: Fontana, 1967) through Michael J. Salevouris and Conal Furay, *The Methods and Skills of History: A Practical Guide* (New York: Wiley Blackwell, 1988) to Wendy Pojmann, Barbara Reeves-Ellington, and Karen Ward Mahar, *Doing History: An Introduction to the Historian's Craft* (Oxford: Oxford University Press, 2015).
11 Carolyn Steedman, *Dust: The Archive and Cultural History* (New Brunswick, NJ: Rutgers University Press, 2002), 69.
12 Ernst Breisach, *Historiography: Ancient & Modern* (2nd ed., Chicago: University of Chicago Press, 1994), 1, 268.
13 Mark Salber Phillips, *Society and Sentiment: Genres of Historical Writing in Britain, 1740–1820* (Princeton: Princeton University Press, 2000).
14 *Elisabetta al castello di Kenilworth* (1829), *Anna Bolena* (1830), *Maria Stuarda* (1834), and *Roberto Devereux* (1837).
15 Ludmilla Jordanova, *History in Practice* (London: Hodder, 2000), 141.
16 Rebecca Conard, "Complicating Origin Stories: The Making of Public History into an Academic Field in the United States," in *A Companion to Public History*, ed. David Dean (Hoboken, NJ and Chichester, West Sussex: Wiley Blackwell, 2018), 19–32; Denise D. Meringolo, *Museums, Monuments and National Parks: Towards a New Genealogy of Public History* (Amherst and Boston: University of Massachusetts Press, 2012); Bronwyn Dalley and Jock Philips, eds., *Going Public: The Changing Face of New Zealand History* (Auckland: Auckland University Press, 2001).
17 National Council on Public History, "What is Public History?" https://ncph.org/what-is-public-history/about-the-field/.
18 David Dean, "Publics, Public History, and Participatory Public History," in *Public in Public History*, eds. Joanna Woydon and Dorota Wiśniewska (New York and London: Routledge, 2021), 1–18.

19 Roy Rosenzweig and David Thelen, *The Presence of the Past: Popular Uses of History in American Life* (New York: Columbia University Press, 1998).
20 Paula Hamilton and Paul Ashton, *Australians and the Past* (Perth, Western Australia: University of Queensland Press, 2003); Conrad, Margaret, Kadriye Ercikan, Gerald Friesen, Jocelyn Létourneau, Delphin Andrew Muise, David Northrup, and Peter Seixas, *Canadians and Their Pasts* (Toronto: University of Toronto Press, 2013).
21 Greg Dening, "Performing on the Beaches of the Mind: An Essay," *History and Theory* 41, no. 1 (2002), 1.
22 Erving Goffman, *Presentation of the Self in Everyday Life* (London: Anchor, 1959), 15–16.
23 Marvin Carlson, *Performance: A Critical Introduction* (London: Routledge, 2017), 5.
24 Richard Schechner, *Performance Studies: An Introduction* (2nd ed., New York: Routledge, 2002), 28; Richard Schechner, *Between Theater and Anthropology* (Philadelphia: University of Pennsylvania Press, 1985), 36.
25 Schechner, *Between Theater and Anthropology*, 39, 79.
26 Schechner, *Between Theater and Anthropology*, 110.
27 Taylor, *The Archive and the Repertoire*, 2, 32.
28 Bertolt Brecht, "The Street Scene: A Basic Model for an Epic Theatre," in *Brecht on Theatre: The Development of an Aesthetic* (London: Methuen, 1964), 121–29.
29 Augusto Boal, *Theatre of the Oppressed* (London: Pluto Press, 2019), xxi–xxii (preface to the 2000 edition), 134–35.
30 Freddie Rokem, *Performing History: Theatrical Representations of the Past in Contemporary Theatre* (Iowa City: Iowa University Press, 2000), 202.
31 Rokem, *Performing History*, 189.
32 Schechner, *Performance Studies*, 46; Judith Butler, "Performative Acts and Gender Constitution: An Essay in Phenomenology and Feminist Theory," *Theatre Journal* 40, no. 4 (1988), 519–31; James Loxley, *Performativity* (London and New York: Routledge, 2007), 112ff; Katherine Johnson, "Performance and Performativity," in *The Routledge Handbook of Reenactment Studies*, eds. Vanessa Agnew, Jonathan Lamb, and Juliane Tomann (New York and London: Routledge, 2020), 169–72.
33 Taylor, *Archive and Repertoire*, 28. The discussion that follows is drawn from 29–33.
34 Taylor, *Archive and Repertoire*, 31.
35 Taylor, *Archive and Repertoire*, 32.
36 Greg Dening, "The Theatricality of History Making and the Paradoxes of Acting," *Cultural Anthropology* 8, no. 1 (1993), 73–95.
37 Dwight Conquergood, "Performance Studies," *The Drama Review* 46, no. 2 (2002), 146.
38 Hans Kellner, *Language and Historical Representation: Getting the Story Crooked* (Madison, Wisconsin: The University of Wisconsin Press, 1989), 3.
39 Kellner, *Language and Historical Representation*, 4.
40 Nick Sousanis, *Unflattening* (Cambridge, MA: Harvard University Press, 2015), 31.
41 Sousanis, *Unflattening*, 35–36.
42 Sousanis, *Unflattening*, 40, 89.
43 R. G. Collingwood, *The Idea of History* (Oxford: Clarendon Press, 1946), 249.
44 William Guynn, *Writing History in Film* (New York and London: Routledge, 2006), 42–44.

45 Elizabeth Kostova, *The Historian: A Novel* (New York and Boston: Little, Brown and Company, 2005), ix–x.
46 Stein Helgeby, *Action as History: The Historical Thought of R.G. Collingwood* (Exeter: Imprint Academic, 2004), 5.
47 Collingwood, *Idea of History*, 215.
48 Collingwood, *Idea of History*, 282, 246.
49 Collingwood, *Idea of History*, 247.
50 Minoru Hokari, *Gurindji Journey: A Japanese Historian in the Outback* (Honolulu: University of Hawai'i Press, 2011), 107.
51 Hokari, *Gurindji Journey*, 107.
52 G. R. Elton, *Return to Essentials: Some Reflections on the Present State of Historical Study* (Cambridge: Cambridge University Press, 1991).
53 C. L. R. James, *The Black Jacobins: Toussaint L'Overture and the San Domingo Revolution* (new ed., London: Allison & Busby, 1980), 365.
54 James, *The Black Jacobins*, 291; Stuart Hall, "Breaking Bread With History: C.L.R. James and *The Black Jacobins*, Stuart Hall Interviewed by Bill Schwarz," *History Workshop Journal* 46 (1998), 26–27.
55 James, *The Black Jacobins*, v.
56 Hall, "Breaking Bread," 22. *The Black Jacobins* is ranked 15th in a list of the most important works written by historians in the twentieth century, "The 100 Best History Books of All Time," https://www.listmuse.com/100-best-history-books-time.php. Acc.
57 Ronald Bergan, *Sergei Eisenstein: A Life in Conflict* (New York: Overlook Press, 1999), 266–69.
58 Hall, "Breaking Bread," 29.
59 Hayden White, *The Content of the Form: Narrative Discourse and Historical Representation* (Baltimore, MD: Johns Hopkins University Press, 1987); Alun Munslow, *Narrative and History* (Basingstoke: Palgrave Macmillan, 2007); Joan Scott, "Storytelling," *History and Theory* 50, no. 2 (2011), 203–9.
60 Rachel Douglas, *Making the Black Jacobins: C.L.R. James and the Drama of History* (Durham and London: Duke University Press, 2019).
61 Douglas, *Making*, 56–59 and ff.
62 Joanna Kidman, "Captain Cook, Tuia 250 and the Making of Public Memory," in *Fragments From a Contested Past: Remembering, Denial and New Zealand History*, eds. Joanna Kidman, Vincent O'Malley, Lania Macdonald, Tom Roa, and Keziah Wallis (Wellington: BWB, 2022), 25.
63 Kidman, "Captain Cook," 24; Radio New Zealand, "Protest and Hope as Cook's Endeavour Replica Lands in Gisborne," October 8, 2019. https://www.youtube.com/watch?v=NtYHjBvRVFs, at 1:32–1:33.
64 Giovanni Torre, "New Zealand Divided as Replica of Captain Cook's Endeavour Marks 250th Anniversary Landing." *The Daily Telegraph*, October 8, 2019. https://www.telegraph.co.uk/news/2019/10/08/new-zealand-divided-replica-captain-cooks-endeavour-marks-250th/.
65 Torre, "New Zealand Divided."

2
THE TRUTH ABOUT ARCHIVES

In July 2005, historian Edeliberto Cifuentes and his team of investigators stumbled across an unfinished building full of bundles upon bundles of papers piled up on shelves, spilling out of filing cabinets, stacked in heaps on the floor. They were dirty, damp, mouldy, and covered in animal faeces. These "huge volcanoes of documents," as he called them, provoked a deep emotional response, for these were the archives of Guatemala's National Civil Police (PNC). As head of the Human Rights Ombudsman's Office's investigation unit, Cifuentes was touring PNC buildings in Guatemala City to verify that potentially explosive materials had been removed because there had recently been a massive explosion at a nearby military facility. When it became obvious to Cifuentes's team that this had not happened, they decided to check to see if there were any other dangerous materials on the site. Their guide, PNC official Ana Corado, had no hesitation in showing them everything, including the dilapidated office building where the papers were found. It held over 80 million pages meticulously recording the arrest, torture, and murder of thousands of Guatemalans during the civil war period between 1960 and 1996.

It had been thought that these archives had been destroyed. Indeed, Corado, who was in charge of the records, had been ordered to do so. Instead, she and her colleagues had bundled them up, protected them as best they could, and stored them away, because, in her words, she saw them not as "garbage" but as a "treasure." So too thought Cifuentes:

> [Y]ou can imagine, when one finds a document, a piece of information that is key in the construction of a case or a story or an investigation,

DOI: 10.4324/9781003178026-3

that's one thing. But to find all of this documentation there – you say to yourself, this is a treasure that will help us to construct enormous histories. . . . My emotional reaction was that of a historian![1]

In the words of a Central American archivist cited by Kirsten Weld on whose account this story is based, archives such as these are "paper cadavers" that deserve "resurrection."[2] The discovery of these archives in Guatemala – the largest accumulation of secret state records ever uncovered in Latin America – was a vital step towards achieving social justice for the thousands of victims of the terror and their families. Bringing the dead back to life to bear witness to past atrocities is a feature of truth and reconciliation processes across the globe. These are archival stories that reveal truths, fill in the blanks, populate silences with voices, and help us begin the process of righting wrongs and healing.

The historian's encounter with the archive is one of the focuses of this chapter. It considers how historians perform in the archives and how archives are made to perform. Two case studies, one a feature film and the other a play, highlight issues of proof, evidence, and truth-telling in and around archives. After a discussion about what we can do when the archives fail us, it is suggested that a rethinking, or at least a widening, of the notion of what constitutes an archive is necessary. This is especially important when we move from western notions of archive-based truth-telling to non-western understandings of history, memory, time, and space.

Performing in the Archive

In *Dust*, her compelling study of the archive and cultural history, Carolyn Steedman writes about the various fevers suffered by historians working in the archive, from the night terrors worrying about what will turn up (or not) when the archive opens its doors to the fear that time will run out before the work is done. Historians go to the archive "to be at home as well as to be alone."[3] We are at our most comfortable, and our most content, when sitting with our pencils or our smartphones anticipating the arrival of our sources, searching them, losing ourselves in them. This is also true when we are left alone to explore a museum's artefacts that have been withdrawn from storage for our viewing or when we stand reading a landscape, building, or archaeological site. This is a treasure hunt, and it carries with it all the thrill of discovery and the pleasure of doing something slightly illicit since the sources we are examining were created by, and for, someone else.

Reading and looking, handling and smelling archives are performative acts. In his essay, "Reading as Poaching," Michel de Certeau reflects

on the activity of reading which has "its detours" as "the travelling eye" encourages "imaginary or meditative flights" in the mind.[4] Greg Dening sees theatricality in archival work: "self-effacing roles to be played before steely-eyed librarians," "Brazen in-your-face roles sharpening pencils on a noisy pencil sharpener," and outraged roles "when denied access to critical material."[5] These performances are staged for the benefit of ourselves and others, we self-fashion and self-regulate in the archive as we do when we visit a gallery or a museum. These performances enable historians to tell stories, but the stories we tell are not our own. As we read (written sources), view (visual sources, landscapes, buildings, sites), touch (material sources), or listen (aural sources), and in certain circumstances even perhaps taste and smell, we are attentive to what is *not* being said (shown, made) as much as we are to what *is* being said (shown, made) why, and for whom. In this way, we make these stories our own. This is our craft, our history making.

Sometimes we do not like what we find when we are making history. Steedman found herself disliking Joseph Woolley, an early nineteenth-century stocking maker from Clifton, Nottinghamshire, England, who kept a remarkable diary of his life. "I 'found' Woolley in an archive," she writes, "Found is in inverted commas because I want to demonstrate that I am well aware of the problematic social history mission of 'rescuing' historical subjects from oblivion; from silence, from what E.P. Thompson calls 'the enormous condescension of posterity.'"[6] Her first reading of Woolley's diary was not an easy experience.

> I had trouble with him right from the start. I was not sure I liked him very much. I knew I had no right to be bored by his interminable narratives of drunken nights out and alehouse trashing; but bored I was. On first reading, I thought he was a bit of a misogynist, even though I had no right to be offended by that, either.[7]

If reading is a performative act, Steedman also draws our attention to the performance in copying or transcribing sources. Doing so changed her mind, at least a little, about the diarist: "Transcription makes you read in a different way: for spaces and absences, erasures and repetitions, for intended ironies, literary allusions, and jokes. You discard your earlier presumptions and assumptions. . . ." She realized that her negative first impression was in part because the working class, pub-loving Woolley reminded her of an episode where her working class father told a politically incorrect joke to her university friends when she introduced him to them in a pub. Historical distance was collapsed: her father and Woolley "were both in the pub, both of them working-class men who were not as

working-class men were meant by their historians to be." This, she says, is the "treachery of history writing," that historians struggle to negotiate "the 'then' they write, and the 'now' of their writing."[8]

In the popular imagination, of course, things are not so complicated. Finding answers to their questions in an archive, library, or museum or by interpreting a building or landscape, comes very quickly and unproblematically for researchers like Dr Henry Walton "Indiana" Jones or Professor Robert Langdon (*The Da Vinci Code*). Their work is never complicated by ambiguities in the evidence, or by personal reflections about positionality. Archives and museums yield up their secrets with astonishing readiness. A more serious story about the work of historians writing histories out of the archives is offered by Michael Verhoeven in his 1990 film, *Das Schreckliche Mädchen*.

Michael Verhoeven's *Das Schrecklicke Mädchen* (*The Nasty Girl*)

Das Schreckliche Mädchen was marketed in English as *The Nasty Girl*. What makes Sonja Wegmus-Rosenberger (played by Lena Stolze) nasty is her desire to uncover the truth about her hometown (Pfilzing, a play on "Filz" or filth, so translated perhaps as "a little filthy town") during the Third Reich as her project for a national essay competition, and when that stalls, as a book project. The town has built its reputation on the claim that it resisted Nazism, yet when Sonja begins to ask questions no one can remember much at all, except that the now-deceased former mayor, Zumbotel, was a Nazi sympathizer.

We then witness a sequence of amusing – but for some historians undoubtedly all too real – experience of using libraries and archives. Sonja first visits the library archives seeking a file and discovers that the Zumbotel file has been marked confidential and permission from the widow is required for access (31:50–32:52). She approaches the widow, who owns the family chocolate factory, but she too refuses to grant permission claiming vehemently that her husband has been wrongly vilified. That all is not what it seems is confirmed by Sonja's grandmother, who speaks more positively about Zumbotel saying he "wasn't that bad" (32:58). Sonja turns to the newspaper archives but suddenly finds herself denied access (48:08–48:18) allegedly because they are being microfilmed. When Zumbotel's widow falls ill her grandson, fiancé of a friend of Sonja's, inherits the chocolate factory and he grants permission for her to see the files. One element in this sequence is playfully funny – the grandson is named Charlie, a nod to the famous 1964 children's book *Charlie and the Chocolate Factory* written by Roald Dahl – and another is savagely ironic – the letter of permission is delivered to Sonja via the lap of the now wheel-chair bound grandmother

who had refused permission and berated Sonja earlier in the film. On returning to the library archive, however, Sonja is again denied access, now on the basis that the papers cannot be seen because they contain material that could be damaging to persons living (49:21–49:38).

Sonja turns to the courts and obtains an order for the files to be released to her (53:29–53:40). She is then confronted by a series of excuses. The files are out on loan, and still out on loan, then they are too old and brittle to be used, and then because the statute of limitations has been increased from 30 to 50 years (54:07–55:52). Sonja turns again to the courts and the limitation is confirmed as 30 years, but now the librarian/archivist claims the files have been lost (57:21–57:40). It is only by a stroke of luck – the librarian/archivist being ill and away for the day – that Sonja is able to get access to the materials she wants to see and manages to photocopy them before the mistake is realized (57:51–1:03). Her research reveals that the editor of the town's newspaper, Juckenack, who in a delicious twist happens to also be a history professor, was a Nazi collaborator. It was Sonja's attendance at one of his lectures that seems to have led him to revoke his initial permission that she should have access to the newspaper archives. At a public meeting while discussing her research findings, a man ("the boat owner") rises to denounce Juckenack as a Nazi (nicknamed "Brown Heinrich" by members of the resistance). Sonja then interviews the boat owner, discovering that he was a communist who had suffered imprisonment and was still being denied his pension; they are attacked by right-wing thugs just as he makes a link between blackshirts and brownshirts and current-day Neo-Nazis (1:15:43–1:17:47).

This then is a story about a historian struggling to uncover the past by searching for primary sources in public, corporate, and newspaper archives. It is also very much a family history. Not only is Sonja often accompanied by her (usually quite noisy or upset) children as she pursues her research but its impact on the lives of her grandmother, parents, and husband is also marked. Verhoeven captures this evocatively by staging the living room at two key moments in the film. First, we see the family sitting on their sofa listening to the abusive phone calls Sonja receives as her determination to uncover the truth becomes known. The sofa moves through the town shown as back projections (52:34–53:17). The same visual strategy is adopted as they sit reading the documents Sonja has obtained shortly before the family home is bombed (1:03–1:07). Dismissed by some critics as a distracting Brechtian alienation effect, this strategy enables Verhoeven to signal the breaching of the private/public divide caused as Sonja's research seeks to make darker and hitherto private histories very public. It is tragic-comedy, humorous, troubling, and horrifying all at the same time.

The film ends by asking another important question about historical truth-seeking, namely the consequences of uncovering truths and what happens to them when they are revealed and made public. Sonja ruins a celebration of her achievement – the publishing of a book – by the town who has commissioned a bust of her to put on display. This, she says, freezes her, silencing her voice: "No, I won't let you put my bust in the town hall. I'm a living human being. But I won't fall for a trick like this. Just because you shit your pants, fearing what I might do next" (1:26:18–39). Her fear is that history, now told, closes off and shuts down memory and the impact of its contested truths. It normalizes what should not be normal. It packages it up and makes it safe so that the original emotional drivers and motivations are lost. It puts it somewhere where it can be forgotten.

While the final scene is an invention, Sonja's story is based on the real-life experience of Anya Rosmus of Passau. Verhoeven interviewed Rosmus and her family, telling her that "It's not a film about the past and what people have done, but about how people behave when you ask them about the past."[9] Rosmus has written about the relationship the film has to her own lived experience, noting that those in charge of the town and church archives obstructed her research, offering the same excuses Sonja hears in the film.[10] This fiction film opens with Sonja as narrator and director and filmmaker of a documentary about her experience and so immediately complicates the distinction between fact and fiction, the imagined and the real. As so often in film, the past is shot in black and white (here the film shifts to colour when Sonja falls in love with her desirable schoolteacher) so that past and present are also synchronized. The subject matter, of course, also troubles boundaries of form: as a docudrama, the film tells the story – the history – of Sonja but is also telling the story – the history – of Anya. While she may have never received a bust in commemoration of her work, her home became a tourist destination and she was "mostly asked about the reality behind the film, about how much of it was true and what was changed" and why she thought Verhoeven chose not to make a straightforward documentary.[11] In fact, as she noted, he did exactly that as a companion piece to the film; *Das Mädchen und die Stadt* ("The Girl and the Town") aired on German television on May 10, 1990, two years after the film's release.

Verhoeven offers a scroll up at the start of the film informing viewers about the inspiration behind it to which he adds a curious caveat: "This film is based on the experiences of Anja Rosmus a student from Passau. The story of this film is both truth and fiction. I'm not concerned with any particular German town but rather the truth about all German towns. My film is set in Bavaria because that's where I live. The characters and events are completely fictitious" (00:23–00:36).

If the film – as is often claimed by historical fiction filmmakers – is based on a true story, what does Verhoeven mean when he says the characters and events are completely fictitious? Is this a distancing mechanism to protect the real Anya and her family or a warning to viewers not to expect a realistic, immersive documentary? Or is it perhaps a deliberate ploy to force us to consider the relationship between "truth" and "fiction" when, though based on lives lived and lived experiences, the characters in the film and the events they are part of are, in the end, inventions?

Inventing the Past

"Invention" has a double meaning of course. In a positive light, inventions are original creations, contributing something new that improves experience and understanding. More negatively, invention carries the notion of being made-up, untrue, fake. This doubling featured in one of the most famous debates among historians, that between Natalie Zemon Davis and Robert Finlay in the pages of the prestigious *American Historical Review*. At issue was the historian's right to go beyond the archive to tell a story, possibly a true story, but one that was not staring at them from the sources. Davis was reading a lengthy report by Jean de Coras, a sixteenth-century French judge about a remarkable case that had come before him. A villager by the name of Martin Guerre had deserted his wife Bertrande and their child and ended up fighting as a soldier. When he eventually returned to the village, he was much changed, physically stronger, sociable rather than taciturn, but because he knew so much about Bertrande and the village and its inhabitants no one doubted this truly was her husband returned. They had another child together and all was well until Martin claimed part of his inheritance. This led to a series of legal actions that were resolved only when the real Martin returned and claimed his place. The imposter, Arnaud du Tilh, was hanged.

What moved the judge to write about the case was the question of how Arnaud managed to pull this off. Some thought the devil was at work, but being inclined towards the new Protestantism, Coras dismissed this as superstition. Instead, he wrote about Arnaud's intelligence, his extraordinary memory (he learned what he knew from conversations with Martin when they were soldiers together), his audacity (learning what he didn't know by seamlessly ingratiating himself with Bertrande, the family, and the villagers), and what was, in the end, a remarkable tale of re-self-fashioning. But it never occurred to the judge to ask about Bertrande; he assumed that because she was a woman, a "weaker vessel" in sixteenth-century language, she was easily duped, or foolish, or both.

Davis, however, was reading the report with different questions, dancing, as de Certeau would say, with her eyes and in her mind. Did Bertrande

know this was not the real Martin? Why would she agree to be with him if she did? Her answers came from a deep and broad knowledge of the period. As an abandoned wife with a child, Bertrande became once again a daughter. From being a companionate wife sharing duties with her husband and running her own household, she found herself a relatively powerless member in that of her mother and stepfather. This loss of status was fully recovered when Martin returned. She was a young woman, and with Martin's return, she could enjoy sexual relations again. Her life was suddenly filled with laughter, confidence, optimism, and pleasure. These conclusions were reached by asking questions that would not have occurred to Coras, the author of the trial report. Davis was not so much reading between the lines, as reading alongside them, over, and under them, putting the report in a much broader context and amongst different voices from the period to answer the questions she was asking.

Finlay objected to this methodology. For him, this was tantamount to writing fake history: if Coras's report did not explicitly, or implicitly, allude to Bertrande's motives, if Bertrande herself did not reveal those truths to the court, or privately in some other documentation, then there was no proof that she had colluded with Arnaud. This was a silence in the archive that could not, and should not, be answered by speculation which, although all historians do it, is, in the end, "supposed to give way before the sovereignty of the sources, the tribunal of the documents."[12] Davis, in her response to Finlay, contrasts their performances as historians: "I see complexities and ambivalences everywhere; I am willing to settle, until I can get something better, for conjectural knowledge and possible truth; I make ethical judgments as an assay of pros and cons, of daily living and heroic idealism." Finlay, she suggested, "sees things in clean, simple lines; he wants absolute truth, established with no ambiguity by literal and explicit words; he makes moral judgments in terms of sharp rights and wrongs."[13] While Finlay acknowledges that historians need to employ invention and possibilities, he disagrees that these gain veracity through context and surmise based on insights outside the archive. Speculation, however carefully controlled, is simply not justifiable. What, then, constitutes "solid" evidence? What types of sources are reliable, and what not? How do we weigh up possibilities and certainties in our performances of the past? This is the question that is at the heart of Jeff Cohen's powerful play, *The Soap Myth*.

Private Memory and Public History: Jeff Cohen's *The Soap Myth*

Milton Saltzman, an aging survivor of the Holocaust, has been fighting a long campaign to convince historians that fat from the bodies of murdered

Jews was used by the Nazis to make soap. While museums used to tell this story, they have since removed it from their exhibits because they could not verify this actually happened. Milton has bundles of sources saying that it did: his own testimony as a 14-year-old boy in the camps and those of other eyewitnesses, evidence presented by a Russian prosecutor at the Nuremberg trials, accounts offered by British prisoners of war forced into labour camps, pieces of soap, and a photograph of a funeral in which the casket contained soap. But, as the museum informs him in a letter: "we believe that your claims do not meet the rigorous evidentiary standards necessary for inclusion in our exhibitions or educational programming."[14] Early on in the play, we witness a confrontation between Milton and curator Esther Feinman. "Historians," she tells him, "strive to get things right" (9:12) but in no way does this mean the museum is disputing his testimony.

In steps a young journalist, Annie Blumberg, who performs the roles of narrator and investigator in the play. Milton, a difficult character, takes some convincing that she is serious enough, and takes him seriously enough, to do an interview with her. She also interviews historians and curators, as well as a prominent academic who claims that she is not antisemitic but Annie discovers otherwise. The play returns time and time again to the issue of evidence and the veracity of the sources. The historian's craft is the focus of an interview Annie has with Esther and another curator, Daniel Silver. Daniel explains that after a thorough investigation, they didn't find the evidence:

Annie: You say you didn't find *the* evidence . . .
Daniel: Perhaps I should have said I didn't find enough evidence or the right kind.
Annie: What is the right kind? What kind of evidence were you looking for?
Daniel: Evidence that would prove it conclusively . . . there is evidence, yes, from memory, from survivors, from rumours, there's even eyewitness testimony, nobody has ever disputed that, but that's the wrong kind of evidence.
Annie: And the right kind?
Esther: The right kind of evidence includes tangible things like shipping bills, physical evidence from a manufacturing plant . . . none of which we were able to find.

(16:42–17:34)

Daniel notes that the Nazis kept meticulous records on the innumerable and almost indescribable crimes they committed, but it turned out nothing on the soap story. Instead, it seems its origin was in French propaganda

during the First World War, re-purposed. The museum's reasoning is simple: the stories they tell must be grounded in the strongest evidentiary standards because to fail to do so would play into the hands of Holocaust deniers. If one story fails those standards, it puts all stories in jeopardy. But why is eyewitness testimony, Milton's own memories, the photograph, evidence presented at Nuremberg, and surviving pieces of soap insufficient? Eye-witness testimonies are partial, memories are faulty, the photograph only proves that a funeral took place, the Nuremberg evidence from the Soviet prosecutor is suspect, and the DNA found in the soap remnants proved inconclusive.

Annie proposes a solution: offer an exhibit that is speculative, telling the soap story but noting that scholars have yet to find evidence to verify these memories and testimonies:

Esther: That would be out of the question.
Annie: Why?
Esther: Our museums are not here for speculation. History cannot be speculative.
Annie: All history is speculative. All history is subjective. The people decide the history. What if the records, the photographs that you consider evidence were destroyed. . . . Would that mean that what happened suddenly didn't happen at all?

(24:25–24:55)

Any distancing the audience experiences in these somewhat academic discussions is shattered by a sequence in which the evidence presented at Nuremberg is performed verbatim, both that of the Russian prosecutor and a British POW. This is a key segue to another meeting, this time between Daniel and Annie. Out of hearing and sight of his colleague, he tells Annie that she was right to say that all history is speculative. Eye-witness testimony, however

> is personal, and compelling, it draws us in emotionally. . . . Historians of this period . . . try to keep our distance from the personal stories we are telling, maybe it's not the right thing to do but it is our way of surviving it. When a man like Milton Saltzman comes calling, my detachment collapses.
>
> (35:40–41:08)

Annie's article does not do what Milton wanted it to do, it is too even-handed in its discussion of the soap story or the soap myth. Eventually, though, she persuades him to take up the museum's offer to record his

story on film as part of an eye-witness testimonial project. This he does, and in doing so reveals the full import of what Daniel said about the need for historians to distance themselves emotionally from the stories they are researching, that they read or hear, and that they re-present. Milton shares the joy of discovering, having being sent to the showers and expecting to die, that instead of gas, real water came out of the faucets. But they were given soap to wash with, soap they discovered had been made from the fat of their loved ones. Some scraped their skin raw to remove the lather, so that the drains were filled with blood. And for him, these memories return every day, once or twice a day, as he bathes: "I can't quite imagine what it would be like. To bathe. With a bar of soap. And to have peace" (1:15–1:17).

The play ends with Annie's account of Milton's death, his funeral, and what this experience has meant for her: "I think that what I learned is . . . whether or not the Nazi's made soap wasn't the real story. The real story wasn't what it takes for a man like Milton to survive the Holocaust. The real story is what it takes for such a man to survive surviving" (1:17–1:18). *The Soap Myth* is based on the real-life story of Morris Spitzer, who gifted writer Jeff Cohen with a magazine containing an article, similar to the one Annie writes. Cohen says that his own research journey is mirrored by Annie's, and that the truth-telling of the play has been verified by historians, eye-witnesses, and survivors. His job was in part "to capture the essence of someone who has to survive surviving."[15] But what does it mean to capture the essence of someone? How can we be confident that we have got the story right? Whose truth is worth telling – what the archives yield that meet certain evidentiary standards or memories that people believe are true? Or can we value each, as Annie suggested to Esther, and let audiences decide?

Challenging the Archive

Underpinning *The Soap Myth* are two views of the ways in which history is written. There are those like the real historian Finlay and the fictional historian Esther who insist on certainties. And there are those like the real historian Davis and fictional historian Daniel who are, or seem, willing to be content with possibilities. From the first position, historians judge non-traditional representations of the past harshly because they cannot meet the rigorous standards by which they live and work. From the second, the memory work of the fictional Milton and the real-life Morris are valued. Although in terms of evidence, this might fall into the realm of speculation, they helpfully offer alternative and even counter-narratives to what is known, or thought to be known, from working inside the archive.

Annie's insistence that all history is speculative, that it is subjective, runs contrary to the traditional view of the historian as seeking to be objective or, at the very least, detached from the past that is both subject and object of their work. Underpinning this view is an assumption that the archive, like the museum, is a neutral institution, and its holdings accumulated dispassionately and with detachment; indeed, they themselves are void of partiality.

Historians of the subaltern have taught us otherwise. Researching in the Philadelphia Academy of Fine Arts, Saidiya Hartman found a photograph of a small Black girl reclining on a sofa taken some time in the late nineteenth or early twentieth century by American photographer Thomas Eakins. He posed her as an odalisque (a female slave in a harem), meant to be alluring to the male gaze. Hartman read the photograph differently, noting that the girl's rigidity "betrays this salacious posture, and her flat, steely-eyed glare is hardly an invitation to look."[16] No name is recorded on the back of the photograph, nor in the studio's ledgers, she is anonymous, nameless, objectified. Some historians would shrug their shoulders with disappointment and move on. Nothing more to say really. But not Hartman. She persists in asking her questions: what can this photograph tell us about the lives of Black women at the turn of the nineteenth and twentieth centuries or about slavery and freedom after emancipation? Hartman "decided to retrace her steps and imagine her many lives" and found the girl everywhere in the places lived in and journeys taken by thousands of other young Black women. Where official archives told histories of disorderliness and promiscuity, Hartman "envisioned her not as tragic or as ruined, but as an ordinary black girl . . . the only difference between this girl and all the others who crossed her path or followed in her wake was that there was a photograph."[17] She encourages us to move beyond those archival narratives to embrace other possibilities.

In "a note about method" to her study of Black women's lives in Philadelphia and New York as the nineteenth century turned into the twentieth, Hartman writes that "Every historian of the multitude, the dispossessed, the subaltern, and the enslaved is forced to grapple with the power and authority of the archive and the limits it sets on what can be known, whose perspective matters, and who is endowed with the gravity and authority of historical actor."[18]

Hartman sought to free her subjects from archives which saw them only as a problem needing punishment, incarceration, assistance, or salvation: "I have pressed at the limits of the case file and the document, speculated about what might have been, imagined the things whispered in dark bedrooms, and amplified moments of withholding, escape and possibility, moments when the visions and dreams of the wayward seemed possible."[19]

For Hartman, then, the archive does not simply silence lives, it distorts them and commits acts of violence against them, erasing their individuality and histories just as Marisa J. Fuentes discovered when researching the lives of enslaved women in Barbados.[20] Ann Laura Stoler, reading "along the grain" of Dutch colonial archives, describes them as a "force field" that "animates political energies and expertise, that pulls on some 'social facts' and converts them into qualified knowledge, that attends to some ways of knowing while repelling and refusing others."[21] Hartman asks, "[H]ow does one recuperate lives entangled with and impossible to differentiate from the terrible utterances that condemned them to death, the account books that identified them as units of value, the invoices that claimed them as property, and the banal chronicles that stripped them of human features?"[22]

Her answer is to refuse the stories told in the archives, and offer instead "a series of speculative arguments and exploiting the capacities of the subjunctive (a grammatical mood that expresses doubts, wishes, and possibilities), in fashioning a narrative, which is based upon archival research, and by that I mean a critical reading of the archive that mimes the figurative dimensions of history."[23]

Such an approach has met with resistance. Reviewing the reissue of Hartman's *Wayward Lives*, Alexis Okeowo cites historian and artist Nell Painter who commends the author for raising "questions for historians to do historical work that they might not have thought of" but is of the view that the book is literature rather than history because Hartman's emancipating lives from the archives necessarily involve speculation and imagination. For Painter, Hartman may have "a lot to say to history, but historians do something that's somewhat different." The reason for this rests on the central, primary role the official archive plays in historical research and writing. Painter continues: "We can't make up an archive that doesn't exist or read into the archive what we want to find," new understanding of the past arises only from asking new questions or finding new sources. In this sense "the archive is a living, moving thing," but not something to be played with.[24]

This reverence for the archive and the authority vested in, and granted by it, is resisted by Hartman who insists, rather as Davis had done nearly 40 years earlier, of the need to "exceed or negotiate the constructive limits of the archive" by engaging in "critical fabulation . . . by exploiting the 'transparency of sources' as fictions of history."[25] In a conversation with Arthur Jafa, Hartman insists that not pushing against the limits of the archive, whose documents are the product of violence and power, means that historians would "be consigned forever to tell the same kinds of stories." And why, she asks, "should I be faithful to that limit? Why should

I respect that?"²⁶ Taking this a step further, archives themselves do violence to colonized, racialized, marginalized peoples. To challenge the archive, as well as what is stored within them, is to decolonize the production of knowledge. Hartman's work cannot be dismissed as literature; it is consummate history writing, and a call to action.

As Jacques Derrida reminds us the word archive has its roots in power, authority, and government; as Tony Bennett insists, museums are part of a Foucauldian archipelago of disciplinary institutions alongside the school, the penitentiary, and the clinic.²⁷ The origins of both archives and museums were in monarchical and aristocratic lives: the papers of officials, assumed to be their personal property, and materials gathered in princely cabinets of curiosities formed the core collections of national archives and libraries, and of museums and galleries. These state-building entities were charged with gathering, keeping, cataloguing, preserving, and displaying the nation to the nation. That this was a successful project in nation building, in contributing to the shaping of the national imaginary, is revealed most clearly when such institutions are targeted by insurgents wishing to unravel the nation state or invaders seeking to eradicate nationhood. Yet it is not only major public institutions that are targeted on such occasions: homes too can also be violated and purged of books, photographs, paintings, stamps, coins and so on. Personal collections telling stories about the past, curated by their owners, are as susceptible as those in public institutions. If the public archive and museum have their origins in taking private histories and putting them under "house arrest" as Derrida put it in relation to Freud's papers and possessions becoming a museum, then the reverse is also true: public histories are performed in the home.²⁸

In her deep reading of Janaki Agnes Penelope Majumdar's diary, Cornelia Sorabji's memoirs, and Attia Hosain's 1961 memory novel, *Sunlight on a Broken Column*, Antoinette Burton makes a compelling case that such sources are "a constitutive, rather than just a supplemental, archive of the past."²⁹ Majumdar called her diary, written in 1935, "Family History," and her intent was to record the lives of her father, W.C. Bonnerjee, the first president of the Indian National Congress, and her mother Hemangini Motilal for their descendants. The story of their lives moving back and forth between India and England is anchored by detailed discussions of the homes in which they lived, challenging the boundaries of public and private history. Sorabji studied law at Oxford and held the office of Lady Assistant in the Court of Wards to determine cases for widows and their children. She was a strong advocate for the *zenana*, the area of a home accessible only to women, and defender of the *purdahnashin* (secluded women). Attia Hosain's novel of the partition places the home at the centre of history, offering rich and detailed descriptions of exteriors and interiors,

of spaces and layouts, of objects and things. These women saw the home as a living, breathing, and giving archive, not only troubling claims about the "self-sufficiency" of official archives, but demonstrating that homes "should be read *both* as archival sites *and* as history-in-the-making."[30] They are much more than simply a "sub-species" of evidence.[31]

Although diaries, memoirs, and literary works, not to mention cookbooks, photograph albums, and family heirlooms, and the objects with which we populate our homes have been used as sources by social and cultural historians, they are usually considered to be private histories that supplement, enrich, and enliven histories written out of the documents found in official archives. Those documents are also created and curated objects, many of them never intended for public access and consumption although certainly written and compiled with a particular audience in mind. Surely, though, a photograph in the family album is no less worthy of status within the historian's craft as a primary source as one deemed by an archivist to be worthy of inclusion in a public office of record?

Indeed, the blurring of what counts as "public" and what counts as "private" has been even more open to question since the digital revolution, particularly with Web 2.0. It is not only public archives that digitize sources such as birth and death records, wills, letters and so on for public access. Through social media, those who have performed as curators of photos and objects at home – and research in Canada revealed that 83% of those surveyed had looked at old photographs of people and places associated with their family, and 74% had kept something meaningful to pass on to others as a family heirloom – can attract considerable audiences for their history work.[32] It would be fair to say that in the past few years, there has been a veritable explosion of private histories made public. Cooks can share the making of grandmother's sauce recipes on TikTok or YouTube, family photos can be shared on Facebook, Twitter, Instagram, or uploaded onto platforms such as Ancestry in the hope of making more familial and kinship connections. Memories, stories of deceased loved ones, photos of family heirlooms or collected objects regularly feature in tweets (now X-files?) and Facebook postings. Just as significant for public historians are the responses from viewers: comments, new images uploaded, re-postings, and likes. Digital communities focused on place, such as "Lost" city sites, also perform history and memory. Archives are places of encounter and exchange; their liveliness is especially visible with intangible histories and heritage.

Intangible Archives

In West Africa, notably Senegal, the Gambia, and Mali, the gewel (Wolof), jali (Mande), or griot (French) perform history through storytelling, poetry,

and music. Emil Magel cites a passage from Djibril Tamsir Niane's *Sundiata: An Epic of Old Mali* in which the griot Djeli Mamoudou Kouyate describes griots as "repositories." "Through their oratorical performances," Magel comments, "they recreate the knowledge of the past, giving life with their breath to events otherwise long forgotten."[33] Senegalese griot Lamine Konte notes the passing down of the musical storytelling tradition from generation to generation within his family which operated like an occupational caste entrusted "with the task of reciting history, and thus of acting as the memory of the African people."[34]

Griots are living archives, functioning as historians, chroniclers, and commentators whose histories are made in performance. In discussing the tensions between national historians and jali, Paulla Ebron argues that for jali, "History is performative; indeed, performance creates history."[35] This tension is beautifully articulated in Dani Kouyate's 1995 film *Keita! L'Heritage du Griot* in which the rigidity of traditional school-learned history is contrasted with the multi-perspective, multivocal histories, told by the griot.[36]

Lamin Jeng, a Gambian gewel, says that he satisfies the community's thirst for knowledge and fills hearts just like millet fills the stomachs of children. The stories must be carefully prepared like the millet he says, so that they will have such sweetness that people will remember them, enhanced as they are with his singing and drumming. Through the storytelling form known as *cosan*, traditionally the gewel offered advice to the ruling family with whom they were associated by offering examples from the past that serve to highlight failures in the present. Another form is the *leb* which is more direct and present-focused. Traditionally performed in storytelling events, gewel performances now regularly feature on radio, television, theatre, and on YouTube.[37] In post-independence Mali, griots, often women, were employed by elites to legitimize their authority but the praise songs employed could carry ambiguous and less flattering messages.[38]

Post-independence leaders of the countries of the greater Senegambia – Senegal, the Gambia, Guinea-Bissau, Mali, Guinea, and Sierre Leone – understood, as the colonialists had not, that dance systems performed history. Many quickly established national dance companies as a way of harnessing the past in the service of the present. Sékou Touré of Guinea, for example, nationalized the dance theatre company founded by Keita Fodéba to form Les Ballet Africains de Guinée in 1959, a year after independence. Ofosuwa M. Abiola argues that the traditional Mandinka dance (of Mande speakers) was adapted to include European dance forms (such as ballet) and more formal attire as dances moved from village settings to stages. More significantly for the nation-building project, dance styles from other ethnicities and regions were incorporated in new works

designed to promote national identity in a harmonious narrative. Dance and dance theatre was at the forefront of Touré's later cultural revolution, asserting his party's roots in traditional rural cultural practices while undermining those it saw as hindering the government's agenda.[39]

Herself a Mandinka dancer, Abiola offers a succinct description of the vocabulary of Mandinka dance combining high, medium, and low torso positions with contractions, movements of the head, hips, and from the knees, leaps, and jumps. Dancers are accompanied by voice and instruments, including drums (notably the djembe and the dundun) and the balafon (a type of xylophone), used often to accompany oral storytelling performances. Drummers, dancers, and audience/participants form a circle with the drummers at its head. As they beat out a rhythm, dancers emerge in successive groups, engaging with the drummers while those remaining in the circle clap. Songs sometimes intervene the drum-dance sequences. In her telling the story of being a dependent in service through the jondon/wolosodon dance, Abiola notes that the dancer performs the first slower-paced jondon to capture the precariousness of their lives followed by the much faster wolosodon that signifies their acceptance into the new household.[40] The call and response rhythms of the drumming involves a master drummer issuing calls – recognizable patterns – that "promotes 'dialogue' between drummers, dancers and the audience."[41]

The language of the drums consists of low, medium, and high tones mimicking the pitch of tonal language. On a djembe, these are created by hitting the drum in the centre with the palm, with open fingers on the edge, or slapping with the fingers in the edge respectively; in cylinder-type drums or gongs, the tones are conveyed by varied combinations of the two lips formed when a slit is cut running down the length thus producing a low and a high tone.[42] Different drumming patterns repeat specific words and phrases, communicating complex thoughts and detailed information.

In Tony Leigh Wind's retelling, women griots embody universal knowledge and herstories that slavery uprooted, which crossed and were adapted in the Americas, as is also the case of storytelling through drumming.[43] In Brazil, the intangible heritage of *jongo* (also known as *caxambu*) – song, dance, and percussion – storytelling of enslaved Africans who worked the coffee-plantations of southeastern Brazil and associated with the *quilombo* communities, is officially recognized as a site of cultural heritage and is intimately associated with reparations and land claims.[44] With roots in Central Africa, especially the Congo and Angola regions, the *jongo* is a circle dance centred around a fire and features a couple who perform the main movements, a soloist (the *jongueiros*) and "call-response" chorus from participants. Verses are improvised; drums and other percussive instruments, such as *puitas*, and bonfires play vital roles in the performance

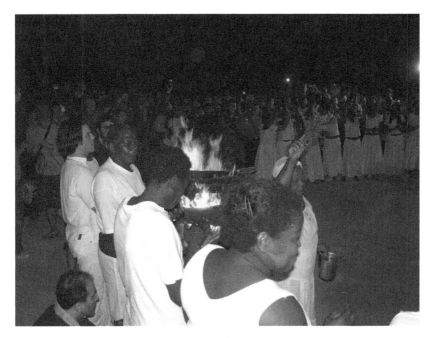

FIGURE 2.1 D. Terezinha blesses the bonfire at the Quilombo São José festival (2005).
Source: Courtesy of the Pastados Presentes Project Archive co-ordinated by Hebe Mattos and Martha Abreu, LABHOI/UFF.

(Figure 2.1). In *jongo* performances repetition and intonation are performance practices that give added intensity and solidity to the claims being made by the verses.[45] The verses spoken by the *jongueiros* take the form of riddles and they refer to the "point," a knot that needs to be untied by participants for the meaning to be understood.[46]

In their study of the *jongo* festivals of Sao José, Brazil, Martha Abreu and Hebe Mattos show how they served to articulate alternative histories of slavery and the period following abolition.[47] Abreu and Mattos found the performances emotional in part because the participants were descendants of slaves and post-abolition Black peasants who "through verses, challenges, dances, music, and prayers" told their own histories of the past in ways that spoke to contemporary political struggles. Black struggles and resistance were claimed as major forces behind the abolition of slavery (decentring traditional historical narratives that gave much of the credit to the monarchy) and stories that reveal the end of slave-like working conditions came only with the government of Getúlio Vargas.[48] The 2005 film *Memórias do Cativeiro* (Memories of Captivity) ends with

a *jongo* performance in the quilombo of São José da Serra.[49] Abreu and Mattos were told that long-dead *jongueiros* and "old Blacks" were still present in *jongo* performances: "they continue to protect us and that's how it should be" (34:37 – 34:56). Délcio Bernardo of Mambucaba explains the need to ask permission – "if the old fathers will permit" – when performing the stories.[50] A recent reading of jongo performances notes that its circularity constitutes a metaphor for the ocean and its crossing, a ritual return to African origins and a celebration of rebirth in the quilombo communities of Brazil.[51] Performer Marilda da Souza of Bracui reports that during slavery "the slaves would plan escapes while singing jongo verses and their masters wouldn't even know."[52]

These intangible archives whose stories are told through performance events – are forms which challenge rather than supplement or embellish writing the past out of the traditional archive. Sometimes of course, they *are* forced to play that role, rather like visuals deployed to illustrate rather than make historical arguments, but when engaged on their own terms they deflect, decentre, and de-stabilize conventional narratives. Although somewhat deadened when recorded and stored in a physical or digital space, something of their original aliveness is sustained. Such stored memories and histories can be retrieved and storied, creating new histories in performative modes as well, of course, new histories on the page.

Archival Engagements

If we can agree that the concept of the archive needs to be expanded from institutional repositories, we also need to recognize that archives, even the traditional ones, are sites of engagement. This makes them lively rather than static. Exploring how narratives of the past that are presented as collective memory can mask continued inequalities and violence, Cullen Goldblatt met Senegalese cartographer and museologist El Haj. Undoubtedly well-aware of traditional notions of the archive because of these occupations, El Haj spoke instead about archive as encounter. He told Goldblatt that one way of knowing was when you receive information from a witness, the other you receive from going to the archives: "those archives will tell a story, what story will they tell? What you did not experience, what perhaps your ancestors did not experience."[53] Archives, like witnesses, speak and tell stories, but only particular ones.

Goldblatt notes that the Wolof word El Haj uses to describe this action is *tibb*, more commonly used to reference the act of eating, particularly partaking in a shared meal (*tibba* meaning to take a handful). He comments:

> *Tibb* therefore does not suggest a unidirectional conception of knowledge discovery: sources are not objects to be found or eaten, research is

not taking to extraction or consumption. *Archives* are not sources and collections alone, because, in El Haj's conception, sources do not exist independently from the desires and social practices that bring them into being. . . . Desire and practice creates *archives* and meals – and knowledge and nourishment – from the world.[54]

Archives then are spaces of encounter, points of contact, elements in a conversation and as such what constitutes an archive can be almost anything if the desire and hunger for knowledge is present. That hunger, that need, was one of the things Derrida had in mind when writing about "archive fever" and, as Steedman and others have pointed out, it consumed Jules Michelet who thought he was "eating" history in order to bring the dead back to life.[55]

Tangible archives such as documents, things, and spaces are intimately related to intangible histories and memories. Thinking about the audiences of the two sites he studied, Goldblatt observes, they are "remembering subjects and invited to share in a collective memory. A specific kind of narrative, testimony, is crucial: the first-person account of the survivor/ witness transforms contemporary listeners, who now too 'remember' past atrocity."[56] When we run our fingers down a page in a recipe book that once belonged to an ancestor or re-trace the steps taken by a forebear in their journey of migration we are exploring the past through our bodies, our senses, and our emotions. Rebecca Schneider sees bodies as transmitting information, functioning like an archive.[57] Borrowing from sisters Megan and Rebecca Lovell who make up the American roots rock band Larkin Poe, we might call this "blood harmony" where the melodies sung by a mother, performing with her daughters, still accompanies her daughters' singing after their mother's passing.[58]

These intangible memories are performed in our heads but also in and through our bodies, passed from generation to generation, a living archive that is re-performed over time. Singing a melody or beating a rhythm once shared with a mother or remembering to add grandfather's secret ingredient to the pasta sauce brings those intangible memories into the corporeal world. The melody must sound perfect, and the sauce must taste just right. This perfection and just-rightness is achieved through a correspondence between our sensorial memories and our present re-enactments, a process of validation that can be just as rigorous (and judgemental) as any applied to documents in an archive. The mother and the grandfather are very much present, haunting our re-making of these histories.

Avery Gordon argues that the past haunts the writing of history, and that there is a constant struggle "between the living and the ghostly."[59] When historians encounter the past, there is also a strong sense of the uncanny, if not in the strict sense that Sigmund Freud understood it but something

akin to it. Certainly, the pleasure and delight that Freud identified as a feature of the uncanny is present both inside and outside the archive. And if not also terrifying, as Freud would have it, the experience of reading and writing the past carries with it levels of uncertainty, anxiety, and worry. Practising the historian's craft is an unsettling experience. Performing as historians thus involves a haunting of us, our writing, our thoughts, our imaginings by the ghosts of the past but also by our own internal ghosts as we, the living, claim authority to tell history.

"I began with a desire to speak with the dead," wrote Stephen Greenblatt in the opening of his 1988 book *Shakespearean Negotiations:* "If I never believed that the dead could hear me, and if I knew that the dead could not speak, I was nonetheless certain that I could re-create a conversation with them." He knew, however, that the voice of the dead was not theirs, rather it was his because "the dead had contrived to leave textual traces of themselves, and those traces make themselves heard in the voices of the living."[60] There is, of course, a heavy obligation in speaking for the dead, and ethics in telling tales out of school as it were, sharing stories belonging to others who may never have wanted them to be told. There is a voyeuristic element to the historian's craft, as Steedman points out, as well as an arrogance, an assumption that coming from another time, seeking answers to questions formed in the aftermath, entitles us not only to seek out stories but also to share them with others, and often for professional if not personal gain.

Theorist Paul Ricoeur observes, "Through documents and their critical examination of documents, historians are subject to what once was. They owe a debt to the past, a debt of recognition to the dead, that makes them insolvent debtors."[61] There is, then, an obligation to give something in return. Greg Dening characteristically puts it beautifully when speaking of the past: "If I claim to represent it – if I claim to re-present it – I owe it something, its own independence. I owe it a gift of itself, unique in time and space. The history I write will always be mine and something more than the past, but there is a part of it that is never mine. It is the part that actually happened, independently of my knowing that or how it happened."[62]

In speaking for the dead, whatever right we have to do so, it is our reflectiveness, our honesty, and our truthfulness that makes it okay. This means "seeing other-ness, hearing silences with the same generosity and fluency of spirit, and the same fullness of experience, that we have in our reading dances."[63] While Dening was thinking about his work as an ethnographic historian writing the history of cross-cultural encounters in Oceania, his words apply equally well to the work of any historian reaching across time and space into the otherness of the past.

Notes

1 Kirsten Weld, *Paper Cadavers: The Archives of Dictatorship in Guatemala* (Durham, NC and London: Duke University Press, 2014), 33 (Corado's words are cited on 36).
2 Weld, *Paper Cadavers*, 2–3.
3 Steedman, *Dust*, 72.
4 Michel de Certeau, *The Practice of Everyday Life* (Berkley, Los Angeles, and London: University of California Press, 1988), 170.
5 Dening, "Beaches," 4–5.
6 Carolyn Steedman, "Archive Fever," in *A Companion to Public History*, ed. David Dean (Hoboken, NJ and Chichester, West Sussex: Wiley Blackwell), 104, citing E. P. Thompson, *The Making of the English Working Class* (Harmondsworth, UK: Penguin, 1968), 13.
7 Steedman, "Archive Fever," 107.
8 Steedman, "Archive Fever," 107, 108–9.
9 Anna Rosmus, "From Reality to Fiction: Anna Rosmus as the 'Nasty Girl,'" *Religion and the Arts* 4, no. 1 (2000), 115.
10 Rosmus, "From Reality to Fiction," 118.
11 Rosmus, "From Reality to Fiction," 116, 136 (note 27).
12 Finlay, "The Refashioning of Martin Guerre," 571.
13 Davis, "On the Lame," 574.
14 *The Soap Myth*, National Jewish Theatre production 2012 dir. Arnold Mittlemann, film dir. with Ron Kopp, *Digital Theatre Plus*, at 6:47.
15 Jeff Cohen, "On Writing," *Digital Theatre Plus*, at 7:14–7:16.
16 Saidiya Hartman, "An Unnamed Girl, a Speculative History," *The New Yorker*, February 9, 2019.
17 Hartman, "An Unnamed Girl."
18 Saidiya Hartman, *Wayward Lives, Beautiful Experiments: Intimate Histories of Riotous Black Girls, Troublesome Women, and Queer Radicals* (New York: W.W. Norton, 2019), xiii.
19 Hartman, *Wayward Lives*, xiv.
20 Marisa J. Fuentes, *Dispossessed Lives: Enslaved Women, Violence, and the Archive* (Philadelphia: University of Pennsylvania Press, 2016).
21 Ann Laura Stoler, *Along the Archival Grain: Epistemic Anxieties and Colonial Common Sense* (Princeton: Princeton University Press, 2009), 22.
22 Saidiya Hartman, "Venus in Two Acts," *Small Axe: A Caribbean Journal of Criticism* 12, no. 2 (2008), 3.
23 Hartman, "Venus in Two Acts," 11.
24 Alexis Okeowo, "Secret Histories," *The New Yorker*, October 26, 2020, 19.
25 Hartman, "Venus in Two Acts," 11.
26 Saidiya Hartman and Arthur Jafa in Conversation, Recorded Hammer Museum June 6, 2019, Hammer Channel. https://channel.hammer.ucla.edu/video/601/saidiya-hartman-arthur-jafa-in-conversation, 39:20–41:15.
27 Jacques Derrida, *Archive Fever: A Freudian Impression* (Chicago: University of Chicago Press, 1998); Tony Bennett, *The Birth of the Museum: History, Theory, Politics* (New York and London: Routledge, 1995).
28 Derrida, *Archive Fever*, 2.
29 Antoinette Burton, *Dwelling in the Archive: Women, Writing House, Home, and History in Late Colonial India* (Oxford: Oxford University Press, 2003), 26.
30 Burton, *Dwelling in the Archive*, 24, 26. Italics in original.
31 Burton, *Dwelling in the Archive*, 139.

32 Conrad et al., *Canadians and Their Pasts*, 111 (Table 6.2).
33 Emil A. Magel, "The Role of the *Gewel* in Wolof Society: The Professional Image of Lamin Jeng," *Journal of Anthropological Research* 37, no. 2 (1981), 183.
34 Lamine Konte, "The Griot, Singer and Chronicler of African Life," *The UNESCO Courier* 4 (1986), 22.
35 Paulla A. Ebron, *Performing Africa* (Princeton and Oxford: Princeton University Press, 2002), 100–1.
36 Dani Kouyaté, dir. *Keita! L'heritage du griot* (1994). https://youtu.be/yzqba FH14CQ?feature=shared), 58:00–58:28, 1:03–1:06.
37 Magel, "Role of the *Gewel*," 184–86, 189–90; Ebron, *Performing Africa*, 100, 106.
38 Dorothea Schulz, "Praise Without Enchantment: Griots, Broadcast Media, and the Politics of Tradition in Mali," *Africa Today* 44, no. 4 (1997), 443–64.
39 Eric Charry, *Mande Music: Traditional and Modern Music of the Maninka and Mandinka of West Africa* (Chicago and London: The University of Chicago Press, 2000), 211; Ofosuwa M. Abiola, *History Dances: Chronicling the History of Traditional Mandinka Dance* (London and New York: Routledge, 2019), 127, 129–44.
40 Abiola, *History Dances*, 39–58, 91; Charry, *Mande Music*, 194–95.
41 Michael J. K. Bokor, "When the Drum Speaks: The Rhetoric of Motion, Emotion, and Action in African Societies," *Rhetorical: A Journal of the History of Rhetoric* 32, no. 2 (2014), 175.
42 Bokor, "When the Drum Speaks," 175–82; Walter S. Ong, "African Talking Drums and Oral Noeties," *New Literary History* 8, no. 3 (1977), 414; John F. Carrington, "The Talking Drums of Africa," *Scientific American* 225, no. 6 (1971), 90–94.
43 Tony Leigh Wind, *Black Women's Literature of the Americas: Griots and Goddesses* (London and New York: Routledge, 2023), 145–47; Tanya Y. Price, "Rhythms of Culture: Djembe and African Memory in African-American Cultural Traditions," *Black Music Research Journal* 33, no. 2 (2013), 227–47.
44 Hebe Mattos and Martha Abreu, "'Remanescentes das Comunidades dos Quilombos': memória do cativeiro, patrimônio cultural e direito à reparação," *Iberoamericana* 11, no. 42 (2011), 145–58.
45 Hebe Mattos and Martha Abreu, "Performing History: Jongos, Quilombos, and the Memory of Illegal Atlantic Slave Trade in Rio De Janeiro, Brazil," in *A Companion to Public History*, ed. David Dean (Hoboken, NJ and Chichester, West Sussex: Wiley Blackwell, 2018), 397; Renata Mattos, "O Jongo: Voz, Ritmo, Memória e Transmissão," *Psicanálise & Barroco em revista* 18, no. 2 (2020), 34–37.
46 Susan de Oliveira and Ellen Berezoschi, "Jongo: do cativeiro à força das ruas," *Esclavages & Postesclavages* 7 (2022), 4.
47 Martha Abreu and Hebe Mattos, "Memories of Captivity and Freedom in São José's *Jongo* Festivals," in *African Heritage and Memories of Slavery in Brazil and the South Atlantic World*, ed. Ana Lucia Araujo (Amherst, NY: Cambria Press, 2015), 149–77.
48 Abreu and Mattos, "Memories of Captivity and Freedom," 162–64; Hebe Mattos, "Memórias Do Cativeiro: Narrativas E Etnotexto," *História Oral* 8, no. 1 (2009), 54–55.
49 *Memórias do Cativeiro*, dir., Guilerme Fernandez and Isabel Castro (2005, 42), 31:45–38:51. YouTube. https://www.youtube.com/watch?v=JEw4k8Wpofw.
50 Hebe Mattos and Martha Abreu, dir., *Jongos, Calangos e folias: musica Negra, memória e posia* (LABHOI, 2011), 09:24–10:18.

51 Ricardo Mendes, "Jongo: Atlantic Crossings and Ritual Return to Aruanda," *Letrônica* 15, no. 1 (2022), 1–11.
52 Mattos and Abreu, *Jongos, Calangos e folias*, 07:34–07:46.
53 Cullen Goldblatt, *Beyond Collective Memory: Structural Complicity and Future Freedoms in Senegalese and South African Narratives* (New York and London: Routledge, 2021), 159–60.
54 Goldblatt, *Beyond Collective Memory*, 160.
55 Derrida, *Archive Fever*, 91; Steedman, *Dust*, 69; Roland Barthes, *Michelet* (Oxford: Basil Blackwell, 1987), 17–25.
56 Goldblatt, *Beyond Collective Memory*, 33–34.
57 Rebecca Schneider, *Performing Remains: Art and War in Times of Theatrical Reenactment* (New York and London: Routledge, 2011), 99–100.
58 "God gave mama a singing voice/And mama passed it down to me/Always with me, near my heart/Beating rhythm with her melody/More than flesh, more than bone/When you sing, I don't sing alone," *Blood Harmony* (2022) by Tyler Bryant, Rebecca Lovell, Kevin-John McGowan, https://www.azlyrics.com/lyrics/larkinpoe/bloodharmony.html. See also Sophie McVinnie, "'Anyone Who Has Siblings Knows How Occasionally Fraught the Relationship Can Get' Larkin Poe on Why Their New Album is More of a Family Affair Than Ever," November 10, 2022. https://guitar.com/features/interviews/larkin-poe-new-ep-blood-harmony/.
59 A. F. Gordon, *Ghostly Matters: Haunting and the Sociological Imagination* (Minneapolis, MN: University of Minnesota Press, 2008), 184.
60 Stephen Greenblatt, *Shakespearean Negotiations: The Circulation of Social Energy in Renaissance England* (Los Angeles, CA: University of California Press, 1988), 1.
61 Paul Ricoeur, *Time and Narrative*, Vol. 3 (Chicago and London: The University of Chicago Press, 1985), 142–43.
62 Dening, "Beaches," 4.
63 Dening, "Beaches," 22.

3
PERFORMING THE REAL

At first, the young boy cannot bear to look at us, but when he does, it is with an accusing glare. He is bedraggled and dirty, and he clutches a blanket around his shoulders to shield himself against the wind. Whatever colour the threads of the blanket and the tam on his head might have been is left to our imagination because we are meeting him face-to-face through a camera lens shooting black and white film stock. The camera has panned across a group of men, pausing now and then so we can look directly into their faces. We hear the mournful sound of bagpipes and on occasion catch glimpses of the muddy moor on which we, and they, are standing. A narrator interrupts our engagement with this group of men and boys by introducing them each in turn, with a brief account of how they came to be here. We know many will die or be wounded on this fateful day for we are present on April 16, 1746, when the English routed the highland clans gathered to support the Stewart claimant to the throne, Bonnie Prince Charlie, at Culloden moor.[1]

This filmic representation of the last major battle fought on British soil is the work of director Peter Watkins. Released in 1964, *Culloden* was a landmark historical feature film that continues to influence the genre, especially in his use of hand-held cameras, close-ups, and slow-tracking shots. Watkins adopted a news-reporter technique where we, the viewer, are both witness and interviewer, listening to a participant's answer to our unspoken question, "Why are you here?" We learn from the narrator that they are here because the feudal clan system demands they obey their clan chief, Alexander Macdonald of Keppoch, who has summoned them to battle. We hear from one of the Macdonald clan who tells us (in Gaelic, we

need it translated for us) that he is here because the Campbells, fighting for the other side, had stolen his cows. The camera pauses at the face of one of Macdonald's taxmen who tells us he has brought tenants from Rannoch; some came willingly, he tells us, others had to be forced. We meet one of the latter, Alistair McMurray, who is appropriately voiceless; the narrator tells us that he is present because if he did not come his cattle would have been taken and the roof of his croft burned.

In the rolling film credits, Watkins describes the film as a "documentary reconstruction." In this reconstruction of the past, Watkins offers little dramatization, not only in terms of plot but also with regard to camera work, staging, lighting, and music. The dialogue is mostly unscripted. Shooting on black and white film stock also reduces dramatic effect; if a less realistic recreation of how we see the world in real time, it serves a Brechtian purpose of insisting that we critically engage with the battle as witnesses. This enables Watkins to make historiographical points through film, using visuals, narration, testimony, and stark sequences of violence. The mis-en-scene and montage not only drive home the horrors of war, on and off the battlefield but also put forward a class analysis of the highland clan system and an account of ethnic cleansing in the British periphery. All of this aligns it as much, if not more, with the documentary *Seven Up!* (about the lives and hopes of a diverse group of seven-year-old children in contemporary Britain) than the historical feature film *Beckett* (about the life of the murdered medieval archbishop of Canterbury) both of which were released in the same year as *Culloden*.

As was noted in the previous chapter, theorist Paul Ricoeur recognized that historians owe a debt to the dead. In their efforts to reconstruct the past, Ricoeur sees "the recourse to documents" as being "a dividing line between history and fiction."[2] Documenting the past through quoting, referencing, and citing primary sources is essential to the historians' re-presentations of the past. Not surprisingly, then, those reconstructing the past in film, theatre, video games, fiction novels, and so forth draw on, and make visible, such sources to prove the validity and credibility of their productions, blurring the divide between fiction and non-fiction.[3] This chapter examines these impulses before turning to consider the ways in which non-western performed histories, such as shadow puppetry, register claims to be speaking about, and addressing, real events.

Capturing the Real in Film

"Our entire civilization has a taste for the reality effect" thought French theorist Roland Barthes citing realistic novels, diaries, documentary literature, news reports, museums, and "exhibitions of ancient objects." Most

of all, however, he believed the value western culture places on representations of the real is seen in photography "whose sole pertinent feature (in relation to drawing) is precisely to signify that the event represented has *really* taken place."[4]

Barthes coined the phrase "reality effect" in reference to the ways in which readers and audiences are made to feel that they are witnessing the events being written and depicted. He argued that descriptive details in literary texts, such as Gustave Flaubert's description of the city of Rouen in his novel *Madame Bovary*, are not needless distractions from the narrative structure but denote the real and the concrete. "It is likely," he observes, "that, if one came to Rouen in a diligence, the view one would have coming down the slope leading to the town would not be 'objectively' different from the panorama Flaubert describes."[5] Reading the historians Herodotus, Machiavelli, Bossuet, and Michelet led him to a similar conclusion about the writing of history: "historical discourse is essentially an ideological elaboration or, to be more specific, an *imaginary* elaboration" even though historians sometimes act as if their narrative is a "pure and simple 'copy' of *another* existence."[6] If their writing captured the essence of the past while not being a replication of it, photography captured the "reality one can no longer touch"; "every photograph is somehow co-natural with its referent" and in photography the reality effect achieved authentication.[7]

To the various genres noted by Barthes, we might add theatre, film, television, and re-enactments, and from our own time, video games, and virtual AR. His views on photography have been displaced by ones which emphasize the creative impulse behind the taking of the photograph, the technologies that mediate the relationship between the photographer and their subject, the methods of production and distribution, and the personal, social, political, economic, and cultural contexts in which the image was created.[8] We have learnt to read photographs less as a capture of the real (a snapshot of time) and more as something that has been constructed for us to see.

Animating photographs was how one of the earliest writers on film, also a filmmaker and film archivist, Bolesław Matuszewski, described the first "documentaires" produced by the Lumiére brothers in France in the 1890s.[9] British documentary filmmaker John Grierson spoke of them as a "creative treatment of actuality" and film theorists since have delineated a variety of modes within the genre such as expository, observational, interactive, reflexive, poetic, and performative.[10] Most documentary films draw on combinations of these elements, and while the expository form (featuring a strong narrative voice) is most comparable to writing history in word, incorporating other elements such as performed re-stagings or re-enactments take on a citational function not dissimilar from a descriptive passage cited from a primary source.[11]

If documentary films employ fictionalized reconstructions that one would expect from a historical feature film, historical feature films sometimes employ the strategies of the documentary signifying the real through using hand-held cameras, minimal dramatization, and offering narration that situates the viewer in time and space. This hybridity seeks to establish the "truth" of the fictional film that is to follow proving that it really *is* based on a true story if not quite the one actually told. Sometimes visual and archival evidence – such as newsreels – are incorporated, part of a montage of actuality that reinforces the invented scenes that came before and after. Occasionally, the film moves seamlessly from one to the other, sometimes fading present-day colour into past-day black-and-white or sepia, and back again. This is where Watkin's "documentary reconstruction" meets Grierson's "creative treatment of actuality."

As well as employing elements more commonly associated with newsreels and video oral histories, Watkins used film techniques linked to French *cinéma vérité* ('truth cinema') of the 1960s where, to take ethnographic film-maker Jean Rouch as an example, films seek to capture the reality of contemporary lives lived without dramatization, without a script, and without much staging if any at all, almost always using hand-held cameras. Many of the filmmakers associated with *cinéma vérité* were influenced by the documentaries produced by the Russian filmmaker Dziga Vertov before them. Vertov tellingly described his documentaries as *kino-pravda*, best translated as "film truth" given its deliberate allusion to *Pravda*, an arts and culture newspaper first published in 1905 that morphed into the official newspaper of the Soviet Union. As seen in films like *Culloden*, there is very real evidentiary power in employing reality effects in documentary reconstruction.

Theatres of the Real

The "main promise" of documentary theatre, Janelle Reinelt writes, "is to provide access or connection to reality through the facticity of documents, but not without creative mediation, and individual and communal spectatorial desire."[12] There is a long tradition of playwrights drawing on sources from, or close to, the pasts they seek to represent on stage: William Shakespeare used Edward Hall's *Chronicle* for his English history plays. Contemporary historytelling in the early modern theatre was sometimes based on "real life" stories: Thomas Dekker, William Rowley, and John Ford drew on a moralizing pamphlet recording the interrogation and trial of Elizabeth Sawyer for their play *The Witch of Edmonton*. Plays of a biographical or autobiographical nature drew on diaries, letters, and personal accounts of lives lived. German playwright Georg Büchner, himself a revolutionary, quoted extensively – about a sixth of his script – from

original sources in his 1835 play about the French Revolution, *Danton's Death*.¹³ Such sources were used by European playwrights associated with the "naturalist" theatre of the nineteenth century, and "newspaper" and "epic" theatre in the early twentieth century.

While acknowledging these earlier practices and forms, theatre scholars usually locate the emergence of a specific genre called documentary theatre between the 1950s and 1970s. German playwright and theatre practitioner Peter Weiss thought it necessary, or felt able, to write "towards a definition" of documentary theatre in 1971. For Weiss, what characterized documentary theatre was not only its use of contemporary documents but that it "refrains from all invention; it takes authentic material and puts it on the stage, unaltered in content, edited in form. . . . This critical selection, and the principles by which the montage of snippets of reality is effected, determines the quality of documentary drama."¹⁴ Theatre scholar Patrice Pavis defined the genre as "Plays composed of nothing but documents and authentic sources, selected and assembled according to the playwright's socio-political thesis."¹⁵

While documentary theatre draws on a variety of original sources, and often employs various theatrical means to present them through sound or image as well as texts from the period, there is another genre of the theatre of the real – verbatim theatre – that is based primarily on words that have been either recorded by the dramatist or extracted by the dramatist from interviews conducted by others. Those which draw entirely (or nearly so) on records such as the transcripts and recordings of trials, committees or commissions of inquiry are often called by practitioners "tribunal plays," a form pioneered in English by London's Tricycle Theatre in productions such as *Half the Picture* (1994, about selling arms to Iraq), *Nuremberg* (1996) and *Called to Account* (2007, asking whether Tony Blair should be indicted for crimes against humanity for the invasion of Iraq).

In each of these forms – documentary, verbatim, tribunal – actors play characters who really lived, and whose words they speak. Canadian Annabel Soutar, artistic director of Porte Parole, a Montreal-based documentary theatre company, emphasises the presentness of such theatre: "they often propose a conscious awareness of the present between audience and actor, they sometimes feature actors playing only themselves, and generally they feature a playing space that represents little more than the stage itself."¹⁶

Soutar has learnt to embrace the irony of re-presenting real-life events through real worlds in a medium that has given us the word for excessive artifice – "theatricality":

> When real material is coaxed onto the stage and arranged respectfully within the basic laws of dramaturgy (i.e. portraying a palpable conflict, characters with clear objectives, and a plot that keeps its audience wondering what

will happen next), it suddenly reveals its underlying poetry and can be perceived as a narrative. And the moment audiences recognize that the real world around them operates much like a poetic narrative, I believe they become conscious of their power to affect and change it.[17]

The use of original material – its re-performance on stage – obliges those involved in the staging to do so respectfully, but there is a tension between the desire to be respectful of the received material (and of those who originated it) and the need to offer audiences a compelling story. One of the strongest motives behind documentary theatre is the desire to change the world for the better, achieved by offering audiences narratives that they will find empowering. What does it mean to be respectful of an original? How does dramaturgy fulfil this desire? How can audiences feel empowered through witnessing performance?

Claims that documentary theatre comprises little more than unaltered authentic material are a little disingenuous, given that to write a script which consists solely of transcripts would not make for very compelling theatre. Necessarily, the playwright interweaves their own words between verbatim quotations, and many employ the device of having a narrator frame the story being told, positioning the audience in place and time, identifying characters, and even offering a sort of running commentary. Necessarily too, the playwright is selecting, ordering, editing, and arranging verbatim text to sustain the narrative. Even if there is little dramaturgy on stage, there is dramaturgy in the making of the script. As verbatim playwright and actor Robin Soans observes, verbatim plays have much more in common with conventional ones than is commonly thought.[18] Playwright and producer Alecky Blythe acknowledges that interviewees' words have been processed so much – by the playwright, by the actors – that "by the time they are spoken in a theatre they have taken on a life of their own"; over time, Blythe found themselves "moving further away from the reality of 'how things actually happened' in my quest to create a dramatic narrative."[19]

How things "actually happened" is, of course, a matter of documenting the past and actors are sometimes heavily invested also in the research process, reading about, and researching into, the characters they represent on stage. One technique used to capture both the spirit and the reality of what interviewees are saying, and how they are saying it, is to have actors speak out loud the words of interviewees while listening to them on headphones.[20]

Playwrights as well as actors in verbatim theatre arguably feel a great sense of responsibility to those whose words they script and perform. Blythe writes:

> The people who agree to be recorded for my shows are entrusting me with their stories, which are often very personal, so I do feel a great

> responsibility to present them in a way that they are happy with. . . . Although they do not have final approval over what is used and what is cut, I try to explain to my interviewees that the recordings will be edited, that they are being used to create a piece of drama, not their biography, and I try to keep them informed of any significant changes that I am making to the material. No matter how much I have prepared them, though, I am always nervous about their reaction when they come to see a show, and I can tell when I have pushed the edit too far, as I tend to break out in a cold sweat.[21]

Some verbatim playwrights stage readings of the play before an audience of their interviewees to receive feedback about what worked and what did not, what they liked, and what they did not.

An excellent recent example of this is Rick Duthie's play *One Day Stronger* that was his doctoral thesis in public history that told the story of labour disputes in 1958 and 1978 in the northern Ontario community of Sudbury. The centre of Canada's nickel industry with a diverse working-class community, one of the long-standing memories of the first strike was that the miners' wives had forced their husbands back to work. The play tells its story from the point-of-view of the daughter of a man who was part of the 1958 strike, now involved in supporting her husband on strike in 1978. She volunteers at the store; in one memorable scene, she is confronted by a striking miner who wants a turkey for Christmas only to find out from her that there are none left. In another, she answers an abusive phone call. Her father's experience – and her relationship with him – is at the heart of the play. We witness their interactions played out in 1958 and then her conversations with the ghostly him in 1978. At the centre of the staging is the table that he and his wife bought, and which may, or may not, remain as the daughter and her family must downsize because of the strike. Not only was the script based on words, phrases, and sentiments derived from the interviews Duthie carried out, but scenarios were created from stories shared with him. Projected images from the period helped situate the play in time and space, while the chosen performance venue – a labour hall – gave it a profound sense of place.

Duthie interviewed men and women who had been involved in the strikes, across two generations, uncovering in the process tensions between what had happened and how what happened was remembered, particularly with regard to women's roles in the strikes. He shared authority with his interviewees by sharing his transcripts, creating the space for corrections and amendments, explanations, and elaborations. Duthie took account of this feedback as he curated the script which was then workshopped with actors drawn also from the community, whose life experiences were also

shaped by the strikes and memories of them. Interviewees were invited to the workshops to witness and comment on the script and the actors' blocking of scenes. More adjustments were made to capture what was learned during these workshops and rehearsals. *One Day Stronger* was created through a constant process of back-and-forth, feedback and playback, assemblage and re-assemblage; a collaboration of historian, actors, and interviewees, as well as the community who shared thoughts and reactions in the talkback discussions that followed every performance.[22]

While celebrating the fact that verbatim theatre makes the raw materials of research visible to audience, director Max Stafford-Clark, in a conversation with playwright David Hare facilitated by Will Hammond, notes that the hard part is turning it into dialogue, "to make the transition between someone talking to the audience and drama."[23] Hare shared a story about his verbatim play, *The Permanent Way* which is about the privatization of British Rail. An American friend who saw it assumed it would have nothing to do with him. Instead, he came away realizing that, for him, in asking the question "What do we need to suffer and what not?" the play was as much about the Aids crisis as British Rail.[24] Both Stafford-Clark and Hare agree that verbatim theatre is a "recontextualizing process" on a spectrum between reality and fiction.[25] Verbatim theatre is, like public history, very audience-centred. Soans is of the view that whereas in conventional theatre around 90% of the actors' interactions are with each other and only 10% with the audience, in verbatim theatre the ratio is reversed and audiences play active rather than passive roles. These differences become visible when documentary theatre is improvised, as was the case in a ground-breaking 1970s Canadian play about rural life in Ontario, Canada.

The Farm Show

True to its title, *The Farm Show* was play about life and work in a farming community in Clinton, near Goderich in southern Ontario. Ted Johns assembled the script which consisted of songs, poems, soliloquies, and dialogues, with some directions for the actors to follow. Director Paul Thompson describes the process of the play's making in the summer of 1972:

> The idea was to take a group of actors out to a farming community and build a play of what we could see and learn. . . . The play was not written down; it developed out of interviews, visits, and improvisations. Most of the words were given to us by the community along with their stories. We spent a great deal of our time trying to imitate these people both in the way they move and the way they speak. We wanted to capture the fibre of what they were and this seemed the best way to do it.[26]

The actors worked and lived in Clinton for around six weeks, becoming part of the community. They milked cows and baled hay, gathered for the orange parade, witnessed town meetings, washed cloths and worked the land on tractors.[27] These experiences became scenes of the play, punctuated by stories they had heard along the way. Thompson called this grass roots theatre.

The Farm Show became a foundational moment in Canadian theatre. In large part this was because the play was about everyday life in Canada, displacing the usual theatrical fare of British and American plays. It resonated with audiences because, as Johns puts it, they could delight in "hearing their own language and observing their own culture."[28] The performance was not only derived from this deep experience of place, it was also first staged there, in Clinton, in a barn, with bales of straw as seats, the stage a map of the community with its concession roads and demarkation lines. Clinton – its spaces and places, histories and memories – came to life on stage, individual experiences brought together to be witnessed by those who lived in the same community.

There is much comedy in the play – notably in the scene where an actor shared his experience of loading hay onto a baler and stacking the bales in a barn and in the laundry scene where a woman trying to do her work is constantly interrupted by the demands of her family, neighbours, and deliverymen. There is also poignancy and tragedy. In Act Two, Scene Two, the woman we know only as Daisie tells stories of death, loss, and near escapes. When a neighbour's tractor suddenly stops running she gets very nervous, worried that it has rolled over on him because this is something that has frequently happened in the community. After an example or two, she offers another story to illustrate that farming is a dangerous occupation, one about a man – "Cox" – who was out cutting trees with his boys who were home for the mid-term holiday and was struck by a branch from a huge old dead elm that severely damaged the side of his face. His boys ran and got a tractor, and he was taken to hospital but died six weeks later never regaining consciousness: "They said he never would have been mentally right, his brain was so badly damaged. Oh, that can happen!"[29] The following scene recounted a similar injury this time caused while baling hay. This story was told by a narrator on stage (known simply as "man") while three other actors re-enact the accident (two playing the baler, one the farmer) on stage. It ends with the farmer being carried off stage by the actors who had played the narrator and the baler, and his wife ("woman") tearfully sharing how her neighbours helped out and her oldest child too in the aftermath of the accident.

Combining elements of documentary and verbatim theatre, *The Farm Show*'s first performance also shared characteristics with both playback

theatre (where actors witness events and then perform them back to the authors of the original) and site-specific theatre (where performances are staged in the spaces where the events originally took place). The point, as is playfully announced in the published script, is that "All the characters in this play are non-fictional. Any resemblance to living people is purely intentional."[30] For the actors, improvising real people's lives after spending only a short period of time immersed in the community was stressful; David Fox hoped that if their individual performances were shallow, the cumulation of stories would do their hosts some justice: "it would be nice to think somehow that's doing justice to them, that they're – that their lives – are there."[31] Doing justice to history, and to past lives lived, is a recurring theme when engaging with capturing the real across a range of media.

The Assassin's Worlds

In 2015, a postcard advertising a lecture series I had organized on the theme "Performing History: Re-Staging the Past" caused some confusion (Figure 3.1). It featured a view of the Victorian city of London as seen

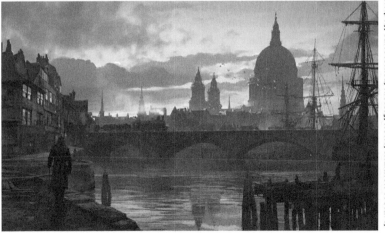

FIGURE 3.1 "London Mood." © Ubisoft Entertainment.

Source: All rights reserved. Concept art by Raphaël Lacoste for Assassin's Creed Syndicate illustrating Performing History Shannon Lecture Postcard at Carleton University, 2015.

by someone standing on the south bank of the Thames at dusk. St Paul's Cathedral dominates. Timber-framed houses are to the left, rigged sailing ships to the right, and London Bridge stretches across the river separating the viewer from the city proper. Many of those attending the series complimented me on the image and asked me about its provenance and the name of the painter. It was not, however, a beautiful landscape by James Francis Danby or Herbert Menzies Marshall, it was concept art by Raphaël Lacoste from Assassin's Creed Syndicate a video game produced by the Montréal, Québec studio of videogame design company Ubisoft, a game where most of the action takes place in mid-Victorian London.[32] For those in the know, the familiar figure of the assassin stood in the shadows on the embankment to the viewer's left, sharing a similar perspective. That the scene could be mistaken for a painting contemporary to the period is a tribute to the reality effects Ubisoft's designers employed in their re-creation of this turbulent time in English history.

Time travelling is one of the major features of the Assassin's Creed (AC) series. The first game, released in 2007, was set at the time of the third crusade. The second, released two years later, took the player to Renaissance Italy. Subsequent games have given players experiences of historical periods and events such as the Ottoman Empire, the Seven Years' War in North America, the American and French Revolutions, the age of piracy, Imperial China, Ptolemaic Egypt, the Peloponnesian War, the ninth-century invasions of England by the Norse, and most recently (2023) Baghdad under the Abbasids. Each game offers "richly detailed, historically accurate, open-ended environments."[33] Players are promised opportunities to "relive" history, to "interact with historical figures," and to explore accurate reproductions of historical spaces ("New York City . . . fully recreated as it existed in the 18th century"). "History is Yours for the Taking" is one of the series bylines.

Based on the fictional centuries-old conflict between the freedom-loving, "anarchic" Assassins and the authoritarian "rigid" Templars, Assassin's Creed is a role-playing game in which gamers enjoy realistic settings and plausible scenarios.[34] They take on the role of an assassin (usually there is also another character, often an assassin-in-training to perform as well) and the game adopts a third-person perspective with the avatar seen from a near viewpoint (usually fixed behind and above) which creates both intimacy and distance. The instalments in what has become one of the most popular and highest-earning video game series of all time, up to and including AC Syndicate were solely stealth-action games; later releases introduced more role-playing elements and multi-player possibilities.

In his lecture for the series (which is why that image was there on the postcard), Ubisoft historian Maxime Durand stressed the significance of

the Animus, a digital DNA reader which a descendant of the Assassins uses to access the memories and histories of their ancestors in the player's present. This archive, however, has failed to record the past fully and so the player's role is to re-enact events in the past to provide the history that is missing. His role as a historian was to dig deep into the past to help the game designers. "Knowing more of the facts," Durand says, "helps you to understand how you can perfect your design, how you can perfect your world environment, and this is complex, we have to make hard decisions, hard choices" (20:37–20:48). Game mechanics – such as choosing landmarks that will work for the climbing and jumping elements of stealth-action games – shape the narrative as do technological capabilities and cost. Buildings might have to be altered or embellished in ways that will satisfy the parkour element of the game. Historical realities though also shape the game: designers decided not to allow the assassin to enter and climb New York's church at a point in AC III when it would have worked for the scenario because it had been burnt down in 1776 (23:14–23:45). Durand likens the challenge faced by designers of historical video games as trying to complete a jigsaw when you do not have the cover art and research has yielded only two pieces of the puzzle: "we have to do the rest . . . trying aways to make it credible" (34:00–34:22). His task is to provide those two pieces, as well as resources to help fill in the missing ones.

For Durand, there are a number of ways in which Ubisoft's claim to historical realism in the Assassin's Creed series is justified. Extensive and deep research into the historical record, drawing on a wide range of textual, aural, and visual sources, as well as location visits, enables the designers to produce a game that gives players a sense of playing in a reasonably accurate historical environment. By taking care about chronologies, effort is made to get the story right according to timelines and contexts. Consulting academic and professionals, as well as communities where deemed to be appropriate (as with the Kanien'kehà:ka (Mohawk) for AC III set in the American revolutionary period), Ubisoft seeks to ensure the plausibility and accuracy of historical content. Such experts are commissioned to provide content that is accessed while playing the game, though not incorporated in gameplay, for the consumption of the historically curious player. Players are given the opportunity to interact with known historical figures – such as Herodotus in ancient Greece (AC Odyssey), Mary Read in the eighteenth-century Caribbean (AC IV Black Flag), or Karl Marx in Victorian London (AC Syndicate). This reality effect re-affirms that the environment is evidentially grounded because those who really *were* there are present. While the needs of the game as a game are paramount, getting the story straight sometimes wins out over potentially unrealistic scenarios or inaccuracies when weighed against the historical record.

As Adrienne Shaw has demonstrated in her analysis of AC III, there are several other layers to the question of realism in the series which significantly shape the players' experience of playing the past including the persona that the player assumes, the limitation of options, and assumptions about users and target audiences that underpins the series.[35] Historians have criticized the games for a focalization that at the end of the day, and however many exceptions or nuances are deployed, is essentially one that is western, white, and masculine. The absence of options during game play that might challenge conventional narratives, the erasures of some histories, and missed opportunities to tell more complex histories and challenge assumptions are frequent criticisms levelled against the games. Shaw highlights a number of these in her analysis of AC III including the fact that while Kanien'kehà:ka consultants were successful in convincing Ubisoft that because warriors of their nation did not routinely practise scalping that game element had to go, but neither did the game challenge underlying assumptions by creating a scenario in which colonists paid for scalps which is a matter of historical record.[36] While acknowledging the meticulous attention to architectural detail and new urban development in AC Syndicate, Alana Harris noticed that the city's population shows much less racial and ethnic diversity than was in fact the case and that the opportunity to talk about campaigns to enfranchise women were missed.[37]

While the value of the series as history may be compromised for some historians, for players, the reality effects employed seem to be more than sufficient to ensure they feel both immersed in the past while playing the game and that they feel they have connected with the past when gameplay comes to an end. Qualitative research into American secondary school students playing AC III found that they had a good deal of faith in Ubisoft's game designers as far as the restaged past was concerned, trusting that their gaming experience offered an authentic experience of lives lived in the American revolutionary period. Students commented on the emotional connections they felt which not only created empathy and understanding but also fostered an appreciation of different perspectives and viewpoints.[38] Ubisoft (Montpellier)'s *Valiant Hearts: The Great War* has also been seen as effective public history: offering an interactive archive of objects and sources, encouraging empathy with historical actors, and collaborating and sharing in "affinity spaces."[39]

The performance types discussed so far in this chapter are firmly within a Western cultural tradition that assumes creators have complete freedom to narrate whatever stories they choose in whatever manner they wish within whatever limits the medium might set. The Western tradition also assumes mimesis, namely that performances should bear some semblance to the real by way of imitation and representation (re-presentation, re-production).

How this resemblance is achieved through reality effects is thus a valid question. But what of performance types which resist mimesis because they are grounded in an other-worldly aesthetic? Where asking the question of how it bears resemblance and relates to the real would be somewhat irrelevant and certainly reductive? This is the case of one of the world's most popular types of performance, the shadow puppet play where, as Ward Keeler observes, effectiveness is judged more by its offering of "a pleasurable but seductive forgetfulness" than realizing a didactic function.[40]

Nuancing the Real: *Wayang Kulit*

In Indonesia, there are three main forms of puppet play: *wayang kulit* (shadow puppets), *wayang golek* (wooden hand puppets), and *wayang wong* (human shadow puppets). Performances of the first two are guided by a *dalang* (puppeteer) who is in command of a vast repertoire of stories drawn from the great Indian epics, the *Ramayana* and the *Mahabharata*. The latter is by far the more popular for *wayang* in Java and, within that huge plethora of stories, those that focus on the story of the *Bratayuda*, the civil war in the kingdom of Ngastina between the Pandawa (the heroic and virtuous sons of Pandhu) and their envious and untrustworthy cousins, the Kurawa, are the most performed. In Javanese *wayang*, a distinction is made between main stories (*lakon pokok*) that are central to the epic and therefore should be performed without change, and secondary ones (*lakon carangan*) that allow for a degree of innovation, imagination, and even invention although always having to fit into the larger design of the main stories.[41] While details and storylines will differ, everyone knows the Pandawa will win in the end.[42]

The puppets used in wayang kulit are unnatural to the human eye: elongated arms and faces (for elegant, aristocratic types), exaggerated facial and bodily features (such as big bellies and bottoms) for the clowns, puppets with carefully choreographed and restricted movements. Every character's nature is indicated through an embodied lexicon: thin or bulbous noses, oval or rounded eyes, glittering or dull clothing, high-pitch or guttural voices, movements that are slow and elegant or jerky and uncontrolled. Faces may tilt downwards – signalling humility and decorum – or upwards and direct – suggesting crudeness and impudence. These traits assigned to each character are unalterable. Performances make no use of natural or realistic landscapes situating viewers in time and space. Wayang performances certainly tell stories about power and conflict, modes and styles of behaviour, about battles and about master/servant relations, but there is no need to confront those tensions or explore cause and consequence, let alone resolve them. "Wayang engages in a much more fluid and

analytically less focused relationship with the 'real' world," Keeler writes; fortuitousness or coincidence are sufficient explanations.[43]

Although the essential hierarchy of power – gods, aristocrats, servants – is a given (and a requirement), this does not mean that notions of right and wrong are clear cut. Although their claims to the kingdom of Ngastina are not entirely illegitimate (which is part of the story), the rude Kurawa can never be given thin bodies or made to look down because these are two of the key characteristics of the refined Pandawa, unless, of course, they are impersonating them.

The Rāmayana, the primary source for shadow puppet performances in south India, relates to Ravana's abduction of Sita and her rescue by Rāma and his ally the monkey-god Hanuman. It offers ample opportunities to explore everyday themes, such as questions of how to exercise self-control and not allow oneself to be dominated by passion and emotion, how to treat others with respect (including enemies and those who have done one harm), how to navigate challenging family relations, and how to act ethically and responsibly by resisting the various temptations that life throws one's way. The puppet version of the Rāmayana story of Rāma's killing of Vāli, for example, disrupts assumptions that this is an act justified by heavenly providence: Rāma confesses that he has behaved wrongly and asks for Vāli's forgiveness, insisting as Stuart Blackburn reads it, on "moral balance."[44]

It is the *gara gara* part of a traditional wayang performance that offers the most explicit opportunity for the dalang to comment on social and political aspects of contemporary life more freely. Translated as "great upheaval," this comic interlude lasts for at least an hour and is usually staged three hours into a performance (usually beginning at 9 pm, so around midnight, with the performance ending near dawn). This comic scene inevitably features the punokawan or clown-servants to the Pandawa, Semar and his sons Petruk, Bagong, and Gareng.[45]

Semar – whose origins are divine – has a bulging bottom, round belly, and barrel chest. His nose is flat, his lower jaw protrudes, and he wears a checkered cloth around his hip that signals his sacredness. In *wayang wong*, he always moves with one palm up behind him resting on his back and the other in front of him. He is always leaning with his bottom exaggeratedly pushed out, even as he walks. He is known for his powerful flatulence. Gareng and Bagong have pot bellies, Petruk is taller and thinner. The punokawan function in *wayang* as clowns, in ways that North American audiences might recognize as similar to the *Three Stooges*. They speak directly and have little self-restraint, they act according to their emotions, and their concerns are having enough to eat and live by. They ridicule and tease each other, they squabble and fight, they play practical jokes, and

they mimic the behaviour of their betters. They both adore their father and mock him. They can speak their mind and do so in languages outside that used by all the other characters. In the performance of *wayang wong* I witnessed they interacted not only with each other but directly with the audience. The fourth wall was broken in two directions: audience members ran up on stage to toss envelopes with requests and gifts, and the actors ran off stage to engage amusingly with an audience member or two. From the reactions of those around me, it was clear they offered commentaries on everyday life through the different forms of Javanese language.[46] The punokawan, and the character of Semar in particular, cross the boundary between the world in which the performers and their audiences live and the world of *wayang*.

This is also true of the less often performed female clown servants, Cangik and her unwed daughter Limbuk. Exchanges between the two offer opportunities to make comments on mother-daughter relations, marriage, and children. After Suharto seized the government in 1965 and launched a murderous campaign against communists and their sympathizers, there was pressure on puppeteers to support his New Order government in their performances. Some did their part, although their efforts were not necessarily well-received by audiences. Others refused, knowing this would compromise their integrity and some used the punokawan to raise questions about the government, its policies and personalities, in an entertaining and amusing way. Dalang Sutina Hardakacarita added an interlude to his 1977 performance of *Bima Suci* featuring the female servant clown Cangik and her unwed daughter Limbuk. The dialogue in which Limbuk educates her mother on the details of the New Order's family planning policies lost the audience's attention until the dalang returned to more traditional mother-daughter banter about finding a husband with somewhat ribald references to a dream involving a honey bee and its sting.[47] In a Sundanese wayang golek performance of *Jabang Tutuka*, the dalang recited government slogans in a humorous way that made them sound unconvincing and alluded to scandals.[48] The liminal space between the performed world of the puppets and the real world of the audience is brought into high relief in the work of Enthus Susmono, a dalang who also enjoyed a political career.

Dewa Ruci (2008)

Seen by many as a superstar dalang, Susmono came to support Suharto's Golkar party, eventually running for political office himself, and adapted traditional performances of wayang to campaign-worthy lengths and focused stories in support of aspects of Suharto's New Order policies.[49]

He performed *Dewa Ruci* – The Resplendant God – in Denpasar, Bali, in 2008.[50] An internationally renowned dalang, Susmono's story revolved around the quest of Bima, the second of the Pandawa brothers, to find a source of knowledge which his teacher, Guru Durna, has told him is at the bottom of an ocean. Durna, however, is aligned with the Pandawa's rivals, the Kurawa, and so his instructions are meant to ensure Bima's failure and his death. In the end, Bima survives by acquiring the ability to breath under water, overcomes a fearsome dragon, and returns with knowledge. Durna falls prostrate before him and pleads for forgiveness and the performance ends.

This is the story from the *Mahabharata*, but when Susmono performed it in Bali, the episode was not part of the traditional dark-to-sunrise performance of the Pandawa/Kurawa story, rather it was self-contained and lasted for under two hours. Moreover, Bima's story frames a long interlude featuring the punokawan – the clown brothers Petruk, Gareng, and Bagong – which takes up over half the show. *Dewa Ruci* then is a *wayang kontemporer* – modern wayang – in which Susmono puts the punokawan to very good use to address the latest issues of the day. Their presence would have been new to most Balinese in attendance for the clowns are characters unique to Javanese wayang.

There are several performative elements that situate the audience in the real world of twentieth-century Indonesia. When Guru Durna threatens to kill Bima if he fails in his quest, he brandishes a pistol. Naturalistic tree puppets are used to mark shifts in narrative and location. Petruk appears almost like a rock star, speaking in English: "Good Evening Bali! Good Evening Denpasar! Good Evening Indonesia! Let me introduce myself. My name's Petruk! Alias Pedro." (06:05–06:08). He introduces his brothers Gareng and Bagong to energetic pop rhythms alongside the traditional gamelan.

In wayang, the punokawan always have serious points to make alongside their clowning, but in this performance, Petruk has a particularly important message to convey to the Balinese audience from dalang Susmono, a Javanese Muslim. In 2002, Indonesia was shocked when over 200 people lost their lives to bombs exploded in the popular tourist destination of Kuta, Bali. The perpetrators, three Islamic fundamentalists who had crossed over to the predominantly Hindu island from predominantly Muslim Java, were executed in November 2008. Petruk tells the audience that Indonesia has been embarrassed: "The bomber called himself the voice of Islam. Here, as a Muslim representative, I tell you that Islam knows not of destruction" (13:10–13:21). Indeed, Islam respects all religions, as stated in the Quran, and Petruk lets the audience know that when he had visited an Islamic boarding school, he had told the children that Muslims in heaven

were "dazed" by the bombings. At this point, Gareng and Bagong contribute moments of comedy: "disgraced" shouts one, "stupefied" shouts the other, adding that, by the way, Petruk had never told them what fee he had received for appearing at the school. Undeterred, Petruk warms to his theme, telling the audience that Javanese Muslims are suffering from "Arabism" and all of Indonesia needs to model itself on Bali which truly values its culture. At every turn, the audience shouts approval, applauds loudly, and laughs at the jokes.

Petruk then declares his admiration for Bima and asks Bagong what he thinks. Bagong replies that in his view Bima is naïve, and that Durna is wicked for taking advantage of this. A debate ensues and the exchange provokes much enthusiasm, laughter, and shouted comments from the audience. This is because there are very explicit allusions and references to contemporary Indonesian political figures throughout, including a comment that only the foolish would follow a "stupid general" (a thinly veiled reference to Indonesia's first president Sukarno) and quoting slogans from later presidents, sometimes mimicking their voices, for example "What's the big deal?" a favourite phrase of Abdurrahman Wahid, the fourth president of Indonesia popularly known as Gus Dur (16:07–18:33).

When it comes to Gareng's turn, the interplay between the real world of contemporary politics and the world of wayang is brought sharply into focus. Gareng claims that as "a person too high up" his views would not be shared by most people. When Petruk asks him what he means, given that "Bima was truly extraordinary," Gareng says well, yes, but he is, after all, only a wayang character. "Well of course Bima is a wayang character, used for illustrative purposes" replied Petruk, but Gareng goes further and tells Bagong that he should not condemn Durna because he too is just a wayang character. Besides, Gareng says, he has been wondering about a far more important question the answer to which he has been seeking from morning to night, namely how much dalang Enthus was going to pay him! More comedy follows with Gareng tricking his brothers to lend him large sums to buy milk for a poorly monkey child after telling them a long sob story, only to keep it for himself. When they confront him, he asks why waste it on a monkey child? "I don't even care for my own child. You must think! The Petrol prices are going up. And you're thinking about a baby monkey!" (18:40–22:22).

Once the clown brothers have left the stage, their father Semar arrives and tells Bima he has to make a choice – will he go to the north sea or the south sea? After Bima chooses and heads off to find the south sea, Gareng pops up again to ask his father what would have happened if Bima had chosen the north sea. Nothing, says Semar, because the world is round Bima would have ended up in the right place whichever choice he made.

"That is geophysical science" (26:02–26:37) he tells his son, and the real point is that leaders need to make decisions that improve wellbeing, not ones that undermine the people and the country. And with that, the audience is returned to the world of Bima, the ocean, a frightful dragon, and the successful end to his journey.

These dalang-created scenarios provide social commentary, offer strong political references and allusions, and address issues of religious extremism and national identity, bringing together the real world of twentieth- and twenty-first-century Indonesia and the wayang world of the Pandawa and Kurawa. Petruk even makes a joke about this. When he tells his brothers that Bima has a special power that will help him breath underwater, Gareng asks him how he could possibly know this. Petruk replies "I read the script. It's always like that" (16:28–16:38). The story drawn from the living archive of the *Mahabharata* was known to all, but the real-world intrusions by the punokawan that so resonated with the 2008 Balinese audience of *Dewa Ruci* were unique, original, and personal. Susmono achieved this through variations in language and music, innovative puppetry, and direct dialogue that explicitly referenced the real, and this was made all the more powerful because the punokawan's conventional buffoonery and quotidian concerns were also present.

Drawing on the wayang tradition, including *wayang perjuangan* (struggle puppet) relating to Indonesia's long history of resistance to Dutch colonialism (Figure 3.2), *wayang kontemporer* tells new stories and incorporates new forms of media. Miguel Escobar reveals how its practitioners adapt the language, music, spaces, and puppets of traditional wayang by introducing hip hop or projecting contemporary images, "participating in the present by negotiating layers of tradition."[51] That such ways of doing public history work can be found within many other performance traditions is suggested by the work of Chinnaiah Jangam who has recently shown how the famous Telugu poet Gurram Jashuva worked within the tradition of the Hindu romantic epic, subverting Kalidasa's "Meghaduta" by combining classical archaic language with everyday spoken language. A cobbler (an untouchable) uses a bat (a stigmatized animal) as a messenger to the god Shiva, thus driving home messages of inequality and injustice and revealing "the authenticity of Dalit experience."[52]

"Public history," according to the National Council on Public History, "describes the many and diverse ways in which history is put to work in the world. . . . In this sense, it is history that is applied to real-world issues."[53] This brief examination of wayang puppetry demonstrates that dalangs make the most of opportunities offered within a traditional performance medium to make allusions to present-day life within the carefully choreographed and curated stories they are telling. While history is

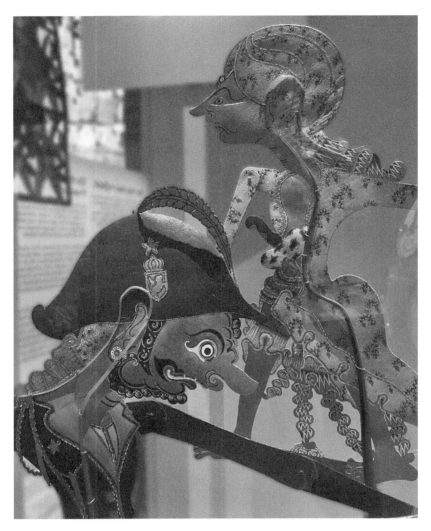

FIGURE 3.2 Wayang Figures of Prince Diponegoro (top) and General De Kock (bottom). Display in Wereldmuseum, Amsterdam, with permission.

Source: Photo: David Dean. The elegance of the prince contrasts with the uncouthness of the general.

not being made to work didactically in the sense of applying the past to real-world present-day issues through citation and reality effects, these allusions function in ways that serve to mediate and close the distance between past and present through performance. Audience reaction and the occasional breaking of the fourth wall between performers and spectators are also aspects that wayang performances share with other forms of

public history performance in which history is used explicitly to inform and comment on real-world issues in the present.

Storying the Past

When his Javanese interviewees spoke to Keeler about *lakan* – the story or plot – they used the words *sejarah* ("what happened") and *crita* ("what people say") interchangeably; in English, he thought, these would be best translated as "history" and "story." Yet Keeler's interviewees described *sejarah* as "genealogy" and *crita* as "embellishment," the former being unchangeable, the latter allowing variation.[54] This suggests that what counts as "history" and what counts as "story" is more nuanced than the translation reveals. Indigenous ways of knowing also offer more complex understandings of the relationship between past and present, as Hokari discovered during his research in Australia (discussed in Chapter 1).

Reflecting on her work with Angela Sidney, a Deisheetaan (Crow) woman of Tagish and Tlingit ancestry, anthropologist Julie Cruikshank suggests that we think of oral tradition not so much as a fixed set of meanings waiting to be discovered but as a social activity. Sidney's story about the discovery of gold in the Klondike was always in a state of flux, told differently at different times, in different circumstances, with different audiences in mind. "Her point," Cruikshank wrote, "is that oral tradition may tell us about the past, but its meanings are not exhausted with reference to the past."[55] Originally assuming that recording life histories was a project of documentation, Cruikshank came to understand through listening to the women elders telling their stories that these accounts had to be seen not as evidence but "as a window on ways the past is culturally constituted and discussed."[56]

Distinguishing what is told about the past and how it is told embraces the performative (imaginative, interpretive, creative, embodied) forces at work in storytelling and forces us, as Della Pollock has put it, to shift emphasis from "validity to value."[57] Much of western historiography focuses on lived realities: uncovering, understanding, and representing/re-presenting them as accurately and truthfully as possible. There is, however, another way of knowing, one that places much greater credence on storied realities. If historians are truly to decolonize their practice by embracing other understandings of the past, then a first step would be to valorize less the authority of the archive and museum and deepen our engagements with intangible heritage and non-western performative traditions in historytelling. As Yukon elder Mrs Ned put it, after listening to hours of scholarly presentations by archaeologists about the territory's pre-history, "You tell different stories from us people. / You people talk from paper – / Me, I want to talk from Grandpa."[58]

Notes

1 Peter Watkins, dir., *Culloden* (BBC, 1964) 00:03:12–00:03:25. The sequence describe below runs to 00:06:20).
2 Ricoeur, *Time and Narrative*, 142. For a succinct account of historical fiction and historical reality see Hayden White, "Introduction: Historical Fiction, Fictional History, and Historical Reality," *Rethinking History* 9, no. 2/3 (2005), 147–57.
3 Robert Vorlicky, "An Intimate Love Letter: Ain Gordon's Art, Life & Show-Biz," in *Dramaturgy of the Real on the World Stage*, ed. Carol Martin (Basingstoke, Hants: Palgrave Macmillan, 2010), 262.
4 Roland Barthes, *The Rustle of Language* (Berkeley and Los Angeles: The University of California Press, 1989), 139.
5 Barthes, *The Rustle of Language*, 145.
6 Barthes, *The Rustle of Language*, 138.
7 Roland Barthes, *Camera Lucida: Reflections on Photography* (New York: Hill and Wang, 1981), 76, 87–89.
8 For example Shawn Michelle Smith, *Photography on the Color Line: W.E.B. Du Bois, Race, and Visual Culture* (Durham, NC and London: Duke University Press, 2004) or the reading of the photograph discussed in chapter 2 by Hartman, "An Unnamed Girl."
9 "What Are the First Documentaries in History? The Lumière Brothers," March 29, 2022. https://guidedoc.tv/blog/first-documentary-films-lumiere-brothers/; Rubén Dominques-Delgado and Maria-Ángeles López-Hernández, "In Memoriam boleslaw Matuszewski: The Origin of Film Librarianship," *Proceedings of the Association for Information Science and Technology* 56, no. 1 (2019), 636–38.
10 Bill Nichols, *Introduction to Documentary* (2nd ed., Bloomington, IN: Indiana University Press, 2010).
11 Philip Rosen, "Document and Documentary: On the Persistence of Historical Concepts," in *Theorizing Documentary*, ed. Michael Revnov (London and New York: Routledge, 1993), 58–89.
12 Janelle Reinelt, "The Promise of Documentary," in *Get Real: Documentary Theatre Past and Present*, eds. Alison Forsyth and Chris Megson (Basingstoke: Palgrave, 2009), 22–23.
13 Ulrike Garde, Meg Mumford, and Caroline Wake, "A Short History of Verbatim Theatre," in *Verbatim: Staging Memory & Community*, ed. Paul Brown (Strawberry Hills, NSW: Currency Press, 2010), 10; Howard Brenton, "Georg Büchner," Program Note for National Theatre (London) Production of *Danton's Death* (August 2010) and "Introduction," Georg Büchner, *Danton's Death: A New Version by Howard Brenton* (London: Methuen, 2010), 3–4.
14 Peter Weiss, "The Material and the Models: Notes Towards a Definition of Documentary Theatre," *Theatre Quarterly* 1, no. 1 (1971), 41–43 cited by Caroline Wake, "Verbatim Theatre Within a Spectrum of Practice," in Brown, *verbatim*, 7.
15 Patrice Pavis, *Dictionary of the Theatre: Terms, Concepts, and Analysis* (Toronto: University of Toronto Press, 1998), 110.
16 Annabel Soutar, "Reality as Poetic Narrative," *Alt. Theatre* 9, no. 1 (2011), 21.
17 Soutar, "Reality as Poetic Narrative," 21.
18 Robin Soans in *verbatim, verbatim. Contemporary Documentary Theatre*, eds. Will Hammond and Dan Steward (London: Oberon Books, 2008), 18–19.
19 Alecky Blythe in *verbatim, verbatim*, 93–94, 97.
20 Blythe in *verbatim, verbatim*, 80.

21 Blythe in *verbatim, verbatim*, 94–95.
22 Rick Duthie, "'One Day Stronger': A Public History Theatrical Experiment About Remembered Sudbury Strikes, 1958–2010," PhD Thesis, Carleton University, 2021.
23 Max Stafford-Clark in conversation with Will Hammond and David Hare, *verbatim, verbatim*, 51.
24 David Hare in conversation with Will Hammond and Max Stafford-Clark, *verbatim, verbatim*, 58–59.
25 Will Hammond, David Hare, Max Stafford-Clark in *verbatim, verbatim*, 73–74.
26 Theatre Pass Muraille, *The Farm Show* (Toronto: The Coach House Press, 1976), n.p. (opening description).
27 Orange parades celebrated the northern Irish protestant community. Considered divisive, most communities abandoned them in the early 21st century, Clinton doing so in 2002, David Yates, "Orange Order Was Once Clinton's Most Popular Fraternal Organization," *Goderich Signal-Star*, July 2, 2020. https://www.goderichsignalstar.com/opinion/columnists/orange-order-was-once-clintons-most-popular-fraternal-organization-2.
28 *The Farm Show*.
29 This scene and the one that follows are watchable in Ondaatje's film *The Clinton Special* at 1:00:01–1:05:30.
30 *The Farm Show*, after the dedication page to farmers of the community.
31 Ondaatje, *The Clinton Special* at 51:06–52:40.
32 Set in the London of 1868, there are two playable scenarios outwith that timeframe: Whitechapel in the 1880s (Jack the Ripper) and the First World War.
33 "Assassin's Creed." https://www.ubisoft.com/en-ca/game/assassins-creed/assassins-creed.
34 The quoted adjectives are taken from Maxime Durand, "From Dreams to Realities: Performing History in the Assassin's Creed@Video Game Series," Shannon Lecture, October 23, 2015, Carleton University, Ottawa, 09:04–09:09.
35 Adrienne Shaw, "The Tyranny of Realism: Historical Accuracy and Politics of Representation in Assassin's Creed III," *The Journal of the Canadian Game Studies Association* 9, no. 14 (2015), 4–24.
36 Shaw, "Tyranny of Realism," 11–12, 20.
37 Holly Nielsen, "Reductive, Superficial, Beautiful – A Historian's View of Assassin's Creed: Syndicate," *The Guardian*, December 9, 2015. https://www.theguardian.com/technology/2015/dec/09/assassins-creed-syndicate-historian-ubisoft.
38 Lisa Gilbert, "'Assassin's Creed Reminds Us That History is Human Experience': Student's Senses of Empathy While Playing a Narrative Video Game," *Theory & Research in Social Education* 47, no. 1 (2019), 119–32. See also Adam Chapman, *Digital Games as History. How Videogames Represent the Past and Offer Access to Historical Practice* (New York and London: Routledge, 2016) and Jeremiah McCall, "Video Games as Participatory Public History," in *A Companion to Public History*, ed. David Dean (Hoboken, NJ and Chichester, West Sussex: Wiley Blackwell, 2018), 405–16.
39 Abbie Hartman, Rowan Tulloch, and Helen Young, "Video Games as Public History: Archives, Empathy, and Affinity," *Game Studies* 21, no. 4 (2021). https://gamestudies.org/2104/Hartman_tulloch_young.
40 Ward Keeler, *Javanese Shadow Plays, Javanese Selves* (Princeton, NJ: Princeton University Press, 1987), 203.
41 This descriptive account is largely drawn from Keeler, *Javanese Shadow Plays* and Ward Keeler, *Javanese Shadow Puppets* (Oxford: Oxford University Press,

1992). For a full study of the performance art of wayang kulit – puppetry, shadows, movement, music, voice etc. – see Jan Mrázek, *Phenomenology of a Puppet Theatre: Contemplations on the Art of Javanese wayang kulit* (Leiden: KITLV Press, 2005).
42 Keeler, *Javanese Shadow Puppets*, 53–54. Keeler notes that "The few stories of indigenous, as opposed to Indic, origin, plus some versions of the *Bratayuda* stories, are the only ones that permit a puppeteer to structure a performance freely."
43 Keeler, *Javanese Shadow Plays*, 203–5, drawing on A. L. Becker, "Text-Building, Epistemology, and Aesthetics in Javanese Shadow Theatre," in *The Imagination of Reality: Essays in Southeast Asian Coherence Systems*, eds. A. L. Becker and Aram A. Yengoyan (Norwood, NJ: Ablex Publishing Corporation), 211–43.
44 Stuart Blackburn, *Inside the Drama-House: Rāma Stories and Shadow Puppets in South* India (Berkeley: University of California Press, 1996), 79–94.
45 In Sundanese *wayang golek* the sons are Cepot, Dawala, and Gareng and perform much the same role. Andrew N. Weintraub, *Power Plays: Wayang Golek Puppet Theatre of West Java* (Athens: Ohio University Research in International Studies, 2004), 117–27.
46 November 2023, Jakarta. See also Keeler, *Javanese Shadow Plays*, 208–10.
47 Victoria M. Clara Van Groenendael, *The Dalang Behind the Wayang* (Dordrecht: Foric Publications, 1985), 179–88. See also Helen Pausacker, "Limuk Breaks Out: Changes in the Portrayal of Women Clown Servants and the Inner Court Scene Over the Twentieth Century," in *Puppet Theater in Contemporary Indonesia: New Approaches to Performance Events*, ed. Jan Mrázek (Michigan: University of Michigan, 2002), 284–95.
48 Weintraub, *Power Plays*, 121–27, and 208–28 on the post-Suharto era. See also Andrew N. Weintraub, "New Order Politics and Popular Entertainment in Sundanese Wayang Golek Purwa," in Mrázek, *Puppet Theater*, 124–35 and Matthew Isaac Cohen, "Entrusting the Scriptures: Wayang Kulit, Cultural Politics, and Truly Popular Art in New Order West Java," in Mrázek, *Puppet Theater*, 109–23 for another example.
49 Mrázek, *Phenomenology of a Puppet Theatre*, 475–80.
50 Dewa Ruci [The Resplendent God] 2008, "Contemporary Wayang Archive," https://cwa-web.org/en/DewaRuci.
51 Miguel Escobar, "Wayang Kontemporer: Innovations in Javanese Wayang Kulit," PhD Dissertation, National University of Singapore, 2015. http://cwa-web.org/dissertation/wayang-dis/index.php. The contexts of wayang kontemorer as post-traditional wayang are set out in Matthew Isaac Cohen, "Traditional and Post-Traditional Wayang Kulit in Java Today," in *The Routledge Companion to Puppetry and Material Performance*, eds. Dassia N. Posner, Claudia Orenstein, and John Bell (New York and London: Routledge, 2015), 178–91.
52 Gurram Jashuva, *Gabbillam: A Dalit Epic*, translated by Chinnaiah Jangam (New Delhi: Yoda Press, 2022), xxvii.
53 National Council on Public History, "What is Public History?"
54 Keeler, *Javanese Shadow Plays*, 245–46.
55 Julie Cruikshank, *The Social Life of Stories: Narrative and Knowledge in the Yukon Territory* (Lincoln, NE: Nebraska University Press, 1998), 25, 41–44, quote at 43.
56 Julie Cruikshank, in collaboration with Angela Sidney, Kitty Smith, and Annie Ned, *Life Lived Like a Story: Life Stories of Three Yukon Native Elders* (Lincoln NE and London: University of Nebraska Press, 1990), 14.

57 Della Pollock, "Moving Histories: Performance and Oral History," in *The Cambridge Companion to Performance Studies*, ed. Tracy C. Davis (Cambridge: Cambridge University Press, 2008), 133. On the performativity of language see especially the work of Richard Bauman, *Verbal Art as Performance* (Prospect Heights, IL: Waveland Press, 1974) and *Story, Performance, and Event: Contextual Studies of Oral Narratives* (Cambridge: Cambridge University Press, 1986).

58 Cited in Cruikshank, *Life Lived Like a Story*, 355–56.

4
FEELING THE PAST

On a briskly cold April evening, I along with another seven adults and a father with his teenage son found ourselves in a small wooden building through a clearing in the woods. We were immediately accosted by three white men who shouted racial slurs at us and ordered us to divide into two groups, men and women or as one of them put it, "bucks" and "breeders." We were lined up and each man, in turn, badgered us with questions about our work skills, fertility, and other things. One or two of us were forced to kneel if our answers were unsatisfactory and threatened with a beating. Our value assessed, we were led off into the woods and given a futile and repetitive wood-stacking task under the watchful eyes of another white man who told us he was taking charge of us now. We dutifully performed this task until one of us noticed that he was no longer with us. We had been abandoned, left to our own devices. Eventually, we stopped performing the task and discussed what to do but were interrupted by two white women carrying lanterns who offered to take us to a safer place. This was an act of kindness, but as we walked along, they scolded us for putting them in danger but pointed us in the direction of the Quaker house where we might find help.

On our way walking nervously in the dark in what we hoped was the right direction, we encountered two Black women sitting in the middle of a field, warming themselves by a fire. We stopped and learned that they were heading in the opposite direction from us – south – to rescue a recaptured relative. Leaving them, we were soon confronted by a very angry white man who yelled at us, saying we were taking work that should rightly be his. We were to blame for the deaths of his wife and child. Threatening

DOI: 10.4324/9781003178026-5

violence if we did not stay put, he lined us up against the wall of a barn before leaving to find help. Here again was a moment of choice: stay or flee? We chose flight and it was a good decision. We found the Quakers and were able to share corn bread while receiving further directions to the north. We realized, however, that we had lost one of the women in our group. Perhaps she had stayed, perhaps she had chosen a different direction, no one knew. From the Quakers, we took a path to another house owned by a Black family – mother, father, and adult son – who shared their own stories with us and sent us onwards to our final destination, a building where we were told by a white woman that we had completed the journey. We were now safe, and free.

At this point, the woman, a professional actor, broke character and told us that in fact, had we been undertaking this journey for real in the 1830s, most of us would not have made it. Some of us would have perished, some of us would have been recaptured and returned to slavery, and some of us would have simply disappeared, fate unknown. For 90 minutes, across 200 acres in central Indiana, we had performed the role of Black slaves who had taken the opportunity to escape and made their way northwards to freedom in Canada by "Following the North Star." We had been part of Connor Prairie's award-winning programme of that name, advertised as "a powerful experience that generates empathy," an "immersive experience" through which "participants gain emotional understanding of the complex challenges that confronted escaped slaves" and "experience in some small way the fear, uncertainty and hopefulness" of the Underground Railroad. Positioned somewhere between "participatory museum theater experience" and first-person interpretation, the programme, which is no longer running, used emotional and physical experience to activate visitor learning.[1]

This chapter explores the role of affect, emotions, and the senses in public history performance. After a brief discussion of concepts, attention is paid to the way music signifies historical meaning with a case study of one of Canada's most controversial operas about the life of Métis leader Louis Riel. Turning then to soundscapes as ways of feeling, the chapter engages with affect and emotion in theatre, particularly in the forms known as playback theatre and the theatre of the oppressed. The ways in which theatre empowers through embodied performance is demonstrated through a case study of India's Jana Sanskriti company and a discussion about living history performers.

Affect, Emotions, and the Senses

Historians of the emotions and the senses often trace their field, in terms of Western historiography, to the cultural historian Johan Huizinga who

offered an alternative way of writing history to the increasingly dominant positivist and empiricist mode associated with Ranke. In his *Autumn of the Middle Ages* published in 1919, Huizinga placed considerable weight on the senses and emotions in the life experience of individuals and the individual's experience of life. Twenty years later, in *Homo Ludens*, he argued that play was a vital part of human culture, a temporary relief from everyday life that involved enjoyment, pleasure, and fun. The French Annales historian Lucien Febvre wrote positively about Huizinga's approach, urging historians to pay more attention to emotions and senses. Febvre's 1973 article, "Sensibility and History: How to Reconstitute the Emotional Life of the Past" became a sort of manifesto.[2] Since then, many have explored the role of the senses, emotions, and feelings in history across time and space and the history of emotions has become an interdisciplinary sub-field of history.

It is difficult to think of a public history performance that is not affective, in other words, that does not elicit emotional responses. Thinking about museums, Adam Bencard writes that affect "germinates thought, feelings, emotions, sensations and other forms of life in the viewing subject."[3] Those studying re-enactments have been most attentive to the affective turn in the humanities. Vanessa Agnew writes, "As a form of affective history – i.e. historical representation that both takes affect as its object and attempts to elicit affect – re-enactment is less concerned with events, processes or structures than with the individual's physical and psychological experience."[4] Not dismissing affect as an approach, Juliane Brauer and Martin Lücke have suggested that emotions and feelings (which they see as synonyms) are a more useful way of thinking about the past because "they are to be located on the border between the body and the psyche, inside and outside," a "contact zone between self and other."[5] Rob Boddice and Mark Smith, authors of ground-breaking monographs on the history of the senses, emotions, and feelings, have recently called for a new "history of experience."[6]

Embodied histories are both corporeal and psychological. Museum exhibits employ text, image, and interactive elements to encourage empathy and enhance understanding, but also bodies. Some have famously put the visitor into someone else's shoes so they can live the past as that person did, discovering their (and their own) fate at the end. Digital imaging has allowed for the creation of immersive experiences of space and time, re-positioning the visitor from outsider looking at to fully entangled and complicit insider. Time-travelling is a marketable feature of living history museums and programmes as well as re-enactments and historically located video games; visitors are – or so it is claimed – immersed with varying degrees of agency. Sometimes, as in re-enactments, they are active listeners and watchers, witnesses to the histories being performed; occasionally they are invited to participate, or play a role assisting the living

history performer or re-enactor. In video games, players experience a much higher degree of agency, especially in first-person shooter (FPS) games, but also witness and experience the history happening around them emotionally and sensorially.

Affective Music and Historical Meaning

In his pioneering study, *Emotion and Meaning in Music*, Leonard B. Meyer reminded his readers that studying how emotions worked musically was not only about composers, conductors, and performers: audiences were active listeners who came into a concert pre-disposed to respond emotionally to the music they were about to hear.[7] Saam Trivedi has recently suggested that there is an "intimate link between the music and ourselves *in our imaginations*" that works by evoking through identification with our own mental states, personas, and projecting onto, or endowing music, with attributes.[8]

Christian Schubart's influential *Ideen zu einer Aesthetik der Tonkunst* published in 1806, provided a useful description of the affective attributes of each of the major and minor musical keys in Western music. E major was joyous, full of laughter and delight while B major was passionate, full of rage and anger. D major was triumphant and G minor was resentful.[9] Composers have drawn on this musical lexicon, played with it, or violated it, to great effect on audiences. At the beginning of Steven Spielberg's *Schindler's List* for example, we are left in little doubt about Oskar Schindler's inherent goodness compared to his friend and fellow Nazi Amon Goeth because of the music that accompanies his introduction. Schindler appears to a soundtrack of non-German 1930s music, including an Argentinian song featuring a Mozart composition in C major, a key that Schubart described as conveying innocence and purity. Music then is clearly a significant conveyor of meaning, argument, and of course emotion. That said, as Elias Berner points out, the song is actually about gambling which complicates our reading of Schindler's masculinity, but overall the soundtrack to the film has a clear pattern: the composed score (by John Williams) "is implemented to denote empathy, courage, and generousness" while "diegetic popular music is used to illustrate hedonism" and noise, silence, or agonized human sounds accompany violent acts.[10] All of these were employed in a landmark opera production of 1967 celebrating the centenary of Canada, which was revived for the sesquicentennial in 2017.

Harry Somers *Louis Riel*

Louis Riel was an opera that was, in 1967, a somewhat courageous choice for composer Harry Somers and librettists Mavor Moore and Jacques

Languirand, and for the newly minted Canadian Opera Company. It was a centenary year, celebrating the founding of a nation, with an international exposition in Montreal and commemorative events across the country from coast to coast to coast. Commemorative stamps and coins, and collectable medals given away at petrol stations, celebrated the coming together of the ten provinces and (then two, now three) territories of Canada. Yet this foundational story was a stretch, because in 1867, only the current provinces of Ontario, Quebec, Nova Scotia, and New Brunswick were joined in union. Others would follow, Newfoundland only in 1949.

Riel commemorated nationhood – the making of Canada through a coming together of the two founding colonial powers of Britain and France – while at the same time reminding Canadians that westward expansion was achieved through conflict. In 1869, the new Canadian government approved legislation annexing western territories, ostensibly owned by the Hudson's Bay Company, provoking resistance by Indigenous peoples. The Métis – peoples of mixed First Nations and settler origin who have since been granted legal status as Indigenous peoples – set up their own provisional government at the Red River Settlement (in the later province of Manitoba which joined confederation in 1870) seeking to form their own colony with allegiance to the Crown, like that then enjoyed by Canada and Newfoundland. The resistance was crushed. Métis leader Louis Riel put on trial, found guilty, and executed. This then was not a feel-good story about the making of Canada, but one signalling that Indigenous rights and freedoms had been suppressed in the making of the nation. The libretto featured English, French, Latin, and Cree, one of the first times audiences would have heard Cree on a national stage, giving force to the competing viewpoints being presented. Albert Braz and Paula Danckert have discussed the resonances and differences between the opera and John Coulter's influential 1950 play *Riel* (librettist Moore had played the title role in a nation-wide tour of the play) as well as the historiographical points the opera makes in its various incarnations.[11]

The Canadian Opera Company commissioned a new production of the opera on Canada's 150th birthday in 2017. Attitudes to Riel had by then changed considerably, he had been deemed worthy of commemoration on a postage stamp (1970), a controversial monument outside the Manitoba legislature (1971, replaced by a more traditional figurative statue in 1996), and growing calls for him to be acknowledged as a founding father of the nation.[12] And by 2017, national soul-searching had begun with the findings of the Truth and Reconciliation Commission, revelation after revelation of the horrors of the residential school system, and a growing realization among many settler and immigrant Canadians that they lived not only in a nation where much of the land was stolen from Indigenous peoples, but one whose origin story was one of cultural genocide.

Whereas the original production literally silenced Métis, they were given a strong voice in the 2017 production with the Métis language, Michif, written into the libretto. With both Michif and Cree being projected on stage, the Indigenous presence in this foundational story was both amplified and emphasized compared to the original production. "It is our intention," director Peter Hinton wrote in the production's programme, "that a more inclusive and expansive history shall be restored," recognizing the challenge of achieving this within the Eurocentric cultural form and traditions of opera.[13]

Musical scholars such as Brian Cherney and Réa Beaumont have pointed out how Somers' original score deliberately added modern elements to traditional music in ways that clashed and contrasted, making both historical and political points. Duplicitous Prime Minister Sir John A. Macdonald is "given highly rhythmic 'sung-speech,'" interrupted rudely by various instruments that ridicule and mock his actions and words, whereas Riel almost always delivers lyrical legato lines that convey seriousness and passion. Songs, and tunes contemporary to the period, are performed straight but interrupted or accompanied by dissonance and discordance. One of the most beautiful moments of the opera is when Riel's wife Marguerite sings a lullaby in Cree, to their baby with each phrase ending with a *glissando* (the voice slowly gliding from one pitch to another) to convey her anguish and those of the Métis people.[14] This is an opera with no great choruses and no conventional arias; the score is dominated by what Dean Jobin-Bevans describes as "a declamatory vocal style that is neither recitative nor spoken."[15]

In late baroque, opera and theatre recitative was used to signify outer action, with arias performing inner thoughts. In *recitativo*, singers would not sing the words in full voice (emphasising the contrast with arias) and vary pace and tone according to the sense of the words, with the primary goal of moving the plot along. In *Louis Riel*, to take one example, Somers's score indicates that the singer performing the ill-fated Irish Protestant Thomas Scott should intone his lines rather than sing.[16] Recitatives could be quite long, and this was decidedly true of recitative soliloquies in baroque and eighteenth-century plays.[17] Recitative then is the perfect venue for the delivery of words taken from original sources, and in *Louis Riel*, there are long such recitations. All but one are for Riel himself (the other is for Marguerite) and they are remarkably effective on stage (to judge from reviews and my own experience seeing the 2017 production in Toronto).

Somewhere in between aria and recitative, Riel often delivers his lines in melismatic style where a single syllable is sung moving between different notes as opposed to being sung to a single note. This style is associated with religious chanting as well as baroque religious music, musical

traditions from the Middle East, North Africa, and Ireland, as well as American country and gospel music. Riel eventually came to believe he was doing God's work, and that God was working through him. Many Métis believed this, enemies were concerned about it, and such claims were used by those hoping to save him from execution on the ground of insanity. The musical element thus makes a key historiographical point about Riel's messianic nature as well as linking the Métis to musical genres associated with resistance and religiosity.

In her detailed analysis of music as representation in the opera, Donna Zapf notes that Riel's "Au milieu de la foule" (Act One, Scene Two) uses not only melismatic vocal lines but also a long descending glissando; "interjections" by the tom drum and a trumpet flourish in the form of appoggiatura (playing a note that displaces the main one, but then returns to it) are among the musical gestures that are (or were at least for 1967) outside normal operatic convention.[18] Musical elements are used to signal group identity, race, and culture: modal/atonal for the Métis (the rural west, Manitoba) and tonal for the anglo-protestants (the urban east, Ontario).[19] These contrasts are evident also in forms of declamation (Macdonald usually performs straight speech or sung speech, Riel employs fully sung lines with a much wider vocal range) and timbre (more woodwinds for anglo-protestants/east/Ontario and a wide range of percussive instruments for Métis/west/Manitoba).[20]

These are not absolute binaries; variations, echoes, and counterpoints are used by Somers to support the dramatic narrative with musical meaning. Sometimes this is ironic and sometimes provokes laughter, at other times it reveals the tragedy. The moving arioso delivered by Riel in a melismatic, emotional style earlier in the opera, contrasts sharply with the lack of lyricism and vocal range in his trial scene where he offers only sung speech reflecting his loss of power. Piano and mallet percussion are predominant in the courtroom scene, in contrast to the rousing and vibrant mixed percussion and full orchestra ensemble in the earlier church scene.[21] The defeat of Riel and the aspirations of the Métis are established as much by the musical vocabulary as by the events unfolding on stage. *Louis Riel* was described by Somers as "music drama" and in reviewing the 1967 production Raymond Ericson of *The New York Times* located the production's success in its theatricality, describing the libretto as an "historically accurate book," with the recitative style chosen by Somers for Riel's monologues as heightening the emotional experience for the audience.[22] In its latest manifestation, *Riel* was not merely staging the past but also performing public history.

Witnessing the past through re-presentations in the present is, as we saw in previous chapters, an important aspect of public history work for both

audiences and actors/performers. The 2017 production of *Riel* featured a physical chorus of 35 Indigenous men and women who witnessed the events onstage. The Land Assembly was intended to "represent those who are directly affected by the outcomes, victories and losses of history" and was directed by the production's assistant director Estelle Shook, who is Métis, and Indigenous members of the professional ensemble.[23] In contrast to the opera company's professional choristers who performed in the opera as the settler immigrant Parliamentary Chorus, the Land Assembly was silent throughout. It was a constant, and eloquent, reminder to audiences of the legacies of colonialism, not only of Métis rights and claims denied, and often still disputed in the present, but a powerful critique and protestation of the events as they unfolded on stage.

The Sounds of Silence

Michel-Rolph Trouillot says that his aim in writing his influential book *Silencing the Past* was to show that "the many ways in which the production of historical narratives involves the uneven contribution of competing groups and individuals who have unequal access to the means for such production."[24] Those who ultimately triumph in this competition, Trouillot argues, create dominant narratives which marginalize or silence other narratives. These silences serve to suppress not only alternative interpretations and perspectives but also ways of knowing, historical understanding, and historical consciousness.

Yet, as Trouillot shows in his deep reading of the silencing of Colonel Jean-Baptiste Sans Souci in Haitian history and memory, silences are never truly silent. He begins his chapter with a first-person narrative of his experience visiting what is left of Haitian revolutionary general and later king Henry Christophe's palace of *San Souci* at Milot in the north of Haiti: "I walked in silence between the old walls, trying to guess at the stories they would never tell."[25] Trouillot shares with us his imaginings and his dreams as he approaches the stone that marks Christophe's grave: "I bent over, letting my fingers run across the marble plaque, then closed my eyes to let the fact sink in. I was as close as I would ever be to the body of Christophe – Henry I, King of Haiti."[26]

Trouillot decided to offer this first-person narrative in italics, leading to, but separate from, his account of the history of Colonel Jean-Baptiste Sans Souci which follows. This is a story little known, a task of historical recovery. Trouillot suggests that one reason for the neglect by historians is that Sans Souci appears little in the archival records. Another is that because Sans Souci led a rebellion against his fellow revolutionaries who had allied with the French for a time; a story about divided revolutionaries sits

uncomfortably in the national narrative of the Haitian revolution. These silences are, of course, due also in part to the physical silencing of Sans Souci, treacherously murdered by Christophe during a diplomatic meeting. Yet the greatest silencing, for Trouillot, was when Christophe named his palace *Sans Souci*. Most had assumed the name was chosen because he did indeed hope for a life without worry (the literal meaning of the French) or wished to emulate Prussian king Frederick the Great whose *Sanssouci* palace was built in Potsdam decades earlier. It was through walking that Trouillot connected the palace's name with Christophe's determination to eradicate all memory of his enemy. Looking down from a terrace, Trouillot took on the ruler's perspective: "I surveyed the kingdom as he imagined it: the fields, the roads, the past in the present; and below, right below the clouds, the royal walls of Sans Souci, the King's favorite residence."[27]

Deserted spaces and places feature in Tsalko Svetlana's poems *People, Where Should I Look for You?* and *Quiet Conversation*. In the first, a crane circles a deserted village and asks the question of the poem's title. In the second, the trees speak amongst themselves wondering why their village has suddenly become unpeopled. The pear tree is bewildered that its fruit has been left to rot, the apple tree is terribly sad, and the tearful plum tree is bent over with grief.[28] Tsalko was in her seventies when her poems were transcribed and translated for Peter Cusack's *Sounds from Dangerous Places*. Displaced by the Chernobyl disaster, Svetlana coped by composing poems in her head, poems in which trees and birds wonder why people have abandoned the spaces where humans and the natural world once lived in harmony and to mutual benefit. The explosion of the number four reactor in the Ukraine Soviet Socialist Republic on April 26, 1986, was the worst nuclear disaster in history, leading to the creation of a 30-mile exclusion zone and the evacuation and resettlement of over 100,000 people, including Svetlana. While some of her poems are reflections on humanity – memories of beloved villages, the experience of being uprooted, political ineptitude – it is those that give voice to birds and trees that cut to the quick.

Cusack's field recording projects, which he terms sonic journalism, are "based on the idea that all sound, including non-speech, gives information about places and events" that are different, but complementary to other forms of knowing. Recordings "are allowed adequate space and time to be heard in their own right, when the focus is on their original factual and emotional content."[29] The dangerous places Cusack visits and records are the Chernobyl exclusion zone, Caspian oil fields, and several sites in Britain: airbases and airports, landfills and nuclear power stations, and Snowdonia in Wales which was more affected by radiation from Chernobyl than any other area in the country. The sounds we hear are evocative: creaking metallic sounds of a never-used Ferris wheel in Pripyat (the town

at the epicentre of the nuclear explosion), the crackle of a power cable, and the crunching of feet on debris, broken glass, and school books and papers as Cusack walks the floors and corridors of a Pripyat kindergarten. There are startling contrasts such as the bleep of a radiometer accompanied by the calls of cuckoos.

Cusack's book with its accompanying CDs invites multi-sensory examination: looking at image and reading text while listening to sounds or perhaps just listening. The first activity brings the images to life, or in the case of the Chernobyl project, their post-explosion afterlife. We move from sound to image and back again, perhaps referencing the textual descriptions in the book. It is exploratory and purposeful, registering spaces and places; performing in the second or third person in an archive of image, sound, and text. Listening alone on the other hand is a more personal, interior performance. We hear the wind whistle through empty spaces, we are disturbed by the flapping and banging of some thing or another, and we are aware of how walking over glass feels different from walking over pages of books. Cusack has given us the opportunity to experience these spaces in the first person. Doing so provokes many emotions – sadness, emptiness, loneliness, loss, curiosity, perhaps even anger. Our imagination backfills these not-so-silent spaces with the sounds we have learnt to know and expect from our own lives. We know what it would have been like when the kindergarten children started their day chasing each other in the playground. We can draw on our own pasts to bring into our mind's eye a scenario of toddler excitement when the teacher told them to choose one of the books we are now treading on. We can relate, we can empathise, and we know that this could have happened to us. The presence of the past is evident as we participate in these aural performances, but so too are our own lucky escapes and our worries for a safe future.

Like so much public history work, Cusack's performances of the sounds of spaces and places are a call to action. The interruption of the ringing of church bells in the English village of Great Easton by the roaring engines of jets flying out of nearby Stansted airport asks questions about our relationship to the environment. By 2012, when *Sounds from Dangerous Places* was published, there had been a long-standing campaign against the expansion of Stansted; the juxtaposition of bells and jet engines makes the aural argument that we maximize customer choice and airline profit only at the expense of tangible and intangible heritage.

Affect and Emotion in Theatre

Sounds are an integral part of putting history on film and on the stage. Paul Gareau, musician with the Montreal-based playback theatre Living

Histories Ensemble, notes, "As a musician, I try to deepen the affect and deepen the emotion in a playback performance . . . so that what is happening on stage is also found in your heart." He goes on to reveal that on one occasion, in a playback theatre performance telling lived experiences of the Rwandan genocide, he became stuck and could no longer play because he felt he was re-traumatizing himself and the audience. While performing Holocaust stories, actor Warren Linds found himself "falling into a pit of my own childhood memories" when he had first heard such stories and struggled to listen to the stories he was being gifted which he was to playback to the storyteller.[30] Gareau and Linds were part of the oral history and performance working group of Montreal Life Stories, a project that archived five-hundred interviews with Montrealers who had experienced or were descendants of those who had experienced the Holocaust, the Cambodian and Rwandan genocides, and violence in other countries such as Haiti. On the performance side, those involved with the ensemble drew inspiration from Augusto Boal's Theatre of the Oppressed as well as playback theatre.

In playback theatre, a facilitator (sometimes called a conductor) invites an audience member to share a story. A group of actors will then improvise a performance based on that story and the facilitator will invite the storyteller to comment on the performance. Jo Salas, reflecting on her ground-breaking work in, and book about, playback theatre, suggests that is

> a kind of mic check: we listen to the teller's words and we turn those words into multi-voiced theatre, so that a whole roomful of people can feel what's important in this person's experience. Then the audience goes out into the world, charged and changed by what they've heard.[31]

There is an intentional distancing then in this process: the actors are meant to listen deeply and with empathy, setting aside their own selves to perform another person's experience back to them. The exchange – the gift of a story and the returned gift of performance – assumes a level of objectivity on the part of the actor and generosity on the part of the storyteller. Yet, as Gareau's and Linds's comments reveal, when stories are about traumatic experiences, objectivity is not really possible. Reflecting on her work with the Living Histories Ensemble, Nisha Sajnani found that the actors' habit of "regularly draw[ing] upon our own histories to locate ourselves as 'insiders' to the experiences of our audiences" needed to be made visible, opening up a conversation about intentionality, the ethics of re-preforming traumatic stories, and the need to shift from testimonies of trauma to larger life stories, and sometimes creating alternative endings.[32]

Through practising the "Bridge" (where actors, standing with their backs to the audience, turn to reveal something about their own histories in an improvised sequence), actors "attempt to *meet* the teller *in* the story rather than simply playing it back."[33]

The intimacy, emotionality, and responsibility of playing back stories through dance and drama is very much on the minds of the dancers, dance practitioners, and historians who are part of the Isikhumbuzo Applied History Unit in South Africa. Stories, often heart-breaking ones, are translated for *pantsula*, a fast-paced dance characterized by "precise and technical footwork which is always accompanied by upbeat house music" that developed during apartheid in the Black townships.[34] The slow-paced rhythms of stories have to be carefully transferred into faster-paced dance rhythms, performers have to sometimes slow down the steps to connect text and dance, and doing so finds new meanings and brings new memories.[35] Phemelo Hellemann comments that whereas writing the past inevitably overpowers the received story "when you are interpreting through performance, the body is different every time in terms of the experience that it goes through and the emotions that come with it . . . [the performers have the opportunity to] share this interpretation immediately with the audience."[36]

Jana Sanskriti and the Theatre of the Oppressed

Since the 1980s, the west Bengal-based theatre group Jana Sanskriti has been practising forum theatre, inspired by Augusto Boal's Theatre of the Oppressed. As Boal explained to a crowd of some 12,000 gathered in Kolkata to celebrate the work of Jana Sanskriti, this form of theatre, "is a useful tool to study the past and, in the present, to build our future, rather than waiting for it."[37] A response to oppressive regimes that dominated Latin America in the 1970s, the Theatre of the Oppressed was activist theatre using performance to stimulate societal change. In forum theatre, audience members have the opportunity to participate on stage, turning them, in Boal's words, from spectators to "spect-actors" thereby eliminating the fourth wall and creating spaces for dialogue and discussion. The Theatre of the Oppressed is an applied and decidedly non-hierarchical, democratic theatre. Sanjoy Ganguly, founder of Jana Sanskriti, notes that unlike traditional theatre which seeks to empower audiences through receiving performance, forum theatre empowers everyone involved. Much more than an ensemble or group, forum theatre has become a global phenomenon; in India alone, it has reached over a quarter of a million people. It has become a theatre-based political movement.

In forum theatre, the theatre group identifies a social problem from everyday life and stages it as an oppressive event or experience which affects

one character in particular, the protagonist. At a particular moment, the performance is interrupted by a character Boal dubbed the Joker. Like the joker in a deck of cards – a wild card, able to assume the roles of other cards – the Joker facilitates audience engagement. The Joker comments on what the audience has just witnessed on stage and encourages an audience member to come up on stage and perform the role of the protagonist. The volunteer spectator comes on stage and performs, becoming a spectactor, often choosing to do so in ways that they feel might explain, manage, or prevent their oppression. The actors on stage perform various roles in response, unscripted. The Joker will bring this to an end at a certain point and invite another member of the audience to come up on stage. And then another. The goal is that everyone will discover new ways of thinking and doing that will play out in their everyday lives, turning acting into action as Ganguly puts it.[38]

In *Shonar Meye* (Golden Girl), Jana Sanskriti performs a play that explores women's lives before, during, and after marriage (Figure 4.1).[39] In one scene, we witness the intrusive and objectifying bodily examination of a daughter by the father of her potential husband a long-standing ritual that is part of dowry negotiations. This is regarded, especially in rural society, as an expected social norm, a tradition practised across the generations. It reinforces the inferiority of women, the subjection of wives to their

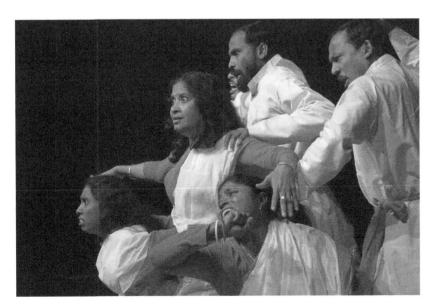

FIGURE 4.1 *Shonar Meye* (Golden Girl). Jana Sanskriti. Performance still.

Source: Courtesy of Sanjoy Ganguly and Jana Sanskriti.

husband and his family, and signifies class difference. In another scene, a wife is berated and then beaten by her husband because he does not like the way his dinner has been prepared and served, his words revealing the underlying cause is his anger about what he sees as an inadequate dowry.

For the actors, these are stories that resonate with their life experiences. In a documentary about the work of Jana Sanskriti, one of the actors, Pradip, talks about how he is deeply in debt because of the dowry required for his sister to marry (14:15–15:01).[40] Another, Sunanda Tanti, talks about her sister who was abused by her husband and in-laws because their family could not afford to offer a television and a motorcycle as part of her dowry. When she witnessed a performance of *Shona Meye* in her village, for the first time, her thoughts – would her sister continue to be abused even if the dowry had been affordable – were given space to be voiced in public and she joined the company (25:34–27:94). Sima Ganguly says she is frequently asked how she manages to cry so often while repeatedly playing the role of the bride in the play. The answer she gives is that the play was based on a real story and is based on a woman she knew well: "Whenever I act that scene, I see her face saying to me: 'What is going to happen to me?' This face is in my heart, how can I forget it? Even when I am old and my hair is all grey, I'll enact the scene with the same energy" (22:12–22:42). For everyone involved, these reality-based performances are emotional and sensorial experiences. If the initial performance encourages empathy for the protagonist, this is transformed quickly into sympathy – or the opposite – through the spectator's involvement and opens up a space for dialogue and action. It is an opportunity to change history.

In the performance of *Shonar Meye* in the village of Medinipur, we see the scene where the wife is serving food to her husband (38:05–39:44). The rice is warm. The dal is not ready. He gets angry and begins to berate her and beat her. The camera pans to the audience and we see many of them smiling even laughing, perhaps knowingly, even though many are women and girls. The action freezes as he is about to strike her again and the Joker asks the audience "Now, who wants to come here? Who wants to intervene? Who is thinking": "It's someone I know, a girl is being beaten." or "I haven't seen it myself but she is being beaten." "It is her problem," the Joker reflects, "but isn't her problem also mine?" and then asks "Who wants to come? Who's ready to help this woman?" People turn and we hear laughter and applause as someone volunteers. He is a man and he becomes the wife.

The spectator is now a spectactor. The husband asks "Why is the rice so warm? I'm exhausted from work and you think I'm going to eat some warm rice?" The spectator says, "OK, I will cool it down right now." The husband continues to complain (now about the dal not being ready).

"What were you doing all this time?" The spectator says, "I was busy" to which the husband responds "And . . . having fun maybe?" "If you want you can serve yourself!" the spectator retorts and the husband yells "What? Get out of here now!" and shoves him/her away. The spectator leaves, promising to complain to the police with their father. Everyone claps and the spectator becomes once more a spectator (39:46–40:30).

In the scene where the bride-to-be is inspected by her potential in-laws, the action is frozen when she is asked to get up. This time a young girl has volunteered to act. When she is about to be touched she declares "I don't want to get married if you look at me like that!" After some back and forth, her father asks "What are you talking about? You are just a kid. This is the custom. . . . He must look at you before he marries you to his son!" Her mother says her daughter's intransigence will dishonour her father: "What will you do when people will gossip about your father?" and the spectator replies "I'll tell them only one thing: That women have some rights too." Her performance is ended by the Joker: "To say that out loud is already a big step," hugs the girl and as she leads her back into the audience tells them "I'm sure that when she gets married, She will be able to defend herself." The camera cuts to a close up of two girls smiling, a young man who seems a little unsure about it all, and then to the spectator returned spectator with her friends while the applause continues (41:51–43:50).

Fear and anguish, indignation and outrage, disappointment and frustration, laughter and hope, the Theatre of the Oppressed is a theatre of feeling, the emotions, the senses harnessed through a theatrical practice that goes beyond participation to embrace collective experience, collaboration, and co-production. It resonates internationally. When the issue of laughter came up for discussion during a forum play about bride-knapping and violence against women in a Jana Sanskriti performance in Kyrgyzstan, Sanjoy Ganguly explained that audiences "laugh to save themselves from embarrassment, the laugh then is not fun, non-serious in nature; it is then the expression of a mental agony."[41]

The villagers who experience Jana Sanskriti performances are generally poor, disempowered, and marginalized; many of the women are illiterate or semi-literate. With these performances, spurs to action, there comes responsibility. As Jana Sanskriti member Rohini Mukherjee explains, "When you start this experience it is your responsibility to see it through to the end . . . this is a political responsibility" (41:02–41:42). She offers an example where their play about bad liquor and its consequences led villagers to form anti-liquor committees, angering local venders who had links with both criminals and the police. Quoting Che Guevara's words – "solidarity is running the same risks" – she argues that having provoked the

action through theatre, she has to be ready to take the same risks whatever happens (46:54–47:59). In the performance moment, there has been collaboration and collective will to explore past practices, present situations, and imagine how the future might be different. Sanjoy Ganguly quotes a poem by Rabindranath Tagore to capture the synergy between actors and spectators through the emotions and senses: "the singer will sing with her melodious voice and the listeners will sing with their sensitive mind."[42]

Affective Labour and Reliving the Past

The synergy between real life and performance, and the feelings, emotions, and senses that are essential in the making of these histories, is exhausting for both audiences and performers. "Interpreting the past to the public in an individuated manner," public historian Amy Tyson writes, taxes "the emotional reservoirs of the workers."[43] Tyson's work as an interpreter at Historic Fort Snelling located in Minnesota in the United States explores how historical interpreters working on the front lines of public history navigate the stresses and strains of trying to perform the past faithfully. Exhausted after a day adjusting their emotions to those of the visitors, interpreters can lose a sense of self. "By the end of the day," one interpreter told Tyson, "I'm not sure what century I'm in, and who I am," while another performing a woman who had lost her only child, became so sad by the end of the day that this emotional state continued well after she had finished work.[44] Another aspect of emotional labour as a living history interpreter is their role in dealing with the emotional effects their performances have on visitors. At Fort Snelling, an actor playing the role of the commanding officer's wife frequently found herself playing the role of therapist as the site brought back painful memories to those who had fought in the Second World War: "listening to men telling their stories about being in Europe . . . with tears streaming down their faces."[45]

For some living history interpreters, their performances collapse historical distance in a deeply personal and emotional way: the boundaries between real life and performed life are blurred. This was the experience of James "Roy" MacNeil who performed Father Isidore, the eighteenth-century military chaplain at Fortress Louisbourg in Cape Breton, Nova Scotia, in Atlantic Canada. One of the first federally funded recreated living heritage sites in Canada, it features an eighteenth-century town of some 60 buildings and two bastions, filled with historically accurate historical reproductions and animated by living history interpreters. The site's declared objective is to ensure visitors will enjoy an authentic experience. In MacNeil's performing of Father Isidore, real and performed lives were simulacra.[46] Describing himself to fellow interpreter and public

historian Amy MacDonald as a "Catholic boy, in a Catholic school and a Catholic town," MacNeil had chosen to pursue a religious life and entered a seminary school. Circumstances forced him to leave the seminary and return to Cape Breton where he found work as an interpreter at the Fortress. He worked at the roles of a domestic servant and an administrator's assistant, before being chosen to play that of military chaplain Father Isidore Caulet. He would do so for the next 30 years.

MacNeil already knew Father Isidore having researched into the eighteenth-century Recollect priests of New France out of interest. He now fully immersed himself in Isidore's writings, his appearance, and his life-story. MacNeil described his embodiment of Father Isidore as not only "owning" the role, but "transcending" it. Not only was he performing a priest, he had become, for all intents and purposes, the priest he had wished to be in real life:

> How I encounter people, my willingness to be of service and care that they are okay and all of those things. . . . The more I can be authentic in my own qualities within the Isidore persona, then I think the more I can bring Idisore.[47]

As MacDonald puts it: "living history can provide participants like MacNeil the opportunity to re-embody parts of themselves that once were or, alternatively, re-embody an imagined or wished experience that never was."[48] MacNeil reports that he sometimes sets himself up in a chair serving essentially as a space like a confessional in a church. His eighteenth-century self is then sometimes asked questions by visitors about issues facing the Catholic church in the twenty-first century such as sexual abuse and queerness. MacNeil's working life resonates with those Tyson interviewed at Historic Fort Snelling even though they were not performing characters who corresponded so closely to who they had hoped to be in real life. As with the actors performing characters in Jana Sanskriti's *Shona Meye*, there is overlap between the actor as performer and the actor as person.

While the transition from spectator to spectactor is explicit in forum theatre practice, and is also evident in living history performances, something very similar can happen in other public history contexts. Participants in walking tours, for example, can react emotionally and sensorially to the spaces and places they encounter. Whether the goal is to re-visit or re-create the past, often in ways that complicate accepted historical understanding, or whether it is to address traditional practices that have historically been considered uncontestable, performing the past publicly is to feel the past presently.

Theatres of Memory: Oral Histories and Performance

The embroidery is the size of a small tablecloth or window hanging, 95 × 104 cm, and it bursts with vibrant colours: carmines and orangey reds, purply browns, cerulean, navy blue, pink, and greens of various shades (Figure 4.2). There is no one focal point, instead the eye is drawn to the many shapes and images, resting on each for a moment to take in the full effect before moving on. The embroidery is populated with chickens, a pig, items of clothing, a wheelbarrow, a burning incense holder, a cluster of cooking pots. A fence protects some sort of crop, yellow spotted with red, identifiable if one only had the right local knowledge. There are trees whose leaves are in bloom and pots with sprouting plants. On the left, there is a house with wall-hangings and on the right what seems to be a water tank from which a pipe descends irrigating a flourishing patch of green. One soon realizes that this story of a thriving home in a village rests above or immediately below a grey horizontal line. While exploring this beautifully rendered domesticated public space from side to side, one is also aware of an insistent pull on the eye downwards. This is compelled by dozens of tendrils that attach the colourful display above with red monochrome outlined images below: a dog, a mug, some jewellery, a framed photo, a basket, a floral bag spilling its treasures, some books and papers, a stray boot, a locked chest.

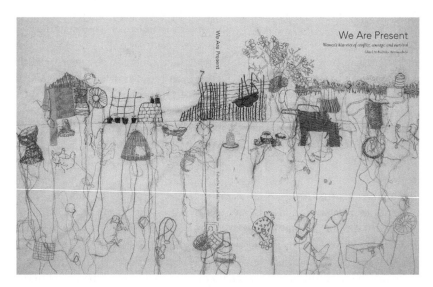

FIGURE 4.2 Hema Shironi, "Buried Alive Stories." Embroidery, 2020.

Source: From the cover of *We Are Present Women's Histories of Conflict, Courage, and Survival*. Courtesy of Radhika Hettiarachchi and with permission of Hema Shironi.

The embroidery was created by Hema Shironi in 2020 and she gave it the title "Buried Alive Stories." This is how she describes it:

> This is my grandmother's story. She was a mother of twelve children and she lost half of them to Sri Lanka's dark past of war and violence. One of her children has been missing for thirteen years. She is the sole witness to her children's lives, their existence and disappearance. Like her, many other mothers wait for the return of their loved ones. When my grandmother left her home in Kilinochchi during the war, she buried many things in the garden of her home. She left behind my grandfather's photographs, documents, jewellery and many other things that meant so much to her. She thought they would be safe in the ground until she returned a few weeks later. Weeks turned into months and in the end, it took her more than 20 years to return. When she did, many of the things she buried were no more or could not be found again. The earth had already swallowed up her memories. The objects may be lost forever, but her memories continue from generation to generation as a story.
>
> <div align="right">*We Are Present*, 2022, title verso</div>

The embroidery references two sources of knowledge about the past: objects and memories. Both tell stories, and the objects served both as containers of memory and memorial devices, evoking memories though a look, a touch, perhaps a smell. Although the objects had been swallowed by the history of the village since their burial, those memories were not, and were retold by her, to her daughter, and to Shironi, her granddaughter. On each telling, the memory archive was not only preserved, but renewed and refreshed; to borrow from Homi Bhabha's discussion of mimicry, the story is "almost the same, but not quite."[49] Stories that might have been buried but instead are still alive through being re-performed through oral history-telling. After reading the explanation one revisits the image with more emotions and imaginings. This is a story both of loss and gain. Was the animal at the bottom of the embroidery on the left a casualty of war? Was the framed picture the one and only photograph of a loved one? Are books a sign that once enjoyed classroom education had been denied?

Shironi's embroidery graces the cover of *We Are Present: Women's Histories of Conflict, Courage, and Survival* edited by Radhika Hettiarachchi. The book offers testimonies obtained through oral history projects capturing women's stories of the conflict between Tamil separatists and the Sinhalese-dominated government that engulfed Sri Lanka from 1983 until its bloody conclusion in 2009. This oral history storytelling is a form of

performance, re-telling, and re-living the past in the present, and it is done not only in words but also in movement, drawing, and mapping. Like oral storytelling, public art as public history practice is deeply emotional and sensory, for both the creators and their audiences.[50]

These performances – in the United States and Canada, in Ukraine and Britain, Haiti, South Africa, India, and Sri Lanka – are offered generously and at some personal cost in the hope that they will enhance historical understanding in the present and shape a better future. Undoing forgetfulness, these theatres of memory enable stories to be told so that they will not be lost. Experiences are shared in the hope that the living can learn from the past. These are quests of belonging, insisting on having one's place in history and for that to be known, recognized, and appreciated by others. Historians should both value and give credit to such public histories performed off the page as assiduously as they do histories written in more conventional forms. To do so not only acknowledges that "History is emotional. History is painful" and that while history is "made up of multiple perspectives . . . it can also be born out of emotions," it opens up new ways of doing that challenges the contention that good history can only be made through distanced objectivity.[51]

Notes

1 I draw here on Thomas Cauvin, Joan Cummins, David Dean, and Andreas Etges. "'Follow the North Star: A Participatory Museum Experience,' Conner Prairie, Fishers, Ind.," *Journal of American History* 105, no. 3 (2018), 630–36. Other scholars who have written about their experience include Ruth Laurion Bowman, "Troubling Bodies in *Follow the North Star*," in *Reframing Immersive Theatre: The Politics and Pragmatics of Participatory Performance*, ed. James Frieze (London: Palgrave Macmillan, 2016), 63–76; Scott Magelssen, "'This is a Drama: You Are Characters.' The Tourist as Fugitive Slave in Conner Prairie's 'Follow the North Star,'" *Theatre Topics* 16, no. 1 (2006), 19–34.
2 Johan Huizinga, *The Autumn of the Middle Ages* (Chicago: The University of Chicago Press, 2020); Johan Huizinga, *Homo Ludens: A Study of the Play-Element in Culture* (New York and London: Routledge, 1998); Lucien Febvre, "Sensibility and History: How to Reconstitute the Emotional Life of the Past," in *A New Kind of History From the Writings of Lucien Febvre*, ed. Peter Burke (New York: Harper and Row, 1973), 12–26. See also Rob Boddice and Mark Smith, *Emotion, Sense, Experience* (Cambridge: Cambridge University Press, 2020); Ute Frevert, "Affect Theory and History of Emotions," *Bloomsbury History: Theory and Method Articles*. Accessed October 18, 2021. https://doi.org/10.5040/9781350970878.069.
3 Adam Bencard, "Presence in the Museum: On Metonymies, Discontinuity and History Without Stories," *Museum and Society* 12, no. 1 (2014), 30 cited in Marzia Varutti, "The Affective Turn in Museums and the Rise of Affective Curatorship," *Museum Management and Curatorship* 38, no. 1 (2022), 61.
4 Vanessa Agnew, "History's Affective Turn: Historical Reenactment and Its Work in the Present," *Rethinking History* 11, no. 3 (2007), 301.

5 Juliane Brauer and Martin Lücke, "Emotion," in *The Routledge Handbook of Renactment Studies*, eds. Vanessa Agnew, Jonathan Lamb, and Julian Tomann (New York and London, 2020), 53.
6 Mark M. Smith, *Sensing the Past: Seeing, Hearing, Smelling, Tasting, and Touching in History* (Berkeley and Los Angeles: University of California Press, 2007); Rob Boddice, *The History of Emotions* (Manchester: Manchester University Press, 2018); Rob Boddice, *A History of Feelings* (London: Reaction Books, 2019); Boddice and Smith, *Emotion, Sense, Experience*.
7 Leonard B. Meyer, *Emotion and Meaning in Music* (Chicago: University of Chicago Press, 1956), 11.
8 Saam Tivedi, *Imagination, Music, and the Emotions: A Philosophical Study* (Albany, NY: State University of New York Press, 2017), 141. See also Malcolm Budd, *Music and the Emotions* (London: Routledge, 1985) for a critique of Meyer et al.
9 A convenient breakdown of Schubart is available in Rita Steblin, *A History of Key Characteristics in the Eighteenth and Early Nineteenth Centuries* (Ann Arbor: UMI Research Press, 1983), 121–26.
10 Elias Berner, "'Remember Me, But Forget My Fate' – The Use of Music in *Schindler's List* and *In Darkness*," *Holocaust Studies* 27, no. 2 (2021), 159. Mervyn Cooke, *A History of Film Music* (Cambridge: Cambridge University Press, 2008), 456–66 discusses Williams and his reinvigoration of nineteenth century symphonic music in (historical) films.
11 Albert Braz, "Singing *Louis Riel*: The Centennial Quest for Representative Canadian Heroes," *Canadian Review of Comparative Literature* 47, no. 1 (2020), 107–22; Paula Danckert, "Louis Riel: History, Theatre, and a National Narrative – An Evolving . . . Story," *University of Toronto Quarterly* 87, no. 4 (2018), 39–50.
12 Shannon Bower, "'Practical Results': The Riel Statue Controversy at the Manitoba Legislative Building," *Manitoba History* 42 (Autumn/Winter 2001–2002).
13 Peter Hinton, "Notes," Canadian Opera Company, *Louis Riel/Tosca* Program (Spring 2017), 9 reprinted as "Director's Notes," *University of Toronto Quarterly* 87, no. 4 (2018), 37–38.
14 Brian Cherney, *Harry Somers* (Toronto: University of Toronto Press, 1975), 131–40; Réa Beaumont, "Composer Harry Somers Adopts a Modern Tone *in Louis Riel*," Canadian Opera Company, *Louis Riel/Tosca* Program (Spring 2017), 14–15. The lullaby was based not on a Cree or Métis song, but on the "Song of Skateen," a Nisga'a mourning song that had been recorded by ethnographers and was appropriated by Somers for the opera. For the 2017 production, Nisga'a protocols were sought out and followed by the production company, Dylan Robinson, Wal'aks Keane Tait, and Goothl Ts'imilx Mike Dangeli, "The Nisga'a History of the 'Kuyas' Aria," *Canadian Opera Company, Louis Riel/Tosca* program (Spring 2017), 15.
15 Dean Jobin-Bevans, "The Complexity of Musical Influences From the Opera *Louis Riel*: Vocal Challenges and Performance Perspectives," *The Phenomenon of Singing* 5 (2005), 136.
16 Jobin-Bevans, "Musical Influences," 136.
17 Winton Dean, "The Performance of Recitative in Late Baroque Opera," *Music & Letters* 58, no. 4 (1977), 389–91; Margaret Murata, "The Recitative Soliloquy," *Journal of the American Musicological Society* 32, no. 1 (1979), 45–49.
18 Donna Doris Anne Zapf, "Singing History, Performing Race: An Analysis of Three Canadian Operas: *Beatrice Chancy*, *Elsewhereness*, and *Louis Riel*." PhD Dissertation, University of Victoria, 2004, 132–37.

19 Andrew Michael Zinck, "Music and Dramatic Structure in the Operas of Harry Somers," PhD Dissertation, University of Toronto, 1996, 51–55, 118–28.
20 Zinck, "Music and Dramatic Structure," 128–43.
21 Zinck, "Music and Dramatic Structure," 352–53.
22 Raymond Ericson, "'Louis Riel,' Music Drama, Presented in Toronto," *The New York Times*, September 25, 1967, 55.
23 Canadian Opera Company, media release *Louis Riel*. https://coc-learn-staging.coc.ca/about-the-coc/media?entryid=15316.
24 Michel-Rolph Trouillot, *Silencing the Past: Power and the Production of History* (Massachusetts: Beacon Press, 1995), xxiii.
25 Trouillot, *Silencing the Past*, 31.
26 Trouillot, *Silencing the Past*, 31–32.
27 Trouillot, *Silencing the Past*, 32–33.
28 Peter Cusack, *Sounds From Dangerous Places* (Berlin: ReR Megacorp and Berliner Künstlerprogamm des DADD, 2012), 28, 45.
29 Cusack, *Sounds From Dangerous Places*, 23.
30 Paul Gareau, speaking with Nisha Sajnani, "Coming into Presence: Discovering the Ethics and Aesthetics of Performing Oral Histories Within the *Montreal Life Stories Project*, in 'Oral History & Performance (Part I),'" *Alt. Theatre* 9, no. 1 (2011), 45.
31 Jo Salas, *Improvising Real Life: Personal Story in Playback Theatre* (New Platz, NY: Tusitala Publishing, 2013), 176.
32 Sajnani, "Coming into Presence," 44.
33 Sajnani, "Coming into Presence," 47.
34 Phelemo C. Hellemann, "Negotiating Public Participation Through Dance and Drama Techniques: A Roundtable Discussion on the Challenges of Public History Work by the Isikhumbuzo Applied History Unit in South Africa," *International Public History* 2, no. 1 (2019), 6 (n. 15).
35 Hellemann, "Negotiating Public Participation," 6 (conflating the words of Likhaya Jack and Masixole Heshu).
36 Hellemann, "Negotiating Public Participation," 6.
37 Sanjoy Ganguly, *Jana Sanskriti: Forum Theatre and Democracy in India* (London: Taylor and Francis, 2010), xiii.
38 Ganguly, *Jana Sanskriti*, 4; Sandra Mills, "Theatre for Transformation and Empowerment: A Case Study of Jana Sanskriti Theatre of the Oppressed," *Development in Practice* 19, no. 4–5 (2009), 550–59.
39 The scenario is set out in Ganguly, *Jana Sanskriti*, 27–31.
40 *Jana Sanskriti: A Theatre on the Field*, dir. Jeanne Dosse, 2005. https://edu-digitaltheatreplus-com.proxy.library.carleton.ca/content/interviews/jana-sanskriti-a-theatre-on-the-field.
41 Ganguly, *Jana Sanskriti*, 113–4.
42 Ganguly, *Jana Sanskriti*, 132.
43 Amy M. Tyson, *The Wages of History. Emotional Labor on Public History's Front Lines* (Amherst and Boston: University of Massachusetts Press, 2013), 98.
44 Tyson, *Wages of Living History*, 103–6.
45 Tyson, *Wages of Living History*, 100–1.
46 Amy MacDonald, "'Time Crossing Liaisons': Interpreter/Character Relationships at the Fortress of Louisbourg National History Site," MA Research Essay, Carleton University, 2015, 7. The discussion of MacNeil which follows is based on her account, 8–35.
47 James "Roy" MacNeil, quoted in MacDonald, "Time Crossing Liaisons," 18–19.

48 MacDonald, "Time Crossing Liaisons," 19.
49 Homi Bhabha, "Of Mimicry and Man: The Ambivalence of Colonial Discourse," *October* 28 (1984), 127.
50 Radhika Hettiarachchi, ed., *We Are Present: Women's Histories of Conflict, Courage, and Survival* (New York: International Coalition of Sites of Conscience, 2022). See also Radhika Hettiarachchi and Samal Vimukthi Hemachandra, "Memoryscapes: The Evolution of Sri Lanka's *Aragala Bhoomiya* as a People's Space of Protest," *International Public History* 6, no. 2 (2023), 75–90.
51 Hellemann, "Negotiating Public Participation," 6; Hettiarachchi, *We Are Present*, 11.

5
AUTHENTIC PERFORMANCES

Sombre music accompanies the puritan family as they leave the security of the New England plantation from which they have been banished. We have witnessed the hearing that led to this, the father refusing to accept the authority of the plantation's rulers, and now we feel the abandonment acutely by means of a pull-out shot that places us in the small cart looking backwards at what is being left behind before the gates close on us. Thus opens first-time director Robert Egger's *The VVitch: A New England Folktale* (2015), a historical horror film that was highly successful at the box office (grossing over ten times what it cost to produce) and was well-received by critics and viewers (an approval rating of over 90% on the website Rotten Tomatoes). It received a plethora of awards for the director and several of the actors, as well as for screenplay, art direction, sound editing, cinematography, production design, and costume design.[1] Critic Justin Chang wrote that the "fiercely committed ensemble and an exquisite sense of historical detail conspire to cast a highly atmospheric spell" which resulted in "a strikingly achieved tale of a mid-17th century New England's family's steady descent into religious hysteria and madness."[2]

In other words, Chang believed that those choosing to watch the film could look forward to an authentic experience of puritan New England. As a historian of early modern Britain myself, familiar with both primary sources about witches in this period (pamphlets, trial records, stage plays) as well as academic and popular literature written since, I too found the film to be convincing. It has become compulsory viewing for students taking my courses on witchcraft since it was released. Malcolm Gaskill, a leading authority on the subject, felt the same; in April 2023, he tweeted,

"Just watched Robert Egger's The Witch for the umpteenth time, and feeling more impressed than ever by how skilfully he makes the idea of witchcraft seem plausible, likely even, as god- and devil-fearing 17C folk are gradually overwhelmed by anxiety, conflict and domestic chaos."[3] The approval of such an eminent historian is not surprising, given that Eggers attributed his persuasive capturing of this elusive past in part to his deep reading of the primary sources.[4] As with most historical feature films and other types of historical performance (theatre, opera, re-enactments, video games) seeking to immerse audiences in time and space, emotionally as well as intellectually, accuracy in terms of production design and costume played a major role. Even the title follows the early modern English typographers use of *VV* rather than *W*.[5]

Linda Muir, who won the Las Vegas Film Critics Society 2016 award for best costume for her work on the film, researched deeply into the period. One of her sources was a website created for re-enactors on how hair was dressed in the seventeenth century, information that "turned out to be vital to the look of the film: not only was it accurate, it beautifully reflected the tightly bound up and covered beliefs that eventually unravel" in the film.[6] Muir then used the binding of hair and its loosening as a metaphor for shifts in normative gender roles and tidy, controlled spirits and minds (one is reminded of Shekhar Kapur's 1999 film *Elizabeth* in this regard, though in reverse as Elizabeth Tudor's unbound hair at the start of the time ends up tightly bound up in the construction of Gloriana).[7] Towards the film's end, the young woman of the family, Thomasin, her hair now wild and free, gathers the courage to speak to the goat who has been shadowing the drama throughout the film, named Black Phillip by the children. We are shocked and startled when he answers back, with a deep voice inviting her to sign his (the devil's) book if she wishes to "live deliciously" and see the world. If the audience's reading of the film to this point has seen the family as victims of excessive puritanism and its delusional world view, this event troubles that interpretation. *The VVitch* achieves authenticity in relation to its accurate depiction of individuals, family, society, and belief because it draws deliberately, extensively, and self-consciously on the original sources from that period. What makes Eggers achievement especially unique, however, is not only its careful attention to historical sources, re-creating and re-enacting what he discovered with such care, but its re-imagining of the *mentalité* of early modern society. The viewer is immersed emotionally and sensorially to such a degree that they question their own understanding of what has happened, and why: perhaps, after all, the devil really has been at work and explains all that has happened. *The VVitch: A New England Folktale*, challenges the boundaries between history and horror, the natural and the supernatural, true stories and those that get dismissed as mere

folktales. It opens up the complex issue of historical authenticity which will be discussed in this chapter with reference to a range of media including film, television, theatre, and living history re-enactments.

Historical Accuracy and Authenticity

Historians and public historians alike have generally assumed that if they are attentive to their primary sources, resting their interpretations on an accurate re-presentation of them, that the result will be an authentic representation of the past. If accuracy can be defined as being faithful to an original, authenticity references sincerity, credibility, and trustworthiness. While there is a tendency to use the terms interchangeably, or assume that they are interdependent, differentiating between them can be a productive way of thinking through performances of the past in the present. In the case study of Shakespeare's tragic history *King Lear* which follows, the relationship between accuracy and authenticity is seen as a relationship, a matter of negotiation, and achieving authenticity is shown to rest as much on being truthful to the contexts of a performance as on the need to be faithful to an original source. Distinguishing accuracy and authenticity resonates with the experiences of others who have struggled with the concept of authenticity in the context of performance, notably scholars and practitioners of early music, and of theatrical productions and performances in museums, living history museums, and historic sites.

The tensions between accuracy and authenticity were a feature of the 1970s and 1980s "historical performance movement" seeking authentic musical performances of past repertoires in the present. Associated most commonly with early music (medieval, renaissance, baroque), it also influenced scholars and musicians of the classical and modern periods, not to mention historians such as Collingwood.[8] Gary Tomlinson has identified two strains of thought among those involved. The first asserted that authenticity was achieved by recovering, as much as possible, what the composer or original creator intended and then faithfully recreating this through re-performance. The second took the view that "the authentic meaning of a work is the meaning we come to believe in the course of our historical interpretations its creators invested in it."[9] As Tomlinson notes, the second recognizes the constitutive and constructive role of the performer in these claims to authenticity. To put it another way, it recognizes the present in these performances of the past and invites a conversation about, as Richard Taruskin put it, "the pastness of the present and the presence of the past."[10]

The extensive literature on historical re-enactment likewise reveals two perspectives. On the one hand is the view that deep historical research and

a commitment to accuracy in replicating the event – be it Captain Cook's voyage, everyday life in Puritan New England, or staging the battle of Shiloh – creates an authentic historical experience for audiences. The success of such re-enactments depends on the degree of historical accuracy, even though it is acknowledged that the past – sailors' ignorance of the peoples they encountered, the unexpected deprivation of an eastern North American winter, or the filth and hunger of the ordinary soldier – cannot be fully represented, let alone experienced by those participating (either as performers or as witnesses) in these present-day performances.[11]

In a study of Danish re-enactors of the Iron Age, Middle Ages, Second World War, and the life of Francis of Assisi, researchers found that re-enactors were under no illusion that their time travelling was fully accurate nor a perfect simulation of those lived pasts. Authenticity, for them, was recognized as something "construed, interpreted and pursued in different ways in different situations."[12] The question of authenticity, and its relationship to accuracy, cannot then be answered in the abstract, but rather by looking at how it plays out in particular experiences such as English National Theatre's production of *King Lear* staged at a momentous time in settler-indigenous relations in Canada.

An Indigenous *King Lear*

In 2012, I was privileged to work as part of the first performance of a Shakespeare play at Canada's National Art Centre's (NAC's) performed by an all-Indigenous acting company.[13] This staging of *King Lear* was long time in coming. The idea was to perform Shakespeare straightly: faithful to the original script, to its author's intent, and to its dramaturgy (in so far as that is known). One approach would have been to offer a period production, setting the play in Elizabethan/Jacobean England. Another would have been to opt for an original practices production, seeking to replicate as much as possible the play as it would have been performed by Shakespeare's company. This would have meant setting it in ancient Britain, retaining the original language and pronunciation, and staging techniques such as using a thrust stage. In both cases, the production would be culturally and racially anonymous with the possibility that the Indigeneity of our acting company might disappear.

The decision was made then to set the play in the territories of the Algonquin Anishnaabe in the eastern woodlands of North America in the early seventeenth century and specifically in our own region, the unceded and un-surrendered territories of the Kitigan-zibi Anishinabeg First Nation, which had eventually become the site for the capital city of Canada. This temporal and spatial setting was a period of cultural conflict when

invading French and English settlers introduced new laws, new ideas, new ways of being, and new possibilities alongside land seizures, introducing destructive diseases, and adopting practices that we now recognized as cultural genocide. The first quarto of the play was printed in 1608, the same year that Samuel de Champlain was exploring the St Lawrence River. Artistic director Peter Hinton wrote that the goals of the production were "not to further a history of misrepresentation, but rather [to] bring a quality of inclusiveness to our History, and an often neglected cultural point of view to the performance of Shakespeare in Canada."[14] Operationalizing our goals of inclusivity and Indigenous perspectives required us to resolve tensions between Shakespeare's original text and our repositioning of it in seventeenth-century North America, decisions in which context outweighed strict adherence to the script. Dramaturgically, all references to horses had to go; movement was by foot or canoe. In terms of language, Shakespeare's references to Salisbury Plain and Camelot made no sense in our context and would simply confuse audiences, as would words such as coronets and sheepcotes. They were simply cut. Others were changed ("epicurism" to "gluttony" for example). On occasion, these decisions shed new light on the original as the following two examples will illustrate.

When Edmund reflects famously on the tendency of humanity to blame the heavens for our failings in Act One, Scene Two, he reveals his own birth sign: "My father compounded with my mother under the dragon's tail and my nativity was under Ursa Major, so that it follows I am rough and lecherous." Here was an opportunity to situate the play more firmly in our own landscape by altering and adding (additions in bold): "my nativity was under **The Great Bear**, Ursa Major **she called it**, so that it follows" (NAC English Theatre, King Lear script, 10). We thus created a new back-story for Edmund as Métis, the son of an English mother who taught him the Latin name for the constellation. This helped answer one of the dramaturgical questions every production of the play faces: what to make of Gloucester's comment to Kent at the opening of the play that Edmund had been away for nine years "and away he shall again"? Our script work suggested to audiences that he had been with his mother, being educated in European ways. Throughout the play, Edmund's costume reflected this mixed European heritage.

Our second example comes from Act One, Scene Four, which begins with the banished Kent returning disguised hoping to become Lear's servant. He enters with the words: "If but as well I other accents borrow / That can my speech diffuse, my good intent / May carry through itself to that full issue / For which I razed my likeness" (1.4.1–4). Shakespeare here plays on language as a marker of identity. Kent, a nobleman, must unlearn his normal speech and borrow the vocabularies and intonation of a servant

to "diffuse" or confuse his natural way of speaking. Only by so doing can he realize his ambition of fully erasing his former identity. For early modern English audiences, as indeed for those today, accent signified rank and status as well as geography, but in early modern Indigenous society this was not the case. We therefore changed Kent's linguistic signifiers into costumed ones (changes in bold): "If but as well I other **garments** borrow / That can my speech **disguise**, my good intent / May carry through itself to that full issue / For which I changed my likeness" (NAC English Theatre, King Lear script, 12). In our production it is Kent's new attire that replaces his former identity with the new; his lower-rank dress belies the aristocratic blood flowing in his veins; seeing Kent's new garments, Lear and his followers could believe Kent's desire to serve. This change brought an authenticity to Shakespeare's original envisioning of an ancient British past to his early modern audience. In early modern England, status was signified through clothing as well as language; who was able to wear what was carefully regulated. By being inaccurate (in the sense of not being faithful to the original text) but seeking authenticity for our chosen scenario, we found ourselves saying something authentic about the time of the play's writing.

Our production took place at a significant moment in settler-Indigenous relations in Canada. Public consultations of the Truth and Reconciliation Commission's enquiry into the experience and legacy of the residential school system were underway and the revelations that came almost weekly contributed to a growing realization that the Canadian state had practised policies, well into the 1990s, that could only be described as cultural genocide. Indigenous activists were making the continued legacies of those policies very visible. The Idle No More movement honoured Indigenous sovereignty and the obligations of all to the land and water, while campaigns sought justice for missing and murdered Indigenous women, for clean water in all Indigenous communities, and against corporations exploiting resources (often illegally). Ongoing land claims and disputes over unceded, un-surrendered territories, including some very close to where we were rehearsing and where our play would be staged, also shadowed and shaped our work.

Besides committing to realizing the long-desired goal of staging an Indigenous Shakespeare, a number of dramaturgical and design choices were made that addressed this contemporary context. Lear's knights (usually performed by members of the acting company hastily re-costumed) were reconceptualized as an Indigenous band of followers played by members of the local Indigenous community who workshopped the play as part of what was called the Four Nations Exchange with theatre practitioner Suzanne Keeptwo. They explored theatre practice through the Seven Grandfather's teachings (honesty, humility, respect, courage, wisdom, love, truth). Vastly

outnumbering the cluster of unruly knights in traditional productions, the dozen or so of Lear's followers not only gave a unique visible and aural credibility to Goneril and Regan's complaints but also drove home contemporary politics: one of the followers sometimes carried a Métis flag featuring a white infinity symbol on a blue background. As we saw with *Macbeth* discussed in Chapter 1, the experience of this production of *King Lear* revealed that contexts matter when thinking through the relationship between historical accuracy and authenticity.

Our re-telling of the story of Lear and his daughters, re-located to a world of clashing cultures (fatherhood, family, notions of property, relationships to the natural world etc.) in early modern Canada, carried a degree of authenticity because we adopted but adapted the original text and responded to both the new contexts in which we placed the play and our awareness of, and commitment to addressing, the troubled context of its present-day performance. As Sharon Macdonald has written with regard to a very different context, our claims to authenticity was "concerned with the truth to a disposition and to the story – and vantage point – that deserves to be told."[15] As Daniel Fischlin has observed in connection with adaptations of a Shakespeare original, authenticity "has less to do with 'undisputed origins' than with a form of self-fashioning that seeks autonomy in its relations to originary truth, value, or genuineness."[16]

Authenticity and Audience

Disengaging accuracy from authenticity has been a feature of recent scholarship on historical fiction. Katherine Harris argues that the deliberate use of anachronisms in neo-historical works, such as Sarah Waters evoking both Victorian and contemporary meanings of the word queer in her 1998 novel *Tipping the Velvet*, "accesses a 'truth' about the inescapable presence of the present when narrating the past."[17] A year before the novel's publication, Alex Cox took a similar approach when re-visioning the life of American soldier of fortune William Walker, who ruled Nicaragua in the 1850s. Scenes feature helicopter gunships and Mercedes-Benz cars, characters use zippo lighters and drink cola, and in one scene, a man riding in a carriage is reading *Newsweek* magazine whose cover features Walker as "Nicaragua's Liberator." *Walker: A True Story* insists audiences recognize the presence of the past (United States support for the dictator Somoza and the contras against the Sandinistas in the 1980s and continued destabilization of central America in the 1990s) in this re-staging of a nineteenth-century story. It makes an important historiographical point about the lethal consequences of the belief that the United States has a manifest destiny to govern the Americas in its own vision.[18] The deliberate

use of anachronism is a literary and filmic device that collapses historical distance and makes audiences not only reflect on both the past and the present but also provoke responses and actions that might shape their worlds moving forward.

Of course, this depends on audiences not dismissing such anachronisms as errors, howlers, or goofs. This troubled the director of *The Return of Martin Guerre*, ranked by academic historians as one of the best historical feature films ever made for which Natalie Zemon Davis served as historical consultant. The story, as we know from the earlier discussion in Chapter 2, concerns the sixteenth-century village of Artigat in the Pyreenes where a young Martin Guerre deserts his wife, Bertrande de Rols and their young child. When he returns he is very much changed and despite Bertrande's embracing him as her husband doubts are raised and eventually her prodigal husband is revealed to be an imposter, Arnaud du Tilh. In staging the story, Martin and Bertrande are married at a very young age, something Davis knew was inaccurate for the period when most newlyweds were in their early to mid-twenties. The film's director insisted, however, that audiences believed the veracity of the Romeo and Juliet story for this period of history; if not staged as young lovers, viewers would think it mistaken and this would compromise the film-makers commitment to capturing this event from early modern France as accurately as possible. Davis's suggestion that a minstrel could serenade the wedding guests with a song that remarked on how unusually young the bride and groom were went unrealized.[19] The story resonates with Laura Saxton's argument in her examination of accuracy and authenticity in Hilary Mantel's *Wolf Hall* and Peter Morgan's *The Crown*: a book's authenticity ultimately lies in "the audience's impression of whether it captures the past, even if it is at odds with available evidence."[20]

Hans-Theis Lehmann's influential notion of post-dramatic theatre identifies two ideologies competing to define the work of contemporary theatre: an interpretive rhetoric, in which performance is valued for its capacity to repeat, realize, and communicate the dramatic work to an audience, and a productive rhetoric, in which the theatre frames performance as an event, speaking not merely to the spectator but also through the spectator's agency in the performance.[21] The interplay between communicating to, and the agency of, audiences is especially present when those re-presenting past events inhabit the bodies of those who experienced those events first-hand.

Performing the Real

We are sitting in Salar's Afghan restaurant sipping tea and chewing on pita bread. We listen as Safi, a 35-year-old former literature student and refugee

from Syria reminds us that those joining us have travelled across the seas and across Europe to get "to safety, to our dreams. . . . People meet, sing, share stories of great journeys, stories of home."²² We are in Zhangal, the Jungle, and we, the audience, are fully immersed in this performance of lives lived in this migrant community on the outskirts of Calais. We want to comfort Salar when he hears the news of a young man's death trying to hitch a ride on a lorry to reach Britain, shout at the French police when they attack the café, and we occasionally glare at those observing at a distance, watching what is happening before their eyes replicated on television screens in front of them. They, like us, are theatre goers, but they sit in the balcony, beyond the cliffs of Dover; we are sitting on cushions, on benches. We are in the café. We are the café. We are migrants and refugees and volunteers. We were not assigned those roles as we entered the theatre through corridors lined with bedding and supplies for the café's kitchen. We chose them because the play has compelled us to do so, through our feelings, experiences, and imaginings. We have repositioned and reinvented our-selves in the bodies and experiences of others. We have embraced difference.

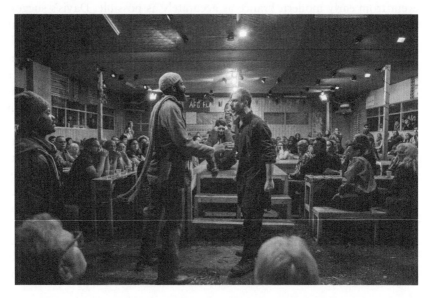

FIGURE 5.1 Mohammed (Jonathan Nyati, left) and Salar (Ben Turner) in *The Jungle* at the Curran, San Francisco, United States, April 5, 2019.

Source: Photo: Little Fang/Curran.

The Jungle, which ran at London's Young Vic, National, and Playhouse Theatres throughout 2017 and 2018, spoke to real issues, drew on verbatim and documented stories, and performance strategies associated with the Theatre of the Oppressed (Figure 5.1). Positioning the play in the traditions of applied, verbatim, documentary, and realist theatre places significance on the eight months writers Joe Murphy and Joe Robertson spent working with refugees in Calais. Their lived experience, and those with whom they shared time and space and whose stories they heard, ensured that audiences attending the play experienced something that was authentic. It was authentic not just because it reflected lives lived in an accurate way – grounded in those primary sources gathered during those eight months – but because the staging, lighting, sound, script, and spatial arrangements of the audience, each contributed in their own way to effectively place audiences in another space and another time which became, for them, the here and the now. Authenticity was also achieved through the actors, not only because of their training and experience which enables convincing performances that represent – re-present – others on stage, but because some of the actors were themselves migrants and refugees. Safi was played by Ammar Haj Ahmad, an actor trained in Damascus who ended up in Britain seeking asylum and who had lived in the Jungle and experienced first-hand the journeys to and from that refugee camp and of course life inside it.[23] Safi was essentially performing himself, re-living his life on stage. That this synergy can be experienced by actors re-presenting an even more distant past is evidenced by the experience of those performing the Paris Commune.

Peter Watkins's *La Commune – Paris, 1871*

The camera shows us desert sands as the narrator informs us that we are seeing an environmental disaster, the disappearance of Central Asia's Aral Sea. We learn that its waters evaporated in just over 30 years, sapped by irrigation canals that exposed what was left to the desert sun. A few moments later, we are watching beautiful facades of buildings in central Paris drift past us, floodlit by the tourist boat that is our vantage point, beginning with the Cour de Cassation, the supreme court. "There is sand here too," the narrator tells us, "Petrified in these facades, hardened into the touchstones of a history that is about forgetting. Frozen in the lights of tour boats is a flesh and blood history. Stories of courage, hope, sacrifice and honour are being whispered once again in the streets of Paris."[24]

So begins Geoff Bowie's documentary about the making of Peter Watkins's historical docudrama, *La Commune – Paris, 1871*. Non-professionals who acted in *La Commune* found it to be an experience that collapsed

historical distance in a deeply personal way. A social worker reported that she thrived doing the research into her character for almost two months and appreciated that every actor/character would have their own story. She tells us that a common question among the actors was whether the Commune would be possible today, and that she thought not because the social work system of which she was part was designed to prevent such an uprising (26:15–28:58). A special education teacher, who joined the cast with her son, noted: "It's up to us to figure out what we're going to say. They set the mood of a scene, and it's up to us to speak – to give it our best" (33:30–36:47). Another shares a thought that seems to be held by many of those participating in the film, that while they don't have much optimism that society will change, the film gave them an opportunity "to express ourselves and do something" (57:52–58:47).

In Bowie's film, we witness an Algerian immigrant, who arrived in Paris at the age of one and has always lived in its suburbs and who had lost his papers, discuss how to capture their (Communard) experience of alienation, suffering, and marginalization that has led them to conclude that it would be better to die by firing squad fighting against injustice than dying a slow death, "quietly within." For him, the experience taught him to stop living "outside myself, shut out from myself" (49:23–55:53). For another, Renaud, acting in the film connected him physically and spiritually to his great uncle Louis Coquillet, a communist and resistance fighter, who was executed by the Germans during the Second World War (59:20–1:02:57). For the Algerian what must have been a special moment came up in the film when Watkins decided to include the story of the crushing of the Algerian resistance to French rule immediately after the Commune was defeated, members of both revolts ending up being exiled to New Caledonia. "This history as well as the issue of the rights of illegal immigrants is why we're introducing this group," he told the company (52:16–53:20).

Watkins shared authority with over 200 non-professional actors "inviting them to become creative participants in television . . . over three months they blow on the ashes of their ancestors to illuminate the present," Bowie tells us as we watch Watkins run around the set gesturing at the actors encouraging them to react spontaneously to what is happening around them (07:04–07:12; see also 1:02:57–1:04:05). Armand Gatti, of La Parole Errante Theatre in Paris, spoke to the non-professional actors of the "fantastic adventure" they are about to embark on, working with a director who resists conventions and fights against the system (3:10–3:40). "You are not merely extras in a re-enactment," he tells them, "You are creators, active participants in an ongoing battle. A battle where you become the sequel." Moved by the revolutionary sounds and actions he hears living close by the rehearsal space, Gatti later reveals that he now believes that it does not matter that the Commune was defeated, but that it "is still with us" (1:07:18–1:08:24).

For Watkins, the history of the Paris Commune remains open-ended, because its aims, ambitions, and reforms in the hope of creating a better future were crushed almost as soon as they began (05:16–05:21). The director of *Culloden* believes film to be "a social act, a political act, a human act of work, love and communication." (00:11). For Bowie, the grains of sand remind him of pixels, and he reflects that at one time making a documentary "was about seizing reality and commitment to social change," but now it feels more like a deception. A major reason for this is the "universal clock" of the television industry that limits broadcast time to 47.5 minutes for a standard hour and 23.5 minutes for a half-hour with commercials (29:27–29:32), whereas Watkins's *La Commune* ran for some six hours. The filmic languages he employs are those of the everyday: long takes (over ten minutes) and hand-held cameras (08:12). Watkins tells the actors to look directly at the camera if it is in front of them so that it does not create an unnatural distance between them and the viewer (8:39–8:52) and he uses anachronistic scenarios such as staging a news programme type interview with experts about the Commune (29:32–32:35) to make the past, present. One of the few professional actors in the production tells Bowie, "This is an amazing way to learn history. In the sense where history serves as a memory to understand what's going on now." The younger people involved she thought would remember the commune for their whole lives because they had participated physically in research, deciding "what to say, how to say it, when it would take shape, what actions we might take in the Commune, and today" (11:05–11:45).

Performing Real People

How do professional actors play the real? Do they draw on real-life experiences of their own to shape their re-presentations of people who have lived – some now dead, some still alive – on stage? Most start by immersing themselves in original sources such as biographies, letters, diaries, photographs, newsreels, films) and reading biographies, and secondary sources. Henry Goodman who played Sigmund Freud says that research "liberates the creative instincts: you can't create a performance by reading books about things, but you can get assurance, comfort and support as well as new ideas for instincts that may have come to you from the script."[25] Goodman was one of the many actors British actors interviewed by Tom Cantrell and Mary Luckhurst almost all of whom reveal how much they enjoy researching the characters they are portraying. At some point, though, as the actor Michael Pennington observes, the research has to end because

> you can become obsessed by historical reality and lose your connection with the fictional world of the drama. . . . All that research gives you

support and one would hope authenticity, but a historical narrative is not the same as a dramatic one.[26]

Thinking about his role as the king in Alan Bennett's play *The Madness of George III* Pennington notes that because very little is known about what George III spoke like or how he walked, he felt liberated from "the worry about historical accuracy"; his research served "to reassure myself that I was authorised to play the part. . . . You want to be legitimate. You want to be able to defend what you have done should you need to."[27]

For Ian McKellen, being precise about the physicality of the real person is key: getting one characteristic is enough so that "you can use your actor's imagination and apply it to the rest of your body and to their mind."[28] Research by actors also involves visiting spaces and places inhabited by those they are portraying and also embodying actions. In order to play Mozart, Simon Callow learned a small minuet and the overture to *La Nozze de Figaro* and he taught himself engraving to play the printer Marcantonio Raimondi discovering how he used his hands which would have been always covered in ink. Such actions help ground Callow in the real worlds of Mozart and Raimondi, but "As an actor I still had to find a truth in it, the emotional context."[29] Most of the actors interviewed by Cantrell and Luckhurst rejected the notion that they are engaged in impersonation, but Siân Phillips describes her playing real people as involving a degree of imitation.[30] Here, of course, is where actors turn to teachers such as Konstantin Stanislavski and Michael Chekhov in creating characters, building roles, and acting strategies (Callow mentions Chekhov's notion of "'psychological gesture,' which means a gesture which cystallises the central essence of a character" as being particularly helpful).[31]

Bodies also perform, transmitting meaning to audiences. In *And for Today . . . Nothing* (1972), the British performance artist Stuart Brisley immersed himself for two hours a day for two weeks in a bathtub filled with dark water beside which was a rotting pile of offal, staging Jacques-Louis David's famous painting of the death of the French revolutionary Jean-Paul Marat, murdered by Charlotte Corday while taking a medicinal bath. While in the painting we see Marat as both living writer and murder victim, for Sanja Perovic, "the timeframes of life and death that David's painting arguably collapses" are disrupted in Briseley's performance.[32] Similarly, Jerome de Groot shows how effectively Howard Brenton employs bodies (and hauntings) as a canvas for making historiographical arguments in *Anne Boleyn* (2011).[33]

As well as Stanislavskian and Chekhovian techniques, rehearsal strategies for the actors in Out of Joint's 2005 production of *Talking to Terrorists*, written by Robin Soans and directed by Max Stafford-Clark, included "hot-seating," where the actors, having conducted interviews (and

sometimes re-interviewing), recreate interviewees' responses as other company members pose the original interview questions to them.[34] The director asked the actors what the interviewee said, asking them to "just do that," and then they are asked further questions and are expected to answer as the character, shifting from third-person re-enactment to first-person.[35] Re-creation, simultaneous re-enactment, and imitation are means to establish character but also grant, as Pennington put it, legitimacy and authorization. Giving permission, or feeling one has permission, to re-present real people, living or dead, is an ethical issue that troubles many actors (of whatever genre) and those who deliberately aim to re-enact the past with as much veracity as possible hoping that they, and their audiences, will participate in and witness an authentic recreation.

When history and performance intersect, theatre scholar Freddie Rokem suggests, actors can connect the historical past with its performance in a later present:

> they become a kind of historian, what I call a "hyper-historian", who makes it possible for us – even in cases where the reeneacted events are not fully acceptable for the academic historian as a "scientific" representation of that past – to recognize that the actor is "redoing" or "reappearing" as something/somebody that has actually existed in the past.[36]

Acting becomes the embodiment of history, and the theatrical energy of performed history creates spaces where the real meets its representation although never becoming the real that actually happened. For Rokem, the spectators "create the meanings of a performance, by activating psychological, social, and even supernatural energies."[37]

As we have seen one of the greatest concerns of actors when tasked with portraying real people is getting it right. While conducting deep research, sharing it with other cast and members of the creative team, reporting and recreating through hot-seating and other theatrical strategies each play a vital role in shaping the actor's performance, at the end of the day whether audiences find the performance convincing is the ultimate test. Joseph Mydell, who played Robert Mugabe in a production of Fraser Grace's play *Breakfast with Mugabe* in 2005, deliberately dressed as differently as possible from Mugabe to create some distance between himself as actor and the character. Yet, after one performance one of Mugable's nieces approached Mydell and told him "You are just like him, just like him, the way you move your hand and everything it is just like him" and was going to encourage other family members to attend the show.[38]

The ultimate test perhaps is when the person being portrayed witnesses the performance. Anti-apartheid activist Albie Sachs witnessed himself on stage in a 1988 performance of David Edgar's *The Jail Diaries of Albie*

Sachs at the Young Vic in London. Not only was Sachs himself there (and this was known to the audience as he was scheduled to speak after the performance) but so too was his mother, ex-wife, and children. Four actors who had played him in previous productions were on stage, one fulfilling that role, the other playing policemen. Sachs's notes that the event (held as a fundraiser after he had been seriously injured by a bomb planted by the South African police) had an intense theatricality:

> The audience will wonder as they see the person representing me how I am identifying with him, and will also be trying to imagine how the actor [Matthew Marsh] feels knowing that I am watching him playing me. In fact it is even more complicated, because I know that he will be wondering how I feel about his representation of me, and he knows that I know, and we both know that the audience will be wondering about how we feel about knowing that we each know about the other knowing . . . and so on and so on.[39]

Sachs writes that he forgot his own experience; he was "just a spectator, ready to laugh and be moved." He was pleased that the Marsh succeeding in moving the audience and holding their attention, but at one moment the distancing between self and spectator dissolves:

> the actor is sitting down quietly, and I am staring at him, evoking the memory of endless hours on the floor, looking at my feet, the wall, my feet again, only now I am thrilled that the device I imagined is working, the silence is stirring up the audience and I, who knew nothing about drama except what I liked, have helped create a distinct and memorable theatrical moment.

One of Sachs's survival strategies during prison and torture was to imagine he would one day write a play about being in jail, that it would be put on in a London theatre, and at one point in the play, he would ask the audience to just look for three minutes in utter silence.

The explosion had cost him one of his arms and so Sachs cannot clap and join in the applause. This was a moment where he felt excluded from the audience, no longer a spectator, rather he is in a London theatre witnessing himself, in as convincing a performance as Marsh (and perhaps Sachs himself) might have hoped for. In the end, on stage, Sachs leads a rapturous applause by clapping his one hand against his cheek, introducing the audience to his mother and family and another prisoner, Dorothy Adams, who was also present and who came up to Sachs during the interval. Adams had sustained Sachs in prison by whistling back to him the "Going Home"

theme from Antonin Dvořák's New World Symphony. This on-stage emotional reunion undoubtedly offered reassurance to the audience that what they had witnessed on stage was truthful storytelling. It was a celebratory and performative version of feedbacking – testing authenticity by asking the storyteller what they felt about the performance. As we saw in the previous chapter, this theatrical strategy has played a vital role in shaping more traditional theatrical productions based on oral histories as well as playback theatre.

Living Histories

Those acting in living history performances and historical re-enactments are perhaps the most assiduous is seeking historical accuracy and assuming that this will guarantee authenticity. For Richard Handler and William Saxton, "An authentic piece of living history is one that *exactly* simulates or re-creates a *particular* place, scene, or event from the past."[40] Manuals and instructions for those choosing careers as living history interpreters at historic sites, animating the past for visitors, are tasked with performing their roles according to "the same rules of validation and criticism as the work of professional historians" as one site historian in charge of living history performances at Fortress Louisbourg in Cape Breton, Nova Scotia, Canada, put it.[41]

The degree to which such living history performers have the freedom to deviate from scripts and training manuals varies. They play games to get them through the workday, but uniquely at living history sites, these games often focus on authenticity, with interpreters trying to outdo each other with the accuracy of their costumes, accessories, or actions. This playfulness can, however, turn into a Foucauldian world of self-discipline and surveillance, where autonomy, spontaneity, and unauthorized scenarios are policed. Amy Tyson tells the story of how she decided to exercise a degree of creative interpretation by creating a scenario where as a domestic servant serving dinner to an officer, she had forgotten to put her shoes on and decided that rather than go back for them she would play it out: "I was exercising the creative autonomy that I had come to value at this job by playing a workplace game with an unpredictable outcome."[42] Anticipating that perhaps the officer would notice and she would be chastised for her improper dress, this did not happen. Later, however, having seen a photograph taken by a visitor, one of the lead guides did criticize her performance as lacking authenticity, creating a sense of shame.

Living history is both a movement and a practice that seeks to simulate how lives were lived in the past. The impulse to embody the past in the present through performance, re-storying the past through poetry, prose,

drama, dance, music, or ritual, is a shared human experience, found in all cultures and at all times. As a movement, however, living history is conventionally traced to European open-air folk museums in the late-nineteenth century and can be seen as part of the larger project associated with other disciplinary impulses associated with governmentality such as museums, world fairs, libraries, and shopping malls and have since become a global phenomenon.[43] Seeking to re-enact past lives by practising everyday activities, using first-person interaction with visitors, living history is a self-conscious attempt to represent past lives as they were actually lived. Although aware of the limits of historical knowledge and the inability to fully capture the experience of the dead through the simulations of the living, practitioners and advocates of living history often make claims that participating in these re-enactments closes historical distance enabling visitors to feel like they have stepped back in time.

In his reflections on "resurrectionism," British historian Raphael Samuel observed that living history assumes "events should be re-enacted in such a way as to convey the lived experience of the past."[44] Performing in the first person is considered to be the "purest" way of achieving this goal and practitioners have been especially preoccupied with accuracy and authenticity, usually conflating the two or assuming that the first ensures that visitors will experience the second.[45]

First-person interpreters adopt a role, usually of a known person from the period and who has a certain relationship to the historic site, and are usually age, race, and gender appropriate. First-person interpreters wear clothes that are newly made but contemporary to the time their adopted persona lived. Their bodies are situated in spaces that are as close to the original as possible, they use objects that are authentic reproductions or originals in their daily activities, and try to replicate original movements, gestures, and actions. First-person interpreters speak in the present tense and refer to themselves as "I," using only period-appropriate accent, intonation, and vocabulary and many experience it as empowering.[46] First-person interpretation is the closest form of living history performances to actors on stage.[47]

Researchers who have conducted interviews with re-enactors at living history sites or who have participated in re-enactments themselves have observed that the pursuit of historical accuracy varies. All re-enactors conduct research, or draw on research carried out by interpretative planners, and focus their attention on getting the look of the past right. This is generally achieved by turning to original sources for information about appearance, materiality, and behaviour. Yet, as historians who have studied living history performances at Plimouth Patuxet Plantation and Historic Fort Snelling discovered, sometimes manuals offered to living history trainees

contain secondary sources – modern historian's interpretations – without distinguishing them from period sources. In effect, living history interpreters enact scenarios in which archive (source) and repertoire (performance) have become entangled.

When it comes to manufacturing clothing or accessories, some living history re-enactors will insist on using only original materials and methods, while others will compromise as they see fit or as their own needs might require. Scholars of American Civil War re-enactors uncovered tensions between "hardcore" re-enactors – those who were willing to go to any extreme to capture perceived historical accuracy (such as using real blood or reshaping their bodies to mirror bloated corpses) – and "farbs" – re-enactors able and willing to permit elements of their own contemporary lives to intrude in their performances of the recreated past.[48]

Visitors also have a role to play in this adventure in time travel: they are seen by interpreters as coming from another place concurrent with the time period, not from the future. The purpose of first-person interpretation is to capture the audience's imagination, to make them feel as if they are witnessing everyday life as if they were really present in the past. Although on occasion, visitors might engage in activities to be taught certain skills or assist with certain tasks, interactions between interpreters and visitors at sites that adopt first-person interpretation are generally verbal, usually taking the form of question and answer, becoming conversational on occasion. Through first-person interpretation, rendering historical accuracy as much as is possible in appropriate spaces, living history re-enactment navigates historical distance by collapsing past and present. This past/present performance event is fixed in a specific time and space, performed by those who are committed to embodying the past through dress, language, gesture, and action. During the performance event, re-enactors are living past lives somatically and living them anew.

Historical distance is experienced differently in another performance strategy adopted by living history sites: third-person interpretation. Rather than playing a particular historical role, third-person interpreters act as informed guides to past lives lived. They may be situated in actual or reconstructed historical spaces, and they may be in period costume, but they are under no obligation to move, act, or speak in a time-bound fashion. They speak of the past using past tenses and are free to make observations about the past and engage fully with what happened between the past that is being represented and the current day shared by interpreter and visitor. Indeed, the point of third-person interpretation is to engage visitors in discussion about the similarities and differences between past and present. Not only do visitors learn something about the past, but they are able to think critically about the present by situating themselves momentarily

in the past. Tyson notes that at Fort Snelling, the shift from first-person to a modified form of third-person interpretation enabled stronger telling of painful histories.[49]

Although living history re-enactments most commonly take the form of either first- or third-person interpretation (and it is not unusual for the same site to use both strategies) they have always had an element of the hands-on, learning from doing approach known as second-person interpretation. Conventionally this involves visitors trying out a particular activity be it firing a musket, churning butter, or ringing church bells, all under the careful observation and instruction of an interpreter. They may even engage a first-person interpreter in conversation by themselves acting the role of someone from the appropriate period. This participatory form of living history allows visitors a degree of agency, albeit limited and constrained because the experience is carefully designed for them. As we saw with the discussion on performing the role of fugitive slaves in the highly structured and curated living history experience at Connor Prairie in Chapter 4, visitor agency is limited. Where there is a greater degree of agency, scholars have argued that there is a corresponding increase in the levels of historical consciousness and historical understanding.[50]

There are many motivations that drive individuals and families to participate in living history re-enactments. Some play roles from the past or visit the past as a form of escapism from the present, a therapeutic response to the trials, tribulations, and traumas of daily life. As well as learning about the past and developing new skills, many of those interviewed by researchers speak of living history permitting them to explore emotions and feelings that otherwise would be elusive. Others reference the satisfaction gained by indulging nostalgic urges, or that locating themselves in another time and space gives them a sense of belonging and community.[51] In re-creating (and acting out) their experiences as miners and police during the 1980s' miner's strikes in Orgreave, South Yorkshire, England, re-enactors experienced synergies between past and present like some of the actors performing in *The Jungle* and *La Commune*.[52]

Even hardcore re-enactors know that as much as they strive for authenticity by using methods, materials, and actions that would have been used by those whose lives and experiences they are re-enacting, with as much fidelity to the past as is possible, that ultimately closing historical distance is a matter of negotiation and degree. Since the past can never be fully and completely recovered – in re-enactment as in all other forms of media – authenticity is achieved when creators, actants, and audiences experience it as such.[53]

Notes

1 "The Witch: A New-England Folktale." https://www.imdb.com/title/tt4263482/awards/.
2 Justin Chang, "Film Review: 'The Witch,'" *Variety*, January 23, 2015. https://variety.com/2015/film/reviews/sundance-film-review-the-witch-1201411310/.
3 Sarah O'Malley, "Witches in Space: An Introduction," *Early Theatre* 26, no. 2 (2023), 131.
4 Chris O'Falt, "How Robert Eggers Used Real Historical Accounts to Create His Horror Sensation The Witch," *IndieWire*, February 19, 2016. http://www.indiewire.com/2016/02/how-robert-eggers-used-real-historical-accounts-to-create-his-horror-sensation-the-witch-67882/.
5 Goran Proot, "Miracles Latey Vvrovght: The Use of 'vv' for 'w' in 17th-Century Titles." https://www.folger.edu/blogs/collation/miracles-lately-vvrovght-the-use-of-vv-for-w-in-17th-century-titles/.
6 Matthew Toffolo, "Interview With Costume Designer Linda Muir (The Witch, Bitten)." https://matthewtoffolo.com/2016/02/21/interview-with-costume-designer-linda-muir-the-witch-bitten/.
7 David Dean, "Staging the Settlement: Shekhar Kapur and the Parliament of 1559," in *Managing Tudor and Stuart Parliaments: Essays in Memory of Michael Graves*, ed. Chris R. Kyle, *Parliamentary History* 34, no. 1 (2015), 30–44.
8 See Kate Bowan, "R.G. Collingwood, Historical Reenactment and the Early Music Revival," in *Historical Reenactment: From Realism to the Affective Turn*, eds. Iain McCalman and Paul A. Pickering (Basingstoke, Hants: Palgrave Macmillan, 2010), 134–58.
9 Gary Tomlinson, "The Historian, the Performer, and Authentic Meaning in Music," in *Authenticity and Early Music: A Symposium*, ed. Nicholas Kenyon (Oxford: Oxford University Press, 1988), 117.
10 Richard Taruskin, "The Pastness of the Present and the Presence of the past," in Kenyon, *Authenticity and Early Music*, 137–207.
11 Vanessa Agnew, "History's Pure Serene: On Reenacting Cook's First Voyage, September 2001," in *Staging the Past: Themed Environments in Transcultural Perspectives*, eds. Judith Schlehe, Michiko Uike-Bormann, Carolyn Oesterle, and Wolfgang Hochbruck (Bielefeld: Transkript, 2002), 205–18; Tony Horwitz, *Confederates in the Attic: Dispatches From the Unfinished Civil War* (New York, NY: Vintage Books, 1998); Scott Magelssen, *Living History Museums: Undoing History Through Performance* (Lanham, MA: The Scarecrow Press, 2007); Stephen Eddy Snow, *Performing the Pilgrims: A Study of Ethnohistorical Role-Playing at Plimoth Plantation* (Jackson, MS: University of Mississippi Press, 1993).
12 Anne Brædder, Kim Esmark, Tove Kruse, Carsten Tage Nielsen, and Anette Warring, "Doing Pasts: Authenticity From the Reeanctors' Perspective," in *Authenticity: Reading, Remembering, Performing*, ed. Patrick Finney (London and New York: Routledge, 2019), 54.
13 What follows is drawn from David Dean, "Negotiating Accuracy and Authenticity in an Aboriginal King Lear," *Rethinking History* 21, no. 2 (2017), 255–73 republished in Finney, *Authenticity*, 125–43.
14 Peter Hinton, email to the National Art Centre's English Theatre Company performing King Lear, February 21, 2012 (author's possession).
15 Sharon Macdonald, *Memorylands: Heritage and Identity in Europe Today* (London and New York: Routledge, 2013), 118.

16 Daniel Fischlin, "Nation and/as Adaptation: Shakespeare, Canada, and Authenticity," in *Shakespeare in Canada: 'A World Elsewhere'?*, eds. Diana Brydon and Irena R. Makaryk (Toronto: University of Toronto Press, 2002), 325.
17 Katherine Harris, "'Part of the Project of the Book Was Not to Be Authentic': Neo-Historical Authenticity and Its Anachronisms in Contemporary Historical Fiction," in Finney, *Authenticity*, 76.
18 https://www.imdb.com/title/tt0096409/?ref_=fn_al_tt_4.
19 Personal communication, June 1, 2010, post round-table on "Theatre, History, Storytelling" with Natalie Zemon Davis, David Fennario, Edward (Ted) Little, and David Dean, Canadian Historical Association Annual Conference, Concordia University, Montreal, Canada. See also Natalie Zemon Davis, "'Any Resemblance to Persons Living or Dead': Film and the Challenge of Authenticity," *Historical Journal of Film, Radio and Television* 8, no. 3 (1988), 269–83 and "Movie or Monograph? A Historian/Filmmaker's Perspective," *The Public Historian* 25, no. 3 (2003), 45–48.
20 Laura Saxton, "A True Story: Defining Accuracy and Authenticity in Historical Fiction," *Rethinking History* 24, no. 2 (2020), 128.
21 W. B. Worthen, *Shakespeare Performance Studies* (Cambridge: Cambridge University Press, 2024), 7.
22 Joe Murphy and Joe Robertson, *The Jungle* (London: Faber & Faber, 2017), 36.
23 Joe Gill, "From the Jungle to the West End: 'It's Not About Refugees, It's About Humans," *Middle East Eye*, July 20, 2018. https://www.middleeasteye.net/features/jungle-west-end-its-not-about-refugees-its-about-humans; Playhouse Theatre (London), *The Jungle* program, October 2018.
24 Geoff Bowie, dir., *The Universal Clock – The Resistance of Peter Watkins* (National Film Board of Canada, 2001), 00:00–02:26.
25 Tom Cantrell and Mary Luckhurst, eds., *Playing for Real: Actors on Playing Real People* (Basingstoke, Hampshire: Palgrave, 2010), 74.
26 Pennington, *Playing for Real*, 128.
27 Pennington, *Playing for Real*, 134.
28 McKellen, *Playing for Real*, 101.
29 Callow, *Playing for Real*, 44.
30 Cantrell and Luckhurst, *Playing for Real*, 11–12, 18; Phillips, *Playing for Real*, 139–40.
31 Callow, *Playing for Real*, 46. See also Joseph Mydell's discussion of learning to play Robert Mugabe, Joseph Mydell, *Playing for Real*, 118–120.
32 Sanja Perovic, "Dead History, Live Art: Encountering the Past With Stuart Brisley," in *Authenticity*, ed. Finney, 146.
33 Jerome de Groot, *Remaking History: The Past in Contemporary Historical Fictions* (New York and London: Routledge, 2016), 204–11.
34 Tom Cantrell, *Acting in Documentary Theatre* (Houndmills, Basingstoke, Hampshire: Palgrave, 2013), 15–53.
35 Cantell, *Acting in Documentary Theatre*, 34–35.
36 Freddie Rokem, *Performing History: Theatrical Representations of the Past in Contemporary Theatre* (Iowa City: University of Iowa Press, 2000), 13.
37 Rokem, *Performing History*, 192; Freddie Rokem, "Angels of History: A Reconsideration of the Actor as a 'Hyper-Historian,'" in *Geschichte im Rampenlicht. Inszenierungen historischer Quellen im Theater*, eds. Thorsten Logge, Eva Schöck-Quinteros, and Nils Steffan (Berlin: De Gruyter Oldenbourg, 2021), 27–47.
38 Mydell, *Playing for Real*, 121.

39 Albie Sachs, *The Soft Vengeance of a Freedom Fighter* (Oakland: University of California Press, 2014), 180.
40 Richard Handler and William Saxton, "Dyssimulation: Reflexivity, Narrative, and the Quest for Authenticity in 'Living History,'" *Cultural Anthropology* 3, no. 3 (1988), 243.
41 MacDonald, "Time Crossing Liaisons," 17.
42 Tyson, *Wages of Living History*, 131–32.
43 David Dean, "Living History," in *The Routledge Handbook of Reenactment Studies*, eds. Vanessa Agnew, Jonathan Lamb, and Juliane Tomann (London and New York: Routledge, 2020), 120; Bennett, *The Birth of the Museum*.
44 Raphael Samuel, *Theatres of Memory, Volume 1: Past and Present in Contemporary Culture* (London: Verso, 1994), 176.
45 See Stephen Gapps, "On Being a Mobile Monument: Historical Reenactments and Commemorations," in *Historical Reenactment*, eds. McCalman and Pickering, 50–62; Richard Handler and Eric Gable, *The New History in an Old Museum: Creating the Past at Colonial Williamsburg* (London and Durham, NC: Duke University Press, 1997); and Snow, *Performing the Pilgrims*.
46 Anne E. Birney and Joyce M. Thieren, *Performing History: How to Research, Write, Act, and Coach Historical Performance* (Lanham, MD: Rowman & Littlefield, 2018), 44.
47 Ashlee Beattie, "Interpreting the Interpreter: Is Live Historical Interpretation Theatre at National Museums and Historic Sites Theatre?" EXARC 2 (2014). https://exarc.net/issue-2014-2/int/interpreting-interpreter-live-historical-interpretation-theatre-national-museums-and-historic-sites.
48 Horwitz, *Confederates in the Attic*; Schneider, *Performing Remains*.
49 Tyson, *Wages of History*, 160–65.
50 Magelssen, *Living History Museums*; James Walvin, "What Should We Do About Slavery? Slavery, Abolition and Public History," in *Historical Reenactment*, eds. McCalman and Pickering, 63–78.
51 Katherine Johnson, "Performing Pasts for Present Purposes: Reenactment as Embodied, Performed History," in *History, Memory, Performance*, eds. David Dean, Yana Meerzon, and Kathryn Prince (Basingstoke, Hants: Palgrave Macmillan, 2015), 36–52.
52 Katie Kitamura, "'Recreating Chaos': Jeremy Deller's *The Battle of Orgreave*," in *Historical Reenactment*, eds. McCalman and Pickering, 39–49.
53 Vanessa Agnew and Juliane Tomann, "Authenticity," and Stephen Gapps, "Practices of Authenticity," in Agnew et al., *Routledge Handbook of Reenactment Studies*, 20–24, 183–86. See also Na Li, "Performing History in China: Cultural Memory in the Present," *International Public History* 5, no. 2 (2022), 137–38.

6
"THE CAT ATE MY BANNOCK" AND OTHER STORIES

It was towards the end of April and we had gathered in the Ojigkwanong Indigenous Student Centre at Carleton University for the first performance of the day. Designed in 2013 by renowned Indigenous architect Douglas Cardinal, the Centre's name means morning star. It was chosen on the recommendation of Kitigan Zibi, the First Nation whose territory our university occupies because it was the spirit name of Algonquin Elder William Commanda. As a first-generation settler-Canadian, who had returned to Canada in 1996 after many years away, I'd first learnt about the morning star's significance in Indigenous culture through the extraordinary work of that name by Denesuline artist Alex Janvier. It adorns the interior of the dome in the Haida Gwaii Salon at the Ottawa river end of what was then the Canadian Museum of Civilization and is now the Canadian Museum of History. The morning star, the guide and way of finding direction, is at the heart of a work that, in Janvier's words, tells "the story of the way things happened to me and to my tribe and to my people and it's a true story."[1] It seemed appropriate that after a semester of readings, discussions, and workshops around history, public history, and performance, our final day of performance events would begin here.

Liane Chiblow had originally thought of sharing an Anishinaabe creation story with us, perhaps even one of those her mother had read to her every night before bed. Inspired by traditional storytelling "as acts of resurgence and revitalization," she had decided for cultural and personal reasons to share instead the story of her great-grandmother, Verna Johnston, a well-known Indigenous storyteller.[2] Liane had chosen the Ojigkwanong Centre because its foyer has the shape of a circle which she explained was

DOI: 10.4324/9781003178026-7

how Indigenous peoples view the world, capturing the wisdom that everything is connected and everything moves and grows together. She therefore had us arrange our chairs in a circle, which she joined, and invited us to pour a cup of fruit-based tea to enjoy while listening and witnessing the story. It began with an apology. Amongst the family, there are many shared memories of Johnston telling stories in a home smelling of freshly baked bannock bread and raspberry tea. Liane had baked bannock for us the night before, only to discover that her cat had taken a liking to it. This element of the performance was not to be lost, however, because just as she began her mother rushed into the centre with a tray of freshly baked bannock, willing authenticity to her daughter's performance. As it turned out, the story was all about finding her own way through a complicated family history.

Liane led us through a vibrant and passionate narrative of Johnston's life from her childhood on reserve to her finding success on her own in an urban environment and as a writer. The story resonated with her own journey as an Indigenous student. The welcoming circular space of the Centre nurtured confidence to offer a moving and compelling performance sharing Johnston's story of struggle, hardship, of having to choose between family and profession and negotiating life in what was often a hostile urban environment.[3] It was a personal story of resilience, empowerment, and resurgence that spoke to larger narratives of Indigenous histories and experiences. The re-telling allowed Liane, as she put it, "to understand her story as my own story."

The performative element was key to this understanding. Liane told us that bannock, a bread baked traditionally on an open fire, has become an important cultural icon for Indigenous peoples. Johnston, daughter of an Ojibway father and an Irish mother, had probably learned to cook bread leavened with yeast and baked in an oven. Discovering how to make bannock traditionally and serving it often to family was for Johnston an act of resistance, something learnt while being away from family and community, a performance celebrating her Indigeneity. Following a family bannock recipe, Liane was re-enacting these earlier performances, employing the senses and emotions, embodying the act of baking for a new performance event, a new situation and for a new, and very different (non-Indigenous) audience than the original. Reflecting on the performance she wrote: "This process of sharing of bannock as part of the performance became part of my re-living part of my great-grandmother's resurgence which aided in my sharing of her story and overall narrative of Indigenous survival."[4]

Teaching Narrativity and Performance in Public History

Liane's performance was the culminating event in my graduate seminar that carried the somewhat daunting title "Narrativity and Performance

in Public History." It had its origin as a reading course with a University of Ottawa theatre studies graduate student. Connected through her flatmate – one of my supervisees who knew of my plan to read my way into theatre and performance studies during an upcoming sabbatical – we agreed to do a reading course together with the support of her supervisor and department. In the following summer, I offered the course to two of our public history graduate students who were working on re-enacting food in historical sites and history on film and television. By 2012 what had begun as an informal reading course had become a fully-fledged seminar offered every second year for our MA in public history. In the past decade, it has attracted over 80 graduate students taking that degree as well as from our regular history stream and from disciplines such as communications, journalism, English, art history, film studies, and digital humanities.

Students are encouraged – and most take up the invitation – to perform a story before their professor and peers in whatever medium they choose. They "write" the past in words, paint, dance, and play (to paraphrase Greg Dening) but also in music, re-enactments, animations, films, podcasts, walking tours, online exhibits, graphic novels, game design documents, art, and other media. Students have told complex personal histories of history, heritage, memory, identity, and community through dance and interactive digital platforms; filled in archival silences through poetry, short stories, sagas, and chronicles; knitted and weaved personal stories of family, belonging, and unbelonging; and tested boundaries between accuracy and authenticity by designing and creating a full-size Victorian dress from paper upon which notes and reflections were inscribed.

Assessing such performances was very much outside my comfort zone. I was very confident in grading papers because evaluating written work submitted for a history course or degree programme is grounded on a generally agreed-upon set of criteria: how well the student has sustained a clear and focused argument buttressed by a judicious use of primary sources, meticulously referenced, and positioned carefully within the extant secondary literature, accurately discussed. Given the nature of our discipline and our professorial experience of writing and publishing, confidence in being well-qualified to judge written work, and to do so impartially, gives way to self-doubt and uncertainty when having to assess a student-made documentary film, storytelling event, dance sequence, or staged theatrical performance. If we ourselves have not produced or directed a film, crafted a story for a staged performance, or performed and curated histories told through dance, music, or acting how can we evaluate student work? Must we not end up with subjective assessments that are less valid, and certainly less rigorous (we tell ourselves) than those we offer of essays and theses?

For many public historians, their own collaborative and interdisciplinary experience in making history public mitigates these worries. Working with curators and designers gives them experience of what works and what does not, providing guidelines for developing criteria by which to evaluate historical representations in GLAM (galleries, libraries, archives, museums) settings. Community projects inevitably involve participants with a wide variety of skills necessary for creating walking tours (brochures, online apps), exhibits, videos and films, podcasts, interactive digital games and a myriad of other forms including embodied representations such as re-enactments, storytelling events, living history performances, and theatrical stagings. Again, this experience generates criteria by which such representations can be judged, and the confidence with which to do so.

Within academia, colleagues have been evaluating original productions and performances by students in art and film, music and dance, theatre and performance, architecture and engineering as long as historians have been assessing essays and theses. Invitation by a filmmaker colleague to help determine the winner of the "best film" award in his documentary film-making course gave me the vocabulary by which to judge the qualities of montage and mis-en-scene. Working with architecture and design colleagues on a community-based project about food and identity opened up an awareness of the visual language of display and the possibilities of compelling and high-quality (or not) staging of objects. Moreover, ultimately, although the media may be different, many of the evaluation criteria are strikingly like those I had been much more accustomed to, such as the need to demonstrate solid research, careful referencing, positioning within scholarly work, clarity of argument, overall coherency and writing excellence, and good critical thinking.

Three aspects, however, did challenge and encourage a re-shaping of the criteria with which I evaluate the traditional essay and thesis. First, the problematic nature of the notion that the past can be excavated and represented objectively is brought into sharp relief when history is "written" in non-traditional forms. One important evaluation criterion had to be added to the grading rubric, namely the degree to which students recognized the influence and effect of their subjectivity and positionality on the choices they had made and the final product of their historical work. Second, the degree to which students embraced possibilities rather than certainties became an important element of evaluation. Third, at the end of the day, the quality of the final performance was not as significant a factor as the journey the student had taken to get there. Indeed, if the representation was flawed in some ways or was relatively unsuccessful, what really mattered was how the student gave an account of themselves and the process in getting there.

It is for these reasons that the required reflection paper or aural examination that follows the performance is as important as the performance itself. Students are expected to share with me their decision-making process (choices made, options rejected), the evolution of the project over time, the stages of production, what worked (and equally important, what did not), and how knowing they had to perform before an audience shaped the work. Reflecting on their performance is also important: what they had learnt, how they would approach and do things differently, how they thought audience contributed to the performance. There is also an expectation that they will use the experience of performing the past to speak back to some of the readings, discussions, and workshops they had experienced over the semester.

Liane, for example, was inspired by Thomas King's proposal that "the truth about stories is that that's all that we are" and was careful to situate her work in her own Indigeneity with its rich oral traditions.[5] She also referenced insights into oral histories, storytelling, and performances offered by scholars such as Hans Kellner, Joan Scott, and Diana Taylor. She found the words of Walter Benjamin particularly helpful in thinking through the personal and political implications of Indigenous storytelling to a non-Indigenous audience: "The storyteller takes what he tells from experience – his own or that reported by others. And he in turn makes it the experience of those who are listening to his tale."[6] This brings us back to Thomas King, whose repeated (but always with slight differences) ending to each of his Massey lectures reminds listeners (and later readers) that now that they have heard (or read) the story he has told (written): "It's yours. Do with it what you will. Tell it to friends. Turn it into a television movie. Forget it. But don't say in the years to come that you would have lived your life differently if only you had heard this story. You've heard it now."[7] In the end, it was up to us, the audience, who had heard the story and who had seen, smelled, touched, and tasted the bannock and tea to make what we would of a story that revealed as much about the storyteller as it did about the life of Liane's great-grandmother.

The reflection paper (or aural examination) following the performance offers students the opportunity to re-engage with what we had done throughout the semester. Speaking back to the literature is a vital element of graduate-level work, but having the confidence to do so is daunting for students. And why would it not be? Performing histories of their own choosing, however, in a media, format, or form other than the traditional essay or paper, seems to encourage a belief in themselves. Performing the past on their own terms, often drawing on life-learned skills and interests, empowers them to find their own place in relation to scholarly work and to re-assess, re-examine, and re-engage with that work more critically. The

remainder of this chapter will share some of this work, speaking back to themes and perspectives discussed in earlier ones. It concludes with a discussion of a class-based project that was a collaboration with curators at the Canada Science and Technology Museum.[8]

There Is No Place Like Home

In Chapter 2, it was suggested that living rooms were archives and museums of history and memory. Homes function both as psychological and embodied memory: we not only remember things that happened there but also relive them emotionally and corporeally. Homes, though, are ephemeral spaces, disappearing from our lives as we move on to other homes or disappearing altogether when sold on, torn down, and replaced. Sharing memories of home was the focus of Meranda Gallupe-Paton's presentation which was linked to her larger master's project, capturing memories of her neighbourhood in Ottawa that was rapidly being transformed through gentrification presented as a podcast.[9] The project began with the intention of taking herself out of the story, trying to write, as she put it in her performance, "good, objective history." Realizing that she was unable to distance herself from the story, she decided to "lean into it" and adopt an auto-ethnographical approach. This meant flipping the interviewer/interviewee role by having her brother interview her using the same questions she had put to those participating in the larger project with the intention of turning this into a verbatim script that could be performed for the class. During the process, however, she realized that the interview itself was a performance.

For our class, Meranda got to this point in her presentation when her mobile rang. It was Meranda on the phone needing to talk through her performance anxiety. That resolved, performer Meranda spoke about how she had come to see the interview as a performance event, where *how* something was said was as important in shaping historical meaning as *what* was being said, recognizing the emotionality of the interview process. At this point, another call came in, this time a recording of the interview itself where Meranda had reflected on the changing neighbourhood. Hearing her past self (the interviewed Meranda) talk made her angry because interviewed Meranda answered questions by using language that distanced herself from emotions about losing memories and histories of the neighbourhood. Seeking to appear objective, interviewed Meranda was outed by performer Meranda as being duplicitous, denying her own emotions and needs in the history-making process. A final call interrupts the performance, this time there is just a dial tone cuing the final revelation. Doing field work one day in the neighbourhood Meranda witnessed the tearing down of a community club building that had played an important role

in her life. This was still too raw and emotional to share and so, for the moment, it would be just another silence in the archive.

Space and Place

Places that had disappeared fascinated David Siebert who discovered that alongside the well-known concrete nuclear fallout shelter Canadian Forces Station Carp, now the Diefenbunker: Canada's Cold War Museum, there were other such shelters scattered across the Ottawa Valley.

In a 53-slide Prezi-based exhibition, David mapped out these sites for his presentation. The viewer first encountered what appears to be a watercolour of the entire region, centred on the Diefenbunker and showing the satellite bunkers (Figure 6.1). We are then taken through the entire map zooming in and out of each image offered on the presentation canvas in true Prezi style. A close-up of each image dominates the frame; a text panel then opens up informing the viewer as to what they are seeing and alongside another panel opens that offers a short video showing the creation of the image. This is a very sensorial experience, such as the crinkle of the paper and the scratching of the charcoal David used to write the text beneath the watercolour of the Diefenbunker. A click takes us to other panels with photographs, archival images, and explanatory text, moving through the different levels of the four-storey shelter.

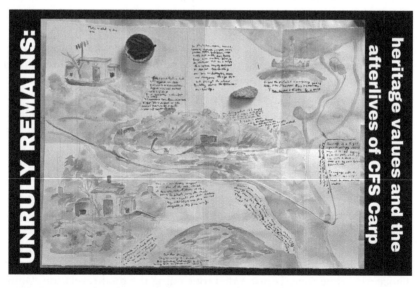

FIGURE 6.1 David Siebert, "Unruly Remains."

Source: Screenshot of Prezi Presentation, April 2020. Courtesy of David Siebert.

We transition from the Diefenbunker to other shelters through a discussion of UNESCO's definition of heritage and David's discussion of his chosen methodology for the performance: waste heritage studies. He explores the "unruly afterlives" of places abandoned, with "unordered and inconvenient" material remains left behind, taking us to other sites on the map where concrete pilings and abandoned buildings raising the question why one site was preserved as a site of national heritage and others ignored, forgotten, and in David's evocative word, "wasted." Like Peter Cusack's *Sounds from Dangerous Places*, David saw these material remnants as carrying living, emotional, and sensorial power. At each of the three sites, he engaged with found materials which he had turned into pastes and inks which were used to create the imaged map. Some – sumac, lichen, dogwood bark, juniper berries – reflect nature's reclamation of the site. Others – cigarette butts – those of the humans that once worked at the site or have since visited it. David describes the messiness of the making of the map: arranging and re-arranging, folding it up in various ways so that it opens like a manuscript parchment, contending that this reflects the evolution of the abandoned places he explored on foot. Yet, he argued, the apparent stability of the Diefenbunker is illusionary, or at least partial, for it too has its abandoned spaces, rooms deemed to be unsafe or unimportant to merit being opened to the public, rooms full of dust, rusty office chairs, peeling lead paint and hazards such as black mould and asbestos. "These are the undesirable pieces of the Diefenbunker. The things that, as a tour guide, I would never engage with."[10] Perhaps, he suggested, these are actually more valid expressions of the building itself rather than the stories it is made to present to the public, proof that it is a living thing like those elsewhere in the Valley. The lichen and sumac, not to mention the gifts left behind by visiting foxes, mice, deer, frogs, and martens, are deemed to be inappropriate and destructive of its heritage value and the proffered Cold War narrative, but, David proposed, these unruly elements question what we value and why, which leads to another question: on what basis do we call it ours?[11]

For Sara Nixon, a sense of belonging to place was disturbed by changes over time. Sara's performance consisted of a hand-held video filming herself walking down the main street of her hometown, Grimsby, Ontario. As we witness the snowy streetscape, we become aware that the narration she is offering is about another time altogether: it is 1921 and a homecoming festival is taking place. The screen is suddenly filled with a black and white photograph of the street decorated for the occasion, fitting the narrative perfectly, but after only 18 seconds the video walking us down the contemporary street resumes, but the narrative of the past event continues. This juxtaposition forces us to imagine visually what we are hearing and

putting them into the spaces we are seeing. This sequence is repeated, until another layer is added (at 04:16), Sara's own memories of the landscape we are witnessing as we continue to walk down Grimsby's main street. This, however, is not a comfortable experience because at one moment, we learn that the built landscape is changing, threatening those memories. At 05:06, the travelogue is interrupted by a superimposed photograph of a building that once stood there, a reminder that what once was is no longer, and the film ends poignantly with a sequence of past images superimposed on present spaces.[12]

Making Archives Perform

Many historians encounter collapses of historical distance in the archive. Video games had always captured Dany Guay-Belanger's imagination. Knowing that in recent years historians have begun to take video games as historical representation seriously, as ways too of enhancing historical consciousness, and historical understanding, Dany's approach as a historian has been rather different. Instead of looking only at how games are designed, analysing them for how they present and re-present the past and how they make history, his focus has also been on the medium itself: technologies and histories.[13] Dany discovered the work of a little-known transgender American game designer Danielle Bunten Berry, who died tragically young in 1998. One of the founders of Ozark Software, Berry created the important multi-player game M.U.L.E. (inspired by a Robert Heinlein science fiction novel) and *The Seven Cities of Gold* for the Atari, Commodore 64, and Apple II which inspired the famous *Civilization* series.[14] In *Seven Cities*, the player is a fifteenth-century Spanish explorer with a quest to acquire gold from the Americas. They explore cityscapes and landscapes, and encounter people (including Indigenous peoples) with whom they can interact through menus that offer a variety of choices as to what actions to take. Berry was of the view that a "peaceful approach" worked best in the game.[15]

For our seminar, Dany performed himself in the archives of the International Center for the History of Electronic Games at the Strong National Museum of Play in Rochester, New York. We watched as he opened file boxes of Berry's papers and notes. As he sifted through them, actions that were projected onto a screen behind along with images of the game designer, the consoles, the games, Dany shared with the audience the questions he asked as he read, offering his first reactions and impressions as he moved backward and forward though the evidence. He spoke out loud to Berry, asking questions, posing possibilities then rejecting them, and returning to speculation. There was a dialogue between himself and the sources, himself and the creator of those sources, and within himself. Like

Carolyn Steedman had found with her work on Joseph Woolley (discussed in Chapter 2), this archival performance recalled stories about Dany's own life, his own experience, prompted by the life encountered in the archive. There were divergences ("I can't imagine what that must have been like") and convergences ("oh, I can relate to that"). Moments of opacity and moments of *simpatico* as some of his own life experiences resonated with Berry's. It was a deeply moving performance, revealing much of Dany the historian while at the same time uncovering Berry's story, offering a perceptive analysis of how we use archives to tell stories, and the ghosts that haunt us in our claims to have the right to tell those stories.

Exploring the life stories of nineteenth-century women who were inmates of asylums, Suki Lee found Dening's proposition that "we write to change the world in some way" both helpful in understanding the diaries she was working with as well as her own interest and approach to the topic.[16] In her unscripted one-person performance, Suki embodied Elizabeth Parsons Ware Packard an asylum inmate in Illinois in the United States who had left an extensive diary of her experience. She had been forced into the asylum because her conservative Calvinist husband wanted to sell some of her property which she had refused to do and also to prevent her liberal views having an influence on her children. Suki used the performance to not only reveal what she knew from an impressive range of archival sources but also speculate about was missing from those archives, such as the reactions of the couple's six children. In the performance, we learned that that one son tried to prevent her mother's incarceration, and continued to fight for her release which was eventually achieved. What the archive was silent on, a plausible scenario filled the space, informed by Suki's knowledge of the experiences of other asylum inmates. The diary itself empowered Suki to speculate about the lives of inmates for whom there was little information beyond police records and institutional records.

While R.G. Collingwood insisted that historians use their imagination to make sense of the archive, Hayden White drew attention to the role of imagination in shaping historical narrative. The fragments of the past that have survived are just that, and in order to make sense of them, historians create a narrative in and around them offering "an image of life that is and can only be imaginary."[17] This reality effect inspired several students to create "missing sources" – those sought for and not found in the archive. One was Rowen Germain, who was moved by seeing Anne Boleyn's Book of Hours during a visit to Hever Castle in England. Motivated by her passion for historical fiction set during Henry VIII's reign and working on a larger master's project on performances of Queen Katherine Parr at Hampton Court Palace, Rowen imagined Anne's reactions to receiving a love letter from Henry VIII around Easter in 1527 while residing at Hever.

Having spent time at the site, and being familiar with living history performances at Hampton Court, Rowen was able to re-create a scenario in her mind of Anne's reading of her Book of Hours in her bedchamber being interrupted by the arrival of royal messengers carrying a letter to her from Henry. She descends to the courtyard and walks into the grounds while reading it. Rowen consulted a conservation assistant at the castle to recreate in her mind the grounds as she would have been at the time; it turned out to be more marsh and forest than today's elegantly laid out gardens, thus offering a very different space than customarily depicted in the many Tudor court-centred representations in film and television as well as novels. This was, then, a site-specific performance playing in the historian's mind. Germain wrote a short-story, focusing on Anne's thoughts as she reads the letter – re-printed verbatim in the story – and engages with its sentiments, language, phrasing, and speculates on the motives of its royal author. Blurring the boundaries between fact and fiction, an invention but one controlled by the author's deep knowledge of the primary and secondary sources, as well as other imaginings by similarly-well researched historical fictions, allowed for the (re)creation of an event that convinced in its sincerity and authenticity.[18]

Performing Family

When the actors performed stories from *The Farm Show* in Ray Bird's barn in Clinton, Ontario, in the summer of 1972, they were worried if they had done justice to those stories and to the members of the community who had shared them. Given that many of the words spoken had been taken verbatim from those who had been interviewed, it must have been both moving and troubling for those hearing their own words performed back to them. Newspaper reports describe laughter and groans of embarrassment. Whatever adjustments were made in light of those playback performances, the script that emerged became fixed and the community it claimed to represent slipped into generality for many audiences across Canada and in Britain where the play toured: a stand in for any North American rural farming community. But for those who lived in the community, this was their story, and that of the generations that followed.

Fiona Sinead Cox, a volunteer at the Huron County Museum filling in time before beginning her graduate degree in public history at Carleton, received an urgent call about her grandmother in the summer of 2011. Sinead lived in the community that was the focus of *The Farm Show*. Resettling her grandmother into care led to her sifting through archives and objects, memories, and histories. Sinead discovered that her father had not seen the show along with his mother in 1972 because he had a

woodshed to rewire; he did see it when Theatre Passe Muraille returned to perform it in 1985. His daughter Sinead, having read the play for the first time in 2010, saw a few scenes from the play performed when some of the actors returned as part of the township's 175th anniversary. This was the experience that Sinead shared with us through a performance of a four-act play she had written and directed.

In "Scene Three: Reading the Accident," Sinead sat cross-legged centre-stage holding a copy of the play and surrounded by research print outs. She comments on her encounter with *The Farm Show*, reacting to words taken verbatim from actors David Fox and Janet Amos (who returned for the 2010 performance) and Miles Potter (who didn't); from director Paul Thompson and Michael Ondaatje (who made a documentary film about the play), as well as with quotes from newspaper reviews. At one point the original script intervenes with Daisie Torrance's story about Sinead's grandfather's death after being struck by an elm branch (noted in Chapter 3). Until that moment, Sinead had only known the bare story, it came as a shock that strangers knew more about what had happened:

> Someone was telling my story to me. Was taking it away. And yet I believed it. It sounded true . . .
>
> Of course my grandmother was there, in the barn, at that first performance. As my father says, she had to be at every dogfight going. She might have been as close as you are to me now. I can't ask her about it; her memories are all mixed up now, her stories don't make sense. But from what I can gather, she seemed to like it.[19]

Surrounded by primary sources, reading (hearing) the voices of those involved in the making of *The Farm Show*, the words of newspaper reporters and academics, unsettles the historian in Sinead. The audience witnesses this difficult discovery as Sinead, playing herself of course, says "Everyone else had other stories, other versions. She saw the play and she went home. But these are my sources. This is all I have. [LIGHTS OUT]."

Freddie Rokem's argument that on stage and through theatrical energies – such as lighting – actors recreate history in the present reminds us that they are offering a new original of the actual past that was earlier experienced by others. While students were not professional actors – although some did have acting experience – performing their own pasts reignited memories and experiences. Many chose to explore their own identities through performance and trusted the class to engage with their work with generosity as well as questioning and searching. Theoretically, such performances stimulated discussions about nostalgia and how it shapes and re-shapes historical understanding. For audiences,

these performances encouraged self-reflection and self-positioning in relation to their own pasts.

"Capturing Oma and Opa" was a stop-motion video created by Kathryn Boschmann, chosen in part because previous experience in this form of filmmaking allowed for the seamless incorporation of abstract and theoretical ideas. She had also created some with her brother and friends and so, in Ottawa away from home, working with the medium itself brought back memories and raised emotions that filtered into the film itself. Kathryn built her stop-motion on an archive she had been assembling for years about her family history and particularly the lives of her grandparents including notes from conversations, recorded interviews, and photographs. Its fragmentary nature did not allow for a coherent narrative, nor was that desirable given the nature of the archive. Paper puppets was a medium that tested the boundaries of realistic portrayal; her visible other-ness – the puppet that was, and was not, Kathryn the narrator – invited a conversation about reality effects when compared to photographs used in the film. While the puppet was clearly fabricated, the words it spoke were not; the photograph appeared static, functioning for them as primary source evidence, but yet was also a construction in the context of the film.[20]

Kathryn found the process of assembling and editing frustrating and worrying. Constraints of the assignment format and classroom context required choices to be made about what to include and exclude, judgements about what was essential to the story she wanted to tell, and what not. The film begins with a quote from John Greyson that editing is an act of deception; in Brechtian fashion, then, Kathryn wanted the audience to know from the get-go that storytelling was a creative process. She found further inspiration from Greg Dening's view that turning lived experiences into narratives is also a lived experience.[21]

Embodying the Past

Allison Smith's original song composition, "Cross the Water," told the story of Black experience from the late eighteenth to the late nineteenth centuries, from enslavement to the period which saw the founding of the white supremacist Ku Klux Klan.[22] Using past events, she put herself front and centre in the song's narrative; using first person, Allison found herself effecting Michel de Certeau's observation that historical writing is an act of "recomposition" where historians "reencounter lived experience, exhumed by virtue of a knowledge of the past."[23] Both form and content reflected Allison's own positionality as a white Canadian telling a history that was not her own. The song is in the style of a ballad, closer to her heritage than African American musical forms, and the words were created newly,

not drawn from historical sources. There are significant references to the real – the name of a slave ship, a reference to the Ku Klux Klan – but Allison reflected that "my song does not posit a proposed reality in any precise sense. Rather it is a summary and a generalization of many lives lived . . . condensed into sixteen lines of verse and a four-line chorus."[24] Emotion was a key element in the performance, the words (displayed for the audience to see as well as hear) accompanied by visual images that deepened the audience's affective engagement. Allison felt intellectually and physically immersed in the performance and it gave her the confidence to move forward with further performances with Black historical referents, notably the documentary film about the life of abolitionist Mary Ann Shadd.[25]

Whereas Allison's performance was pre-recorded, ensuring a degree of stability, and distancing for the audience, Amy MacDonald's performance comprised a recreation of a Cape Breton *ceilidh* for the class which involved not only the sharing of food but the audience pushing aside chairs to make space to participate in a square dance. Wrestling with issues of authenticity, Amy took the opportunity of a performance to think about a past that is heavily mythologized and romanticized for a performance that would take place in the here and now. Moreover, it would be a performance event that sought to recreate a sense of place (homes and public spaces in Cape Breton, northern Nova Scotia) in another space (a classroom in Ontario), with an audience with few connections to the original place with its rich cultural mix of Gaelic-speaking Scots, French Acadians, and Mi'kmaq First Nations and traditions passed down from generation to generation. Unable to reproduce an event with live music, Amy offered a video of Celtic music but achieved the embodied element that would have been created by inviting a fiddler into the classroom by including live dancing. This, she hoped, would resonate with our reading of Joseph Roach, quoting his words in her later reflection paper: "dance can indeed be separated from the dancers as a transmittable form, a kinesthetic vocabulary, one that can move up and down the social scale as well as from one generation to the next."[26] Consulting with her grandmother, the family historian and gatekeeper of memories, Amy drew on her recipes to make oatcakes and biscuits for the performance, drawing friends into the process. The act of baking reminded her of Joy Parr's argument that "smells summon with eery freshness the sensibility of time past"; it made present her lived experiences of her grandmother's kitchen, something shared with friends in the baking and the class in the consuming.[27]

Seeking a personal focalization in the performance proved elusive as these multi-layered approaches de-centred the story from the performer; the experiences of others began to influence not only what was included in the story but also how it should be told. To convey a sensory experience

of a *ceilidh*, Amy decided to show a clip from one of several interviews with her grandmother and photos of family secured through an auntie who had to choose which ones would work best. Acknowledging the collaborative nature of its creation and the multi-vocality of its narrative, she chose to make these visible and transparent rather than have them shadow a first-person performance. The video element created a distance between this element of the performance and the audience. Rendered passive in watching the video was a disconnect with other elements of the performance but also risked realizing something that she had hoped to avoid, playing into stereotypes of Cape Breton and its culture. In terms of the performance, the video worked against her desire to make the audience feel included and immersed in the performance. In personal terms, the video also created a sense of nostalgia as Amy watched it during the performance, bringing out a range of emotions. "In trying to deconstruct the romanticized image of Capers [people from Cape Breton]," she wrote in her reflection paper, "I created one of my own."[28]

Mindful Inventions

In Chapter 2, it was argued that spaces and material culture function as archives. In 2018, curator Anna Adamek of the Canada Science and Technology Museum secured many artefacts from an underground gold mine in Timmins, Ontario, which had closed after over a hundred years in operation. One of the objects was a wooden door that probably dated back to the early 1900s. Its job was to control the flow of air from the ventilation system and was opened and closed manually. What is remarkable about the door is that miners wrote notes on it in pens and markers (it is likely there were earlier ones written in chalk, but these are no longer visible to the naked eye). The notes are many and various. Not surprisingly given the geographical location of the mine in northern Ontario, the topic most frequently addressed was the cold weather. Others are work-related, some refer to sports (such as the defeat of Canada by Russia at a world junior hockey championship), and others notable events south of the border such as the assassinations of Martin Luther King and Robert F. Kennedy.[29]

The door, or rather what I liked to call the graffiti on it, offered an opportunity to create an assignment that brought together the two key elements of the seminar's chosen title: narrativity and performance. On the narrativity side, it drew on our discussions of Mieke Bal's elucidation of three elements in theorizing narrative: the narrative text (the text which is conveyed to someone), the story (the content or plot), and the fabula (the way the related events are ordered). She defines fabula as "a series of logically and chronologically related events that are caused or experienced by actors [agents]."[30] The class had engaged with Bal, with Peter Verstraten's

application of her text-based theory to film: text ("moving images on screen that are usually accompanied by sound"), story ("the specific way in which plot elements are ordered"), and fabula ("the chronological reconstruction of the events according to causal logic").[31] On the performance side, it brought back to me a memory from our rehearsals when we were blocking out the performance for *Romeo and Juliet*. Director Peter Hinton asked an actor in a non-speaking role what she was thinking while witnessing the action taking place. The point was that even non-speaking actors had a story to tell, not only on-stage but also off-stage, and not only in the historical moment of the performance but also in all of the time that had led up to it. What, in other words, was her backstory?

The task for the students was to create a backstory for the person who had come in one morning so motivated that as they passed by the door, they felt compelled to take a pen or marker and write something on it, perhaps "First snow, Sept 24/70" or "Barcoding Goes Live! July 29/03" or "Nov 23/63 Kennedy Shot at Dallas," or "James Lively Miserable Mood Sept 5/78" (Figure 6.2). I copied all of the graffiti onto paper scrolls, rolled up,

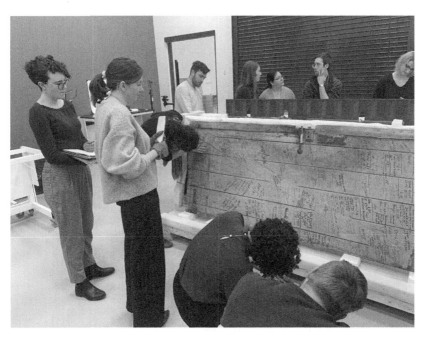

FIGURE 6.2 Master of arts in public history students from Carleton University engage with the Dome Mine door in the Ingenium Conservation Lab, Canada Science and Technology Museum.

Source: Photo: David Dean.

and placed in a basket which was then passed around the class, each student taking one. Thus, randomly assigned (though trading was allowed), each student was tasked with creating a back story. This was not just an exercise in historical research – investigating the history of the mine, the community of Timmins, the time in and around the date the door was so inscribed – but insisted on the need to engage with affect, emotion, and the senses. Some of these words were written lightly, neatly, orderly but others were written with a lot of pressure on the pen, scrawled across the door diagonally, bordered heavily so that they would stand out. The students had to invent back stories for each individual, what had led them to this particular moment where they wrote something on the door not only for themselves but also for other workers to see. This resulted in a script which was then performed for audio recording, for video recording, or if they felt so able, live in front of the class. It was a lesson in narrativity and performance, filling in the silences, contemplating the possibilities that led to the creation of an archival source, developing a believable scenario – believable for them, believable given the contexts they had researched and uncovered, and believable for the audience.

Emma Gillies created a storyline that explained one curiosity: it is clear from the inscription that the same person who registered the assassination of Martin Luther King also recorded the retirement of Canadian Prime Minister Lester B. Pearson. The backstory invented by Emma was that the same worker had inscribed the murder of President John F. Kennedy much earlier and so was motivated years later to also record that of the Black civil rights leader, also a supporter of workers' rights which was very relatable. This, in her scenario, was done on their way into the mine but as the day wore on, they decided Pearson's retirement was also worth remembering and so wrote about it on their way out after their shift had ended.[32] Nicholas Leckey took a reflective approach, a meditation on working life and global politics in his performance (the backstory for the inscription about Bobby Kennedy) and Max Cronkite offered an angry and worried worker's take on changing technologies – the ending of the punch card system registering the beginning and ending of the work day for each individual worker ("Jan 2/85 No More Cards Full Computer God Help Us").[33]

One of the most obscure writings on the door was this: "April 1/82 Fred (Oscar) Radske threatens to wildcat over disappointing lunch." A wildcat in this context is an unofficial strike, walking off the job. Kate Jordan drew this inscription, and the story she created was a play on Fred's evident nickname, Oscar. Research revealed a possible Danish origin for Fred's family. Kate invented the backstory that Fred, having arrived in Timmins from Toronto, was so disappointed by the quality of sausages available

that he learned to make his own. For the audience, this was highly amusing since Oscar Mayer is a famous brand of sausage in Canada and the United States, which is how and why, in Kate's speculation, Fred had earned the nickname "Oscar." On April 1, 1982, Kate proposed, Fred arrived at the canteen (unable to bring own lunch because his sausage grinder has broken down) to find the worst of all possible meals being served – baloney (bologna) meat – provoking the reaction that led one of his workmates to record the incident on the door. It was a convincing and highly entertaining history.[34]

These performances are inventions, but ones that are eminently plausible. They are monologues, but they are also conversations since there is an audience, both imagined by the performer in the performance event and played by us as we listened or in Jordan's case, watched. Whereas in her staged performance the conversation was both immediate and immersive, the filmed versions of the other three performances serve as first-person voiceovers while we view the inscription and documentary footage. While this perhaps distances more than the staged performance, they are nevertheless everyday conversations, centred on explaining an inscription on a mine door, offering a backstory that realizes what Neal R. Norrick calls "tellability."[35] As curator Rebecca Dolgoy concludes, these performances offer "insights that material culture analysis would not have been able to convey on its own."[36]

Notes

1. Canadian Museum of History, "View the Morning Star – Gambeh Then' Interpretive Platform." https://www.historymuseum.ca/cmc/exhibitions/tresors/treasure/283eng.html.
2. Liane Chiblow, "'My Cat Ate the Bannock' & the Story of Verna Patronella Johnston: A Reflection" (Paper Submitted for HIST 5702X Narrativity and Performance in Public History, April 2018), 6. As with other reflection papers noted in this chapter, these are in my professional archive as the instructor and are used here with permission. Each student has reviewed and approved what has been written about their work in this chapter. When referring to students, I have chosen to use first names rather than surnames as it reflects the informality, intimacy, and trust that characterized our seminar experience.
3. Liane quotes our intro: it is "not only the importance of audience in understanding how performances create historical meaning, but also the paying attention to the spaces in which performances happen, to closely engage with the mis-en-scene as well as the montage of performances of the past."
4. Chiblow, "My Cat Ate the Bannock," 8.
5. Thomas King, *The Truth About Stories: A Native Narrative* (Toronto: House of Anansi Press, 2003), 2.
6. Walter Benjamin, *Illuminations: Essays and Reflections* (Berlin: Shocken, 1968), 87.

7 King, *The Truth About Stories*, 28–29.
8 The Canada Science and Technology Museum is one of three – the others being the Canada Agriculture and Food Museum and the Canada Aviation and Space Museum – gathered under the umbrella institution Ingenium.
9 Meranda Gallupe-Paton, "Memories of Mechanicsville: A Personal Public History," Major Research Essay for the MA in Public History with Specialization in Digital Humanities, Carleton University, August 2022. The podcast is available on the web: https://memoriesmechanicsville.wordpress.com and on Spotify: https://open.spotify.com/show/4WD498CLvmpW8iWe7AvZTe?go=1&sp_cid=472a2daea2b0a4650d7917dd21724704&utm_source=embed_player_p&utm_medium=desktop&nd=1&dlsi=475ea21c4edf48a1.
10 David Siebert, "Unruly Remains: Heritage Values and the Afterlives of CFS Carp." (Presentation Performed and Submitted for HIST 5707 Narrativity and Performance in Public History, April 2020), slide 39.
11 David adopted the term "unruly" and "unruly afterlife" from Bjørnar Olsen and Þóra Pétursdóttir, "Unruly Heritage: Tracing Legacies in the Anthropocene," *Arkæologisk Forum* 35 (2016). http://www.archaeology.dk/upl/16170/AF3508BjrnarOlsenraPtursdttirSRTRYK.pdf.
12 Sara Nixon, "Layers: Performing Community Within Grimsby, Ontario's Main Street." https://www.youtube.com/watch?v=yLoGGEgnaIs. The film has had 1,400 views in the past ten years.
13 Dany Guay-Bélanger, "'How Do We Play This Thing?': The State of Historical Research on Videogames," *International Public History* 4, no. 1 (2021), 1–6.
14 "The Seven Cities of Gold." http://www.c64sets.com/seven_cities_of_gold.html.
15 Arthur Leyenberger, "Interviewing Dan Bunten," *Antic* 3, no. 9 (1985). https://www.atarimagazines.com/v3n9/profiles.html.
16 Suki Lee, "Lunatic Asylums as Factories: A Nineteenth-Century Narrativity and Performance Study Based on Stories of Annie May Pernet, Emma Copper, Mary Huestis Pengully, and Elizabeth Packard" (Paper Submitted for HIST 5702X Narrativity and Performance in Public History, May 2014), 8–9.
17 White, *The Content of the Form*, 24.
18 Rowen Germain, "The Letter" (Paper Submitted for HIST 5702X Narrativity and Performance in Public History, April 2018).
19 Fiona Sinead Cox, "The Farm Show Show" (Script Submitted for HIST 5702X Narrativity and Performance in Public History, April 2014), Act One, Scene III, Reading the Accident.
20 Kathryn Boschmann, "Capturing Oma and Opa: A Reflection" (Paper Submitted for HIST 5702X Narrativity and Performance in Public History, April 2014), 4. Uploaded to YouTube, it has had 774 views over the past ten years: Kathryn Boschmann, "Capturing Oma and Opa: A True Story." https://www.youtube.com/watch?v=G3IIiyhXdJ8.
21 Greg Dening, *Performances* (Chicago: Chicago University Press, 1996), 104.
22 Allison Margot Smith, "Eighty Years of History in Sixteen Lines" (Paper Submitted for HIST 5702X Narrativity and Performance in Public History, April 2014).
23 Michel de Certeau, *The Writing of History* (New York, NY: Columbia University Press, 1988), 35–36.
24 Smith, "Eighty Years," 3.
25 Allison Margot Smith, "Film: Mary Ann Shadd Revisited: Echoes From an Old House." https://activehistory.ca/blog/2016/03/08/film-mary-ann-shadd-revisited-echoes-from-an-old-house. See also the interview, https://carleton.ca/ccph/cu-videos/interview-with-allison-margot-smith-1-2/.

26 Amy MacDonald, "Come Ceilidh on Cape Breton Island: A Reflection" (Paper Submitted for HIST 5702X Narrativity and Performance in Public History, April 2014) citing Joseph Roach, *Cities of the Dead: Circum-Atlantic Performance* (New York, NY: Columbia University Press, 1996), 27.
27 MacDonald, "Come Ceilidh," 9–10, citing Joy Parr, "Notes for a More Sensuous History of Twentieth-Century Canada: The Timely, the Tacit, and the Material Body," *Canadian Historical Review* 84, no. 4 (2001), 742.
28 MacDonald, "Come Ceilidh," 15.
29 Anna Adamek, "Multi-Object Acquisition Proposal" Document Re: Goldcorp Canada Ltd., February 21, 2018, in author's possession.
30 Mieke Bal, *Narratology: Introduction to the Theory of Narrative* (3rd ed., Toronto: University of Toronto Press, 2009), 5.
31 Peter Verstraten, *Film Narratology* (Toronto: University of Toronto Press, 2009), 12.
32 Ingenium, "Uncovering History through the Dome Mine Doors," *YouTube* (2021). https://www.youtube.com/watch?v=Cen1ECYE98Q. Emma Gillies performance runs 04:13–05:33. It can also be seen on the museum's channel: https://ingeniumcanada.org/channel/articles/a-door-to-the-past-inscriptions-offer-a-glimpse-into-canadas-mining-history.
33 Ingenium, "Uncovering History," 07:43–09:02 (Leckey) and 9:10–10:18 (Cronkite).
34 Ingenium, "Uncovering History," 05:40–07:33.
35 Neal R. Norrick, "Conversational storytelling," in *The Cambridge Companion to Narrative*, ed. David Herman (Cambridge: Cambridge University Press, 2007), 134–35.
36 Ingenium, "Uncovering History," 03:52–03:54.

EPILOGUE

Performing Public History

Early on in my interview with the town's mayor, Jarmila Nováková, I find myself hesitating about what question to ask next. She is impatient to get on with things. Even after she invited me into her office, she seemed distracted. As I introduced myself and my project, she couldn't keep her eyes from wandering back to the papers she had been working on. And she still hasn't put down the pen she was holding. I want to ask her about the tough times experienced by her town immediately after its liberation from Nazi Germany in 1945, but then I also want to ask her about her ten-year-old brother who was killed while flying the Czech flag when the news of liberation came through. And then there is what I really came for, her thoughts about the local school building which some residents want to tear down and others want to preserve as a historic site. As I ponder which question to put to her, she glares at me and sighs loudly as if I'm wasting her time. Perhaps I am.

This was not a real experience, or was it? I have always been a professor, a researcher, and a teacher, and have never been employed as a heritage designation consultant. I've never walked the streets of a village located in the Czech-German borderlands. Yet for over 20 hours, I *was* there interviewing locals and visiting places that would provide me with the raw material for my report, assembling evidence to support my final decision. And while I was there, I discovered that I was personally connected to the place because while exploring the school's attic, which had become a sort of archive, I'd uncovered a photograph of my grandfather.

Svoboda 1945 Liberation is a video game released by Charles Games in August 2021 (Figure 7.1). It won the 2022 Grand Jury Award at IndieCade as well as the Czech Game of the Year Award. The posting announcing the

DOI: 10.4324/9781003178026-8

FIGURE 7.1 *Svoboda 1945: Liberation*, Charles Games, 2021.
Source: Screenshot. Courtesy of Charles Games.

latter celebrates the fact that the game "does not shy away from controversial, moving and often troubling and dark topics, for a story brimming with unresolved national traumas."[1] This refers not only to the experience of Nazi occupation which is one of the game's focal points but also to the death marches of concentration camp internees that came through the village, liberation from Nazi occupation, the arrival of Czechs from the east, violence against the village's German inhabitants and their expulsion, the rise of communism, and the imposition of collectivization.

The top two user-defined tags for this game (after "Singleplayer") are "Visual novel" and "Emotional"; 7th is "Choices Matter," with "Cinematic," "Conversation," "Story Rich," and "Realistic" are 9th to 12th.[2] All of these speak to the historical nature of the game. When you first open it, the menu is featured with a changing background: the close up of a woman's face and a sequence of newspapers and newsreels that situate you firmly in central Europe in the middle of the Second World War. Clicking on the play button reveals the message "The characters and stories in this game are fictional, but they are based on archived testimonies and real historical events." The game employs various strategies of the real: a strong narrative, archival sources (documents, objects, newspapers, newsreel footage), oral history interviews, buildings, landscapes, and pop-up windows conveying historical information. The filmed sequences are shot in a realistic style (natural light, real time) and the music is unsensational. Against this realism is the more distancing use of graphic novel image forms ignited when listening to a story that adds new elements and dialogue. The synergy

between source and imagination is driven home by the fact that people in the photographs the player has discovered in their quest for knowledge about the school are rendered not photographically but in the form of a graphic novel image.[3] If this signifies constructed rather than experienced pasts, it is no less emotional and affective. The critical thinking and research process is also registered by recording newly acquired information on sticky yellow note pads, which reveal things that, by choosing to ask one question rather than another in the game, the player may have missed out on.

Playing History Privately

"Video games," Aubrey Anable writes, "are affective systems."[4] Video games immerse us in the mechanics of the game, requiring us to make choices within the parameters set by the designer, and for those situated in a particular time and space, they can immerse the user in the past, speak to the present, and engage our feelings, emotions, and sometimes our bodies. *Svoboda 1945 Liberation* ticks all the boxes.

From the moment, the game opens we are looking into the eyes of a woman and then other actors who we will later meet. As the game moves forward we meet others who are also seekers of the past: a German woman who wants to show her granddaughter where she used to live before their family was expelled. Towards the end of the game, encountering and interviewing a man who was responsible for taking many of the photographs you found in the attic, including the one of your grandfather, you realize that he is the woman's long-lost brother who was separated from the family as they fled the village, forced to move into Germany. Facilitating their meeting is an emotional moment for the player, so too is the assigned task – another game within the game – of quickly packing your belongings into a suitcase prior to expulsion. The game comments on your choices.

Our own progress is shaped by accumulating information and creating an archive in the form of a photograph album whose pages are filled in as you click on photographs and learn the story behind them. Another archive, a more traditional one, lingers in the background, available for consultation at any point but not part of the game's action. "They will provide valuable historical, context," we are told, "although reading them is not required to complete the game." Other games within the game are archival or experiential in nature. One challenges you as a farmer resisting collectivization. As you move through the seasons from spring 1945 to the spring of 1950, it becomes increasingly harder and then simply impossible to meet the quotas until inevitably you are forced to join a collective farm. You experience a full range of emotions from happiness (meeting quotas in year one) to disappointment that turns into frustration as you fail to do so, anger as you begin to realize that changing quotas means you will never succeed, and resignation to your inevitable fate.

The player begins with very good intentions. Tasked with investigating the past and its presence in the here and now objectively and impartially, they soon discover, however, that their own personal, private histories entwine with public histories, that they need to examine their own positionality if not subjectivity. Indeed, it is the mystery of your grandfather's photograph found in the attic that is a significant sub-plot to the game and perhaps for some players becomes the major quest: Who took the photograph and what does it signify in terms of your grandfather's involvement in these events?

The game engages with troubled and contested pasts and invites users to consider different interpretations and understandings of those pasts. As a demonstration of historical practice, players of *Svoboda 1945 Liberation* gain experience in exploring archives and artefacts as well as buildings and landscapes, uncovering unexpected archives, and conducting oral history interviews. Making choices, filling silences, and assessing evidence with an awareness of the need to be open to possibilities encourages respect for historians who turn to measured invention and critical speculation for answers. Ultimately, there is no right (winning) answer to the question of whether the school building should be preserved or not. This ensures that it is in the process of getting to that point that the player learns, understands, and gains awareness of this complex period of history. *Svoboda 1945 Liberation* is a strong example of performing history in public as well as performing public history. As history, the game insists that players engage with the relationship between difficult pasts and the present.

Past Present and Present Past

Other media can be just as immersive as video games. Since this book began with my historian's reading of Suzan-Lori Parks's writing about her work as a playwright, it seems fitting to end with a discussion of her latest play, *Sally and Tom* which I went to see in New York when I was in the middle of writing the conclusion to this book. I was anxious to see the play because it seeks to collapse historical distance in a simultaneous telling and re-telling of Sally Hemings' relationship with the third president of the United States, Thomas Jefferson. Hemings was Jefferson's slave who became, or was forced to become, his mistress at the age of 14 (he was 44). She bore him seven children over 30 years and on his death, Jefferson freed their offspring from slavery, but not Sally herself. The play revolves around a play being rehearsed by a theatre company. Originally called "E Pluribus Unum" (out of many, one), it has been renamed "The Pursuit of Happiness." The first title is a motto marking the union of the Thirteen Colonies leading to the formation of the United States and is inscribed still on its coinage; the second is a phrase written by Jefferson as part of the country's Declaration of Independence. Both titles carry ironies both personal and political.

For slaves such as Sally, her brother James, sister Mary, and her husband Nathan, the pursuit of happiness can only come with freedom; denied this, the continued horror of slavery renders any claim of equal union empty of real meaning. The play is staged as the Jeffersons have returned to Virginia from revolutionary France, and Sally discovers she is pregnant with their first child. The actors playing Sally (Luce) and Tom (Mike) are in a tense relationship and she too discovers that she is carrying their child.

Audiences are not always sure whether they are witnessing a scene from the eighteenth-century "real" lives of Sally and Tom or a rehearsal; sometimes there are clues, but for the most part, the audience is drawn into a scene where the past is very much present only to have it abruptly interrupted or broken by an intervention associated with the rehearsal process. The writing is so strong, and acting is so compelling that the play moves seamlessly between past and present, fusing both time and space.[5] On two occasions, Tom (at the end of Act One) and Sally (in Act Two) offer monologues directly to the audience, explicitly asking questions about views and questions we may have about them. Tom says he knows what we are thinking about him (badly, of course) and suggests we need to resist the simplistic binary of good and bad. Sally asks herself the question on all our minds, whether she loved him or not, and also why she didn't run away. We know, though, that running away was hardly an option for someone in her position, and we also know, because we've been told this by Luce/Sally when she resists the impulse of Mike/Tom to bend to their sponsor's wishes, that "this is not a love story." But those questions persist. By play's end, Sally cannot leave Tom, but Luce is able to leave Mike.

One of the remarkable achievements of *Sally and Tom* is its insistence that audiences see the past as a play and the play as a past. The actors all have double roles in this cash-strapped production – one of the actors playing Jefferson's sister Polly doubles as stage manager, Luce is also company dramaturge. One scene is entirely off-stage as we witness the actors talking about the production, life, and history, discussions that are interrupted when one of them has been called onstage and we see them straighten up and exit as if entering the real stage. Like historians, these actors were as present in the past as they were in the present moment.

Theatrical Pasts

In March 2023, celebrating "theatrical pasts" was the theme of a keynote presentation I gave along with Rick Duthie, whose work we encountered in Chapter 3, and Jackie Mahoney, then a master's student with a theatre background whose work (an original script and performance) is briefly discussed in the Appendix. Our conversation was captured by graphic artist Sam Hester (Figure 7.2) and serves as a visual summary of much that this book has addressed.

Epilogue 149

FIGURE 7.2 "Theatrical Pasts." Graphic created by Sam Hester from the keynote at the Underhill Graduate Student Conference, March 17, 2023.

Source: Courtesy of Sam Hester and the Underhill Committee of the Department of History, Carleton University.

My intention in writing this book was to share some of what I experienced and learned in the theatre rehearsal room and later in the classroom as I wrestled with what thinking about history as performance means for the field of public history and the broader discipline. In Chapter 2, I argued for a broadening of what counts as archives and museums and asked why we eulogize such institutionalized memory palaces and what they contain over informal tangible and non-tangible sources of knowledge. Chapter 3 discussed the ways in which different media seek to capture the real and suggested that because these resonate with their practice, academic historians should be more open to the value of non-academic forms of history making. Tracing how performances of the past engage publics through emotions and the senses in Chapter 4 opens up a discussion about the limits of histories that assert their authority solely through claims of distanced objectivity. Chapter 5 proposes that authenticity is achieved through performance experience rather than being bound up in source-driven straightjackets. Offering readers case studies which show the many ways history work is done in public, and by, with, and for publics around the globe will, I hope, encourage more conversation about history, public history, and performance. To a historian who has experienced his own performative turn, disrupting the binaries of fiction and non-fiction and troubling assumptions about which historical representations should and do get valued are worthwhile undertakings. Acknowledging our positionality, as well as embracing our creativity, use of imagination, and the emotions we feel when we engage with lives lived can only lead to better and more generous histories. Historians, after all, are the dramaturges of the past.

Notes

1 "Svoboda 1945 Liberation Chosen as the Czech Game of the Year 2021." https://Steamcommunity.com/app/1076620/allnews/; *Svoboda 1945 Liberation* website. https://store.steampowered.com/app/1076620/Svoboda_1945_Liberation/. The game is demonstrated and discussed in "Let's play! Svoboda 1945–Liberation." https://koerber-stiftung.de/en/projects/ecommemoration/ecommemoration-convention-2021/.
2 *Svoboda 1945 Liberation* website. The tags in between are "Historical," "World War II," and "War."
3 On the relationship between documentation and performing history graphically, see Andreas Etges, "Stories From a Dusty Basement: A Conversation with Richard Conyngham on All Rise: Resistance and Rebellion in South Africa (1910–1948) – A Graphic History," *International Public History* 6, no. 1 (2023), 65–66.
4 Aubrey Anable, *Playing with Feelings: Video Games and Affect* (Minneapolis: University of Minnesota Press, 2018), xii.
5 The production I saw was directed by Steve H. Broadmax III at The Public Theatre, New York City, May 7, 2024.

APPENDIX

Classroom Activities

All of the activities that follow are designed as experiential learning exercises related to the issues and ideas raised in the book. All have been tried and tested in the undergraduate and graduate classroom. For reasons that will become obvious, they work best in the in-person classroom, and one with movable chairs and tables, but a few have worked quite effectively in the online classroom, both the synchronous and asynchronous versions. They have always been intended as demonstrations of Dwight Conquergood's second way of knowing discussed in Chapter 1: "active, intimate, hands-on participation and personal connection."[1]

Most recently, another advantage of such classroom activities – and of the performance-based forms of assessment shared in Chapter 6 – has emerged: they can play a role in inoculating students and instructors from AI-generated plagiarism. The challenge as well as the benefits of AI-generated text was brought home to me through a performance. A graduate student I was supervising, Jackie Mahoney, chose to write an original script that was staged and performed as her master's research essay in public history. "Something Great or Noble: Performing the Life of Johanna Van Gogh Bonger" tells the little known story of Vincent Van Gogh's wife.[2] A form of documentary theatre, the script was created by blending text from original sources, fictionalized text, and text generated by GPT-2 based on primary sources fed into it. Jackie put questions to what she playfully called "JoBot" for which the archives had not yielded answers, generating original text for the script. In the performance programme, Jackie offered the audience three texts – one taken verbatim from a primary source, one written by her, and one written by JoBot – and invited the audience to decide which was which. Most of us got it wrong.[3]

Activity One: *Objective* Thinking

"*Object*ive Thinking" began as a fairly straightforward icebreaker, using an object chosen by each student as a prompt for introducing themselves to another student. It then became a way of getting them to think about the stories we choose to tell, how we tell them, and how our audience influences us when think about telling the same story again. This in-person or online activity was followed with a short-written assignment asking students to reflect on the activity. Through this, I realized that what I'd intended as a straightforward "show and tell" had for them become quite meaningful in terms of the historian's craft. It had led them to think about objects as sources of history and as archives of memory. It had also introduced them to notions of objectivity and subjectivity, and encouraged them to think about their own positionality in history making. In the past two iterations, I have also followed this up by talking students through scholarly discussions about the agency of objects and they have been able to really engage with this complex debate by referring back to their experience in this activity.

It speaks to a number of fields: public history, museum studies, and performance studies. As public history, it reminds students that the various national surveys exploring how publics engage with the past found that collecting objects, heirlooms, and so forth is an important way in which publics engage with the past as well as giving them a taste of oral history practice. Second, the activity speaks also to crowd-sourcing collecting strategies by museums. Last, the performative (storytelling) element was inspired by a workshop I co-led on "museums, objects, performance" with independent theatre practitioner Jennifer Boyes-Manseau. Jennifer had been artistic director of the Dramamuse theatre company attached to the Canada (history) Hall of the then Canadian Museum of Civilization which was tragically disbanded when the museum became the Canadian Museum of History. The workshop was part of the 2015 interdisciplinary and bilingual conference, *History, Memory, Performance*, held at the University of Ottawa which led to two essay collections being published.[4] As this has been a very successful activity for second-year undergraduate students, I include a list of pedagogical goals that are often a requirement for teaching outlines at the undergraduate level. This activity is designed to pick up on some of the themes covered in Chapters 1 and 2.

The Activity:

The Instructor/Facilitator explains: The title of this activity is meant to be playful. It asks you to introduce yourself to a member of the class by telling them something about yourself using an object that you have chosen as a

prompt (getting discussion going with your partner) and prop (sustaining the conversation that follows). Historians are taught that we should keep a distance from our sources (in other words, to be objective), but how does this work when the object in question is something important and familiar to us? What do we learn, as historians, by telling our own histories? So this activity is designed to get you thinking about the objectivity question in history, and it is also about objects and the stories they tell.

1. Find an object from home that represents something important about you. It might be something personal (though be sure you will be comfortable talking about it) or about family, the community you identify with, or any or all of these. It may help to think of this like you are choosing an object to save as an heirloom for your grandchildren or one that you choose to put in a time capsule for someone to find in 2050 who wants to more about students today.
2. Once you've chosen your object ask yourself some questions about it. How would you describe it (using most of your senses)? Why did you choose it? Why is it important to you? These will help you talk about the object when you come to class.
3. Take a photograph of the object and bring it to class (storing them on a mobile device or laptop is fine, no need to have them printed). If it is small enough and it is safe to so, feel free to bring the actual object to class. *[If the class is online then upload the photograph to the online learning platform]*.
4. In class, you'll be paired up with another student. Show your object to your partner and tell them about it. Take about ten minutes. Then listen to them tell you about their object. Again take about ten minutes. Take a final ten minutes to ask questions and exchange thoughts with each other. *[If the class is online you'll paired with another student online forming a "group" of two and connect with them through the learning platform]*.
5. The class will then come back together to share thoughts on the following questions:
 (i) How did you feel sharing the story of the object with someone else? How would you change the story next time?
 (ii) What did you think about your choice of object now that you have shared it and discussed it with someone else and witnessed their show and tell? Would you now choose differently? If so, what would you choose, and why?
 (iii) How do you think objects can tell stories about the past, in the present? What might they tell someone in the future about our histories in the present?

[If the class is online the discussion can take place in the main classroom space if synchronous or you can post your thoughts in the discussion forum if asynchronous].

These questions can be used as the basis of an effective short assignment.

Pedagogical goals:
- To offer students the experience of sharing a story about themselves with someone else and to meet someone else in the class (a useful icebreaker).
- To encourage students to think about objects as "archives" of their individual, family, or community memory and history (what an archive is, discussed in Chapter 2).
- To introduce the idea that history is not always about large narratives, but smaller narratives of everyday life and life histories (historiography, history from below, discussed in Chapter 2).
- To give students a taste of what it is like as an archivist or museum curator faced with choices about what to select for preservation (what gets saved as heritage).
- To encourage students to think about objects as sources for understanding the past (how material culture can help us know about the past).
- To encourage students to reflect on how audiences are not passive but active listeners and how that influences the storyteller (affective history, discussed in Chapter 4).
- To think critically about claims to objectivity by becoming more aware of their own subjectivities and those of others (discussed in Chapter 1).
- Last, the activity opens up an opportunity to discuss object agency and potentiality (how objects perform or are made to perform as history).[5]

Activity Two: Storytelling and Listening

For my graduate seminar on "narrativity and performance in public history," one of my frequent guests was Ottawa-based storyteller Ruth Stewart-Verger. Renowned as a storyteller across the country, she has produced two CDs. *She Pushed from Behind: Emily Murphy in Story and Song* was recorded live at a concert held in Library and Archives Canada for International Women's Day in 2004. *In God Knows Where: The Story of Marie-Anne Langimodiére* tells the life story of this strong francophone woman, grandmother to Louis Riel. The activity she devised for the students, offered here with her permission, involves students preparing a three-minute story ahead of time and then telling it to another student. A carefully curated discussion between storyteller and listener then follows which insists on the listener's critical engagement with the performance, that contributes – as in some theatre practices – to the re-thinking (Ruth uses the word "re-calibrating") of the story and how it was told by the storyteller. The exercise is then repeated, and repeated again.

The activity was extraordinarily effective in giving students experience of how we re-shape our history-telling through the experience of sharing stories with others but also the experience of what is meant when scholars talk about "active listening." This gave life and energy to scholarly work which emphasises the role of the interviewee in shaping oral history interviews (sharing authority, co-production) and the role of audiences in shaping performances (e.g., in documentary, verbatim, and playback theatre and the theatre of the oppressed). It opened up discussions about the listener as witness, where I could draw in writings about performing history from Bertolt Brecht, Freddie Rokem and others. It was a very engaging way of bringing to life performance studies scholar Richard Schechner's concept of "twice-restored behaviour," and invited productive conversations also around Homi Bhabha's phrase in relation to hybridity and space: "almost the same, but not quite." Students interrogated both similarity and difference through this activity, which relates to themes discussed in Chapters 1 and 3.

The Activity:

1. Come to class with a three-minute story to share with a partner.
2. Once you have been paired, tell your story to your partner (one partner is teller first, the second listener, then swap roles).
3. Ask your partner for feedback. Three points to consider:
 (i) Something you "saw" when you read the story
 (ii) Something that confused you
 (iii) Something that you enjoyed

4. Recalibrate your story and then find a second partner and tell them the story (and hear their story). Get more feedback on (i), (ii), and (iii) above.
 Note: if classroom time permits a third review, recalibration, and retelling can have even more impact on both tellers and listeners.
5. Break.
6. Classroom Discussion:

 (i) What was different between the telling, re-telling for the first time, and re-telling for the second time? How was it different? Why was it different?

 (ii) What was similar between the telling, re-telling for the first time, and re-telling for the second time? How was it similar? Why was it similar?

 [This activity can also work online, dividing the class into pairs as "groups" through the learning platform. One person tells their story and the other listens, then they swap roles. The class then takes a break allowing the instructor to reset the groups for a second round with different partner pairings or reassemble the class for a general discussion.]

Activity Three: Playing for Real

This activity is a version inspired by playback theatre practitioners such as Jo Salas. Playwright, director, and educator Megan Piercey Monafu designed and facilitated this activity for my narrativity and performance in public history seminar and is offered here with her permission. The activity involves students working in pairs, one playing the role of interviewer and the other the role of interviewee. The activity can work with the interviewee coming to class having thought about the story they wish to tell, but it works even better and has more energy if you give the class time to think about a story after they've arrived on the day. The interviewee tells their story to their partner, the interviewer, who then performs the story in front of the entire class. They receive feedback first from the interviewee whose story has been performed, and then both receive feedback from the class who had witnessed to the performance and listened to the interviewee/interviewer's exchange post-performance.

The title is borrowed from the book edited by Tom Cantrell and Mary Luckhurst and the activity resembles a workshop run by director Max Stafford-Clark that is described by actor Chipo Chung (who has performed China Keitetsi (former child soldier and activist), Nadira Alieva (partner to a British diplomat), and Condoleezza Rice (former United States secretary of state) on stage.[6] Essentially, the activity asks students to build on what they learned in Activity Two by performing the role of interviewer and interviewee, and then reflecting on the experience through a series of curated questions. The activity resonates not only with practices associated with playback, documentary, and verbatim theatre, but also with recent work on oral history practice which emphasises its performative elements by scholars (and oral history specialists) such as Alessandro Portelli, Della Pollock, Steven High, and Stacey Zembrzycki.[7] The activity speaks to topics in Chapters 3 and 4.

The Activity:

1. The instructor/facilitator asks everyone in the class to spend time thinking about a story they would like to share (or ask them to put the final touches to a story they have thought about telling before they've come to class).
2. The instructor/facilitator breaks the class up into pairs.
3. Each pair decides who will be the interviewee and who will be the interviewer.
4. The interviewee tells a story while the interviewer writes down the key sentences.

5. The interviewer shares the sentences with the interviewee and they discuss what was heard by the interviewer, and how it was heard.
6. The interviewer, having revised their notes as they see fit, performs the story back to the interviewee. Note that there are many possibilities here: the interviewer could choose to tell the story in the third person, or perform the interviewee telling the story, or perform the story itself with varying levels of artistic license and creativity.
7. Having seen and heard themselves and their story performed to them (played back), the interviewee offers feedback and comments.
8. The interviewer spends some time rethinking and revising their performance following this feedback.
9. Break.
10. The class comes together and each interviewer, in turn, re-performs the stories they heard from the interviewee but this time for the whole class.
11. Interviewees share with the class their thoughts on what it was like to see and hear themselves performed publicly.
12. Interviewers share with the class their thoughts on what it was like to perform someone else's story publicly.
13. The instructor/facilitator draws connections between the various experiences.

Activity Four: Embodying the Source

Reading and interpreting sources is a performative action which is highlighted by this activity in which students are asked to turn a source into a performance, literally to put it up on stage, to re-present it to an audience through movement, gesture, and sound. For several years I have done versions of this with historical texts in several classes, particularly those I teach on early modern Britain and early modern witchcraft (I've asked students to perform not just play texts but parliamentary debates, trials and court records, religious debates etc. and then reflect on how performing the text – reading it out loud, adding movement and gestures – informs their understanding of it).

I encountered a brilliantly thought-through exercise along these lines in a workshop led by Rachel Alderman and other members of A Broken Umbrella Theatre based in New Haven, Connecticut, the United States, for the National Council on Public History conference at Hartford, Connecticut, in March 2019. The aim of the activity is to take an original source (Broken Umbrella used a text, France E. Willard's *How I Learned to Ride the Bicycle. Reflections of an Influential 19th Century Woman*) and perform it. Participants are split into groups and asked to read the same text, agree on a set of ideas thrown up by their interpretation of the text, and then collectively devise a performance (initially movement and gestures only) based on those ideas. Each group performs their take, in turn, inviting reactions from the audience (members of the non-performing groups) and then re-perform the text taking these into account. A Broken Umbrella added a third round, the performance now having sound added to it.

This is a wonderful activity that has worked at whatever point I chose to facilitate it in my graduate seminar on narrativity and performance in public history. It works early on in the course as a way of getting students to begin thinking about textual sources as the basis for a performance (whether in film, theatre, opera, video games and so on). It works mid-way, for example, the week before our mid-term break, to capture what we've been discussing about sources, interpretation, objectivity, narration, and so forth in the first half of the course. And it works as a capstone at the end of the course when we've also had time to talk through affect, emotions, senses etc.

The main takeaway for undergraduates (when I've used original sixteenth- and seventeenth-century texts such as court records) is that one source – the same source – can be understood and interpreted so very differently. There are commonalities of course in the various performances by each group, but there are also significant differences. It is a very visual and physical way of demonstrating that history writing and history making are

only partly dependant on the evidence used, and much more about who is writing and making the representations of it. For graduate students, there is the added value of thinking through what happens when you turn text into play, when you take if off the page and stage it, as embodied and affective history.

For the activity offered here, based on that of Rachel and A Broken Umbrella Theatre with permission, I have written an original story, one that is a deeply personal one, but which I realized I felt comfortable in sharing when I participated with my students in doing Activity Three: Playing for Real. It may not have the drama of an early modern witchcraft trial or a chronicle from Henry VIII's reign, nor the dynamic element of learning to ride a bicycle, but it serves the purpose I think. And, of course, almost any text you choose will work for this activity which is designed to follow up on some of the aspects covered in Chapters 4 and 5.

The Activity:

1. The instructor/facilitator asks the class to break into groups. You'll need a minimum of three per group. Four to six is ideal. Ask the group to choose a "recorder" who will take notes.
2. Groups spend the necessary time to read the text you provide ("The Comfy Chair" is offered below).
3. Participants in each group then toss out keywords or phrases that came to the top of their minds immediately after reading the text (A Broken Umbrella calls this "word salad"). These are written down by the group's recorder (preferably on sheets so that they are visible to everyone in the group at any time during the activity).
4. Each group then chooses one or two of these noted thoughts and performs them through movement for the group only.
5. Each group then offers the same performance for everyone.
6. There is a general discussion during which each group receives comments and reactions to their performance. Before this begins the instructor/facilitator should explain that the idea is not be judgmental (e.g. "I liked" or "I didn't like") but reflective (e.g. "I noticed" or "This moment (image, feeling, etc.) is really staying with me") and of course give everyone some time to gather their thoughts before beginning the discussion.
7. The groups then re-work their performance taking into account the comments and reactions and repeat the exercise as in 4, 5, and 6 above.
8. The groups then re-work their performance but this time add sound to it, and repeat the exercise as in 4, 5, and 6 above.

9. The class ends with a general discussion. Some suggested questions would be:

 (i) How different were the interpretations of the same source? Why do you think this was the case?
 (ii) What did performing the text – adding movement – tell you about it that you hadn't picked up just by reading it?
 (iii) What did adding sound do?
 (iv) What changed over the three versions of the performance? What were the gains and what were the losses?
 (v) How did performing to an audience affect your performance and/or change your understanding of the text?
 (vi) How do you think working collaboratively contributed to your understanding of the text?

10. The facilitator draws out general themes, but one in particular is a vital take away: what do we mean when we speak of "getting the story right" or "getting the story straight" as historians?

The Comfy Chair (A Short Story by David Dean)

It had taken weeks, months, even years. But here we were at last. Getting ready to take a hearing test. A few hours earlier my father, now in his late nineties, had finally agreed that he was not hearing so well these days and that taking up a local clinic's offer of a free hearing test might be a good idea. That it was free was important because my father didn't like spending money. On this trip home from Canada, I'd taken him shopping for a new shower fixture. Well, I say "taking him shopping" but what that really means is that he drove us to the hardware store in the forest green 1971 Wolsey which he had lovingly maintained since we had arrived in New Zealand having immigrated from Canada over 40 years earlier. The Wolsey, famous as a police car in my father's native England, had made its own way to Auckland from the home country while we drove across Canada in a 1966 Chevy and boarded the SS Arcadia to take us to New Zealand. Anyhow, from his reaction to the prices in the store, it was obvious that my father hadn't shopped much for hardware since the 1970s. Fortunately there was a sale on, fortunately the sales assistant was willing to sell us the display model at an even greater discount, and fortunately (for all of us) we walked out with a new shower fixture.

My father was always looking to save money. He worked out every day, his pride and joy being the gizmo he'd rigged up having seen an advertisement on telly for a new exercise machine that would reduce the waistline.

"Look at the price of that!" he exclaimed. A week later, he showed off his new invention. An old office chair with wheels had a thick rubber training band wrapped around it, tied to a hook he'd attached to the desk. You wrapped another band around your middle, secured it to the same hook, and gripping the chair's arms you could swivel from side to side. It was weird. It was rickety. And it worked. Well, at least for him. I ended up with a sore back.

So although I knew the free hearing test on offer was a sales pitch, it was a way to convince my father to seize the opportunity. I always knew what my mum and dad were watching on the telly when I visited for dinner because I could hear it as soon as I began to walk down the long driveway to their front door. The visit had to be timed to perfection because the door would be unlocked waiting for me. Because, well, they'd never hear the doorbell, would they?

The Wolsey stuttered, fumed, and clanged its way into a parking spot in front of the shops in Milford on Auckland's North Shore. Helping my father out of the driver's seat with his walking stick, we made our way onto the pavement where, suddenly, he stopped and said "I don't know Dave, my ear seems good today." My heart sank, but my quick reply "Well, that means it's a great time to get it done Dad because you'll ace the test!" seemed to satisfy him. "Well, we're here now so we might as well get it over with. It'll make your mother happy." So in we went and after a few minutes of form-filling and questions my father entered a booth ready for the test. I sat watching and tried very hard not to nod one way or the other when he repeated words into the microphone as he constantly tried to catch my eye for confirmation that he'd got it right. It was challenging, both for me wanting to help and reassure, and for both of us because while he'd been in New Zealand for over 30 years, he'd never – or so it now seemed – quite got attuned to the accent. "Ten" sounds like "tin" and chips is "chups." Many words he misunderstood, perhaps for that reason as much as a hearing issue, but in the end, there was no doubt, the results were in. My father was pretty much operating at less than 40% in one ear. The shock, for him at least, was that he was only scoring around 60% in the other. It turned out my father believed he had a "good" ear and a "bad" ear, and now he knew something different.

While he was perusing the graphs and tables and explanations that had been handed to him, I surreptitiously handed over my credit card so they could order two hearing aids for him. He saw me do this and got a little annoyed that I'd done it without checking with him first, but I told him, stretching the truth, that they'd offered a "two for one" deal which I couldn't refuse and we could sort it later. I could always cancel the order. I also told him that if he only wanted to use the one for his "bad" ear, that

would be fine. A frantic hand gesture, thankfully unnoticed by my father, was needed to keep the assistant from protesting that this was not at all how hearing aids worked.

We tumbled out onto the pavement, my father clutching his walking stick so hard that I could see the whites of his knuckles. I said let's go for a coffee and a bun, and he nodded, visibly still upset. After a few yards, I realized he was shaking, so I guided him into a bank where there were two of those inviting plush armchairs for customers. "Why are we here?" he asked? "I thought you needed to rest for a bit Dad," I said, "and I'll get some money out . . . sometimes they even offer free coffee, at least my bank back in Ottawa does." We sat in the comfy chairs for several minutes looking out onto the street, at the shops across the road, and the passers-by. Suddenly, my father gripped my wrist more tightly than I'd ever remembered. "Dammit," he said, shocking me even more because my father never swore. "What it is Dad?" I asked, worried that he was having some sort of seizure. "You know something Dave?" he said, "I'm an old man!"

Activity Five: Gaming the Past

Human play ("homo ludens") was a key insight offered by cultural historian Johan Huizinga, and it has been referenced frequently by historians and scholars from many disciplines, including, and perhaps more so than any other, those working in the field of game studies. Play is an essential human activity, and playing games situated in and about the past have been present since the very earliest times and in all cultures. A recent exhibit at the Canadian War Museum, *War Games*, offered games ranging from Go and chess to *Settlers of Catan*. This activity is based on one facilitated in my graduate seminar on narrativity and performance in public history by Maxime Durand, historian working with Ubisoft, the creators of the Assassin's Creed series and is offered here with his permission. It invites students to come up with a game narrative, and create characters, events, and actions. It works best in a room where students can write and draw on poster sheets which serve as storyboards and put them around the room, shifting them around as the storyline develops. While we workshopped this as a video game, it has also worked as a way of storyboarding a graphic novel, a documentary, or feature film. Of course, the media shapes the message to some degree.

This activity encourages students to work collaboratively towards the common goal of producing a protype of a game that captures something about the past while also being enjoyable to play (or in the case of a graphic novel, to read etc.). The activity by its very nature means that students wrestle with the "fact" versus "fiction" elements of history writing and history making, and explore their personal boundaries and limits as to what is known and what might have been, between factuality and invention/speculation. This activity relates to discussions in Chapters 4, 5, and 6.

The Activity:

1. The instructor/facilitator outlines the goal of the activity: to come up with five sequenced scenarios for the protype of a game. Students will then make some decisions before working on the five scenarios:

 (i) In which historical period will the game take place? It works best, of course, if several in the class have some prior knowledge and familiarity with the period.
 (ii) What is the overall framework of the game? Where does it begin? Where does it end? What is the ultimate goal?
 (iii) Who is the protagonist? Create a back story for them.

2. Students sketch out five scenarios: a beginning, three events or episodes, and an end. These are recorded on posters and attached to the walls so everyone can see them and they can be moved around as the game develops. There should be a lot of space between the five posters.
3. Students can then be split into five groups each taking one scenario. The object is to centre the narrative on the protagonist/player, creating actions that require choices to be made, the spaces in which these happen, and other characters who may be involved. Completed successfully, the protagonist/player can move onto the next scenario being worked on by another group. The scenario also needs to illustrate the past from various aspects, not only events and biographies but also appearances, sounds, habits, daily life, technologies, and so forth. One very important rule: once new information is added, it should not be removed even if the group decides to put it to one side. This will be helpful in offering options and possibilities at the next stage, but it also allows for all inputs and voices to be valued and recorded.
4. The class comes back together and examines how the game has developed. Actions, spaces, and characters are discussed and the scenarios amended and altered as agreed upon. Scenarios might even be shifted around.
5. The instructor/facilitator plays through the game as the protagonist.
6. The activity concludes with a discussion around several points:

 (i) What compromises had to be made between what is known of the historical record and making sure the game was fun to play?
 (ii) What did the choice of protagonist say about "focalization" (in terms of narrative and performance theory) and "perspective" (in terms of history)?
 (iii) What would players learn about the historical period? What histories were not present in the game?
 (iv) How did our own present shape the past in the game?
 (v) Were there opportunities for players to connect to the past in an emotional way? Why would this be important?

Notes

1 Conquergood, "Performance Studies."
2 Jacqueline Mahoney, "Something Great or Noble: Performing the Life of Johanna Van Gogh Bonger," MA Research Essay, Carleton University, 2023.
3 Mahoney, "Something Great or Noble," 15–24.
4 David Dean, Yana Meerzon, and Kathryn Prince, eds., *History, Memory, Performance* (Basingstoke, Hants: Palgrave Macmillan, 2015); Joël Beddows and Louise Frappier, eds., *Histoire et mémoire au théâtre* (Québec: Presses de l'Université Laval, 2016).

5 See Sandra H. Dudley, "The Power of Things: Agency and Potentiality in the Work of Historical Artifacts," in *A Companion to Public History*, ed. David Dean (Hoboken, NJ and Chichester, West Sussex: Wiley Blackwell, 2018), 187–99.
6 Cantrell and Luckhurst, *Playing for Real*, 54–55.
7 Allessandro Portelli, *The Death of Luigi Trastulli and Other Stories: Form and Meaning in Oral History* (Albany, NY: State University of New York Press, 1991); Martha Rose Beard, "Re-Thinking Oral History – A Study of Narrative Performance," *Rethinking History* 21, no. 4 (2017), 529–48; Steven High, *Oral History at the Crossroads: Sharing Life Stories of Survival and Displacement* (Vancouver: UBC Press, 2014), 241–63; Steven High, "Storytelling, Bertolt Brecht, and the Illusions of Disciplinary History," in *A Companion to Public History*, ed. Dean, 163–74; Pollock, "Moving Histories," 120–35; Stacey Zembrzycki, *According to Baba: A Collaborative Oral History of Sudbury's Ukrainian Community* (Vancouver: University of British Columbia Press, 2014) and "Sharing Authority with Baba." https://www.sudburyukrainians.ca/sharing-authority.

BIBLIOGRAPHY

Published Works

Abiola, Ofosuwa M., *History Dances: Chronicling the History of Traditional Mandinka Dance* (London and New York: Routledge, 2019).

Abreu, Martha, and Hebe Mattos, "Memories of Captivity and Freedom in São José's *Jongo* Festivals." In *American Heritage and Memories of Slavery in Brazil and the South Atlantic World*, edited by Ana Lucia Araujo (Cambria Press, 2015), 149–77.

Agnew, Vanessa, "History's Affective Turn: Historical Reenactment and Its Work in the Present." *Rethinking History* 11, no. 3 (2007), 299–312.

Agnew, Vanessa, Jonathan Lamb, and Juliane Tomann, *The Routledge Handbook of Reenactment Studies* (New York and London: Routledge, 2021).

Anable, Aubrey, *Playing with Feelings: Video Games and Affect* (Minneapolis: University of Minnesota Press, 2018).

Bachmann-Medick, Doris, *Cultural Turns: New Orientations in the Study of Culture* (Berlin: De Gruyter, 2016).

Bal, Mieke, *Narratology: Introduction to the Theory of Narrative* (3rd ed., Toronto: University of Toronto Press, 2009).

Barthes, Roland, *Camera Lucida: Reflections on Photography* (New York: Hill and Wang, 1981).

Barthes, Roland, *Michelet* (Oxford: Basil Blackwell, 1987).

Barthes, Roland, *The Rustle of Language* (Berkley and Los Angeles: The University of California Press, 1989).

Bauman, Richard, *Verbal Art as Performance* (Prospect Heights, IL: Waveland Press, 1974).

Bauman, Richard, *Story, Performance, and Event: Contextual Studies of Oral Narratives* (Cambridge: Cambridge University Press, 1986).

Beard, Martha Rose, "Re-Thinking Oral History – A Study of Narrative Performance." *Rethinking History* 21, no. 4 (2017), 529–48.

Beattie, Ashlee, "Interpreting the Interpreter: Is Live Historical Interpretation Theatre at National Museums and Historic Sites Theatre?" *EXARC* 2 (2014). https://exarc.net/

issue-2014-2/int/interpreting-interpreter-live-historical-interpretation-theatre-national-museums-and-historic-sites.

Beaumont, Réa, "Composer Harry Somers Adopts a Modern Tone in *Louis Riel*," Canadian Opera Company, *Louis Riel/Tosca* Program (Spring 2017), 14–15.

Becker, A. L., and Aram A. Yengoyan, eds., *The Imagination of Reality: Essays in Southeast Asian Coherence Systems* (Norwood, NJ: Ablex Publishing Corporation).

Beddows, Joël, and Louise Frappier, eds., *Histoire et mémoire au théâtre* (Québec: Presses de l'Université Laval, 2016).

Bencard, Adam, "Presence in the Museum: On Metonymies, Discontinuity and History Without Stories." *Museum and Society* 12, no. 1 (2014), 29–43.

Benjamin, Walter, *Illuminations: Essays and Reflections* (Berlin: Schochen, 1989).

Bennett, Tony, *The Birth of the Museum: History, Theory, Politics* (New York and London: Routledge, 1995).

Bergan, Ronald, *Sergei Eisenstein: A Life in Conflict* (New York: Overlook Press, 1999).

Berner, Elias, "'Remember Me, But Forget My Fate' – The Use of Music in *Schindler's List* and *In Darkness*." *Holocaust Studies* 27, no. 2 (2021), 156–70.

Bhabha, Homi, "Of Mimicry and Man: The Ambivalence of Colonial Discourse." *October* 28 (1988), 124–33.

Biel, Mieke, *Narratology: Introduction to the Theory of Narrative* (3rd ed., Toronto: University of Toronto Press, 2009).

Birney, Anne E., and Joyce M. Thieren, *Performing History: How to Research, Write, Act, and Coach Historical Performance* (Lanham, MD: Rowman & Littlefield, 2018).

Blackburn, Stuart, *Inside the Drama-House: Rāma Stories and Shadow Puppets in South India* (Berkeley: University of California Press, 1996).

Bloom, Harold, *Shakespeare: The Invention of the Human* (New York: Riverhead Books, 1998).

Boal, Augusto, *Theatre of the Oppressed* (London: Pluto Press, 2019).

Boddice, Rob, *The History of Emotions* (Manchester: Manchester University Press, 2018).

Boddice, Rob, *A History of Feelings* (London: Reaction Books, 2019).

Boddice, Rob, and Mark Smith, *Emotion, Sense, Experience* (Cambridge: Cambridge University Press, 2020).

Bokor, Michael J. K., "When the Drum Speaks: The Rhetoric of Motion, Emotion, and Action in African Societies." *Rhetorical: A Journal of the History of Rhetoric* 32, no. 2 (2014), 165–94.

Bower, Shannon, "'Practical Results': The Riel Statue Controversy at the Manitoba Legislative Building." *Manitoba History* 42 (2001–2002), 30–38.

Branigan, Tania, *Red Memory: The Afterlives of China's Cultural Revolution* (New York: W.W. Norton, 2023).

Braz, Albert, "Singing *Louis Riel*: The Centennial Quest for Representative Canadian Heroes." *Canadian Review of Comparative Literature* 47, no. 1 (2020), 107–22.

Brecht, Bertolt, *Brecht on Theatre: The Development of an Aesthetic* (London: Methuen, 1964).

Breisach, Ernst, *Historiography. Ancient & Modern* (2nd ed., Chicago: University of Chicago Press, 1994).

Brown, Paul, ed., *Verbatim. Staging Memory & Community* (Strawberry Hills, NSW: Currency Press, 2010).

Brydon, Diana, and Irena R. Makaryk, eds., *Shakespeare in Canada: 'A World Elsewhere'?* (Toronto: University of Toronto Press, 2002).

Büchner, Georg, *Danton's Death: A New Version by Howard Brenton* (London: Methuen, 2010).
Budd, Malcolm, *Music and the Emotions* (London: Routledge, 1985).
Burke, Peter, "Performing History: The Importance of Occasions." *Rethinking History* 9, no. 1 (2005), 35–52.
Burton, Antoinette, *Dwelling in the Archive: Women, Writing House, Home, and History in Late Colonial India* (Oxford: Oxford University Press, 2003).
Butler, Judith, "Performative Acts and Gender Constitution: An Essay in Phenomenology and Feminist Theory." *Theatre Journal* 40, no. 4 (1988), 519–31.
Canadian Opera Company, *Louis Riel/Tosca Program* (Spring, 2017).
Canadian Opera Company, "Media Release Louis Riel," https://coc-learn-staging.coc.ca/about-the-coc/media?entryid=15316.
Cantrell, Tom, *Acting in Documentary Theatre* (Basingstoke, Hampshire: Palgrave, 2013).
Cantrell, Tom, and Mary Luckhurst, eds., *Playing for Real: Actors on Playing Real People* (Basingstoke, Hampshire: Palgrave, 2010).
Carlson, Marvin, *Performance: A Critical Introduction* (London: Routledge, 2017).
Carrington, John F., "The Talking Drums of Africa." *Scientific American* 225, no. 6 (1971), 90–95.
Cauvin, Thomas, Joan Cummins, David Dean, and Andreas Etges. "'Follow the North Star: A Participatory Museum Experience,' Conner Prairie, Fishers, Ind." *Journal of American History* 105, no. 3 (2018), 630–36.
Chang, Justin, "Film Review: 'The Witch.'" *Variety*, 23 January 2015. https://variety.com/2015/film/reviews/sundance-film-review-the-witch-1201411310/.
Chapman, Adam, *Digital Games as History: How Videogames Represent the Past and Offer Access to Historical Practice* (New York and London: Routledge, 2016).
Charry, Eric, *Mande Music: Traditional and Modern Music of the Maninka and Mandinka of West Africa* (Chicago and London: The University of Chicago Press, 2000).
Cheetham, Mark A., Elizabeth Legge, and Catherine M. Soussloff, eds., *Editing the Image: Strategies in the Production and Reception of the Visual* (Toronto: University of Toronto Press, 2008).
Cherney, Brian, *Harry Somers* (Toronto: University of Toronto Press, 1975).
Collingwood, R. G., *The Idea of History* (Oxford: Clarendon Press, 1946).
Conard, Rebecca, "Complicating Origin Stories: The Making of Public History into an Academic Field in the United States." In *A Companion to Public History*, edited by David Dean (Hoboken, NJ and Chichester, West Sussex: Wiley Blackwell), 19–32.
Conquergood, Dwight, "Performance Studies." *The Drama Review* 46, no. 2 (2002), 146–56.
Conrad, Margaret, Kadriye Ercikan, Gerald Friesen, Jocelyn Létourneau, Delphin Andrew Muise, David Northrup, and Peter Seixas, *Canadians and Their Pasts* (Toronto: University of Toronto Press, 2013).
Cooke, Mervyn, *A History of Film Music* (Cambridge: Cambridge University Press, 2008).
Cruikshank, Julie, *The Social Life of Stories: Narrative and Knowledge in the Yukon Territory* (Lincoln, NE: Nebraska University Press, 1998).
Cruikshank, Julie, in collaboration with Angela Sidney, Kitty Smith, and Annie Ned, *Life Lived Like a Story: Life Stories of Three Yukon Native Elders* (Lincoln, NE and London: University of Nebraska Press, 1990).

Cusack, Peter, *Sounds From Dangerous Places* (Berlin: ReR Megacorp and Berliner Künstlerprogamm des DADD, 2012).
Daley, Bronwyn, and Jock Philips, eds., *Going Public: The Changing Face of New Zealand History* (Auckland: Auckland University Press, 2001).
Danckert, Paula, "Louis Riel: History, Theatre, and a National Narrative – An Evolving . . . Story." *University of Toronto Quarterly* 87, no. 4 (2018), 39–50.
Davis, Natalie Zemon, "'Any Resemblance to Persons Living or Dead': Film and the Challenge of Authenticity." *Historical Journal of Film, Radio and Television* 8, no. 3 (1987), 269–83.
Davis, Natalie Zemon, "On the Lame." *American Historical Review* 93, no. 3 (1988), 572–603.
Davis, Natalie Zemon, "Movie of Monograph? A Historian/Filmmaker's Perspective." *The Public Historian* 25, no. 3 (2003), 45–48.
Davis, Tracy C., ed., *The Cambridge Companion to Performance Studies* (Cambridge: Cambridge University Press, 2008).
de Certeau, Michel, *The Practice of Everyday Life* (Berkley, Los Angeles, and London, 1988a).
de Certeau, Michel, *The Writing of History* (New York, NY: Columbia University Press, 1988b).
de Groot, Jerome, *Remaking History: The Past in Contemporary Fictions* (London and New York: Routledge, 2016).
de Oliveira, Susan, and Ellen Berezoschi, "Jongo: do cativeiro à força das ruas." *Esclavages & Postesclavages* 7 (2022), 4–5.
Dean, David, "Staging the Settlement: Shekhar Kapur and the Parliament of 1559." In *Managing Tudor and Stuart Parliaments: Essays in Memory of Michael Graves*, edited by Chris R. Kyle, *Parliamentary History* 31, no. 1 (2015), 30–44.
Dean, David, "Negotiating Accuracy and Authenticity in an Aboriginal King Lear." *Rethinking History* 21, no. 2 (2017), 255–73.
Dean, David, *A Companion to Public History* (Hoboken, NJ and Chichester, West Sussex: Wiley Blackwell, 2018).
Dean, David, Yana Meerzon, and Kathryn Prince, eds., *History, Memory, Performance* (Basingstoke, Hants: Palgrave Macmillan, 2015).
Dening, Greg, "The Theatricality of History Making and the Paradoxes of Acting." *Cultural Anthropology* 8, no. 1 (1993), 73–95.
Dening, Greg, *Performances* (Chicago: Chicago University Press, 1996).
Dening, Greg, "Performing on the Beaches of the Mind: An Essay." *History and Theory* 41, no. 1 (2002), 1–24.
Derrida, Jacques, *Archive Fever: A Freudian Impression* (Chicago: University of Chicago Press, 1991).
Domingues-Delgado, Rubén, and Maria Ángelos López-Hernández, "In Memoriam Boleslaw Matuszewski: The Origin of Film Librarianship." *Proceedings of the Association for Information Science and Technology* 56, no. 1 (2019), 636–38.
Douglas, Rachel, *Making the Black Jacobins. C.L.R. James and the Drama of History* (Durham and London: Duke University Press, 2019).
Ebron, Paulla A., *Performing Africa* (Princeton and Oxford: Princeton University Press, 2002).
Elton, G. R., *The Practice of History* (London: Fontana, 1967).
Elton, G. R., *Return to Essentials: Some Reflections on the Present State of Historical Study* (Cambridge: Cambridge University Press, 1991).
Ericson, Raymond, "'Louis Riel,' Music Drama, Presented in Toronto." *The New York Times*, September 25, 1967, 55.

Etges, Andreas, "Stories From a Dusty Basement: A Conversation with Richard Conyngham on All Rise: Resistance and Rebellion in South Africa (1910–1948) – A Graphic History." *International Public History* 6, no. 1 (2023), 55–71.
Finlay, Robert, "The Refashioning of Martin Guerre." *American Historical Review* 93, no. 3 (1988), 533–71.
Finney, Patrick, ed., *Authenticity: Reading, Remembering, Performing* (London and New York: Routledge, 2019).
Forsyth, Alison, and Chris Megson, eds., *Get Real: Documentary Theatre Past and Present* (Basingstoke, Hants: Palgrave, 2009).
Frevert, Ute, "Affect Theory and History of Emotions." *Bloomsbury History: Theory and Method Articles*. Accessed October 18, 2021. https://doi.org/10.5040/9781350970878.069.
Frieze, James, *Reframing Immersive Theatre: The Politics and Pragmatics of Participatory Performance* (London: Palgrave Macmillan, 2016).
Fuentes, Marisa J., *Dispossessed Lives: Enslaved Women, Violence, and the Archive* (Philadelphia: University of Pennsylvania Press, 2016).
Ganguly, Sanjoy, *Jana Sanskriti: Forum Theatre and Democracy in India* (London: Taylor and Francis, 2010).
Gareau, Paul, speaking with Nisha Sajnani, "Coming into Presence. Discovering the Ethics and Aesthetics of Performing Histories Within the Montreal Life Stories Project," in "Oral History & Performance (Part I)." *alt.theatre* 9, no. 1 (2011), 45.
Gilbert, Felix, *History: Politics or Culture? Reflections on Ranke and Burckhardt* (Princeton: Princeton University Press, 1990).
Gilbert, Lisa, "'Assassin's Creed Reminds Us That History is Human Experience': Student's Senses of Empathy While Playing a Narrative Video Game." *Theory & Research in Social Education* 47, no. 1 (2019), 119–32.
Gill, Joe, "From the Jungle to the West End: 'It's Not About Refugees, It's About Humans." *Middle East Eye*, July 17, 2018. https://www.middleeasteye.net/features/jungle-west-end-its-not-about-refugees-its-about-humans.
Goffman, Erving, *Presentation of the Self in Everyday Life* (London: Anchor, 1959).
Goldblatt, Cullen, *Beyond Collective Memory, Beyond Structural Complicity and Future Freedoms in Senegalese and South African Narratives* (New York and London: Routledge, 2021).
Gordon, A. F., *Ghostly Matters: Haunting and the Sociological Imagination* (Minneapolis, MN: University of Minnesota Press, 2008).
Greenblatt, Stephen, *Shakespearean Negotiations: The Circulation of Social Energy in Renaissance England* (Berkeley: University of California Press, 1988).
Guay-Bélanger, Dany, "'How Do We Play This Thing?': The State of Historical Research on Videogames." *International Public History* 4, no. 1 (2021), 1–6.
Guynn, William, *Writing History in Film* (London and New York: Routledge, 2006).
Hall, Stuart, "Breaking Bread with History: C.L.R. James and *The Black Jacobins*." Stuart Hall interviewed by Bill Schwarz, *History Workshop Journal* 46 (1998), 26–27.
Hamilton, Paula, and Paul Ashton, *Australians and the Past* (Perth, Western Australia: University of Queensland Press, 2003).
Hammond, Will, and Dan Steward, *verbatim, Contemporary Documentary Theatre* (London: Oberon Books, 2008).

Handler, Richard, and Eric Gable, *The New History in an Old Museum: Creating the Past at Colonial Williamsburg* (London and Durham, NC: Duke University Press, 1997).

Handler, Richard, and William Saxton, "Dyssimulation: Reflexivity, Narrative, and the Quest for Authenticity in 'Living History.'" *Cultural Anthropology* 3, no. 3 (August 1988), 242–60.

Hartley, L. P., *The Go-Between* (London: Hamish Hamilton, 1953).

Hartman, Abbie, Rowan Tulloch, and Helen Young, "Video Games as Public History: Archives, Empathy, and Affinity." *Game Studies* 21, no. 4 (2021). https://gamestudies.org/2104/Hartman_tulloch_young.

Hartman, Saidiya, "Venus in Two Acts." *Small Axe: A Journal of Criticism* 12, no. 2 (2008), 1–14.

Hartman, Saidiya, "An Unnamed Girl, A Speculative History." *The New Yorker*, February 9, 2019.

Hartman, Saidiya, *Wayward Lives, Beautiful Experiments. Intimate Histories of Riotous Black Girls, Troublesome Women, and Queer Radicals* (New York: W.W. Norton, 2019).

Helgeby, Stein, *Action as History: The Historical Thought of R.G. Collingwood* (Exeter: Imprint Academic, 2004).

Hellemann, Phelemo C., "Negotiating Public Participation Through Dance and Drama Techniques: A Roundtable Discussion on the Challenges of Public History Work by the Isikhumbuzo Applied History Unit in South Africa." *International Public History* 2, no. 1 (2019).

Herman, David, ed., *The Cambridge Companion to Narrative* (Cambridge: Cambridge University Press, 2007).

Hettiarachchi, Radhika, ed., *We Are Present: Women's Histories of Conflict, Courage, and Survival* (New York: International Coalition of Sites of Conscience, 2022).

Hettiarachchi, Radhika, and Samal Vimukthi Hemachandra, "Memoryscapes: The Evolution of Sri Lanka's *Aragala Bhoomiya* as a People's Space of Protest." *International Public History* 6, no. 2 (2023), 75–90.

High, Steven, *Oral History at the Crossroads: Sharing Life Stories of Survival and Displacement* (Vancouver and Toronto: University of British Columbia Press, 2014).

Hinton, Peter, "'Notes,' Canadian Opera Company, *Louis Riel/Tosca* Program (Spring 2017), 9 Reprinted as 'Director's Notes.'" *University of Toronto Quarterly* 87, no. 4 (2018), 37–38.

Hokari, Minoru, *Gurindji Journey: A Japanese Historian in the Outback* (Honolulu: University of Hawai'i Press, 2011).

Horwitz, Tony, *Confederates in the Attic: Dispatches From the Unfinished Civil War* (New York, NY: Vintage Books, 1998).

Jackson, Anthony, and Jenny Kidd, eds., *Performing Heritage: Research, Practice and Innovation in Museum Theatre and Live Interpretation* (Manchester: Manchester University Press, 2011).

James, C. L. R., *The Black Jacobins: Toussaint L'Overture and the San Domingo Revolution* (new ed., London: Allison & Busby, 1980).

Jashuva, Gurram, *Gabbillam: A Dalit Epic*. Translated by Chinnaiah Jangam (New Delhi: Yoda Press, 2022).

Jobin-Bevans, Dean, "The Complexity of Musical Influences From the Opera *Louis Riel*: Vocal Challenges and Performance Perspectives." *The Phenomenon of Singing* 5 (2005), 142–50.

Jordanova, Ludmilla, *History in Practice* (London: Hodder, 2000).

Keeler, Ward, *Javanese Shadow Plays, Javanese Selves* (Princeton, NJ: Princeton University Press, 1987).
Keeler, Ward, *Javanese Shadow Puppets* (Oxford: Oxford University Press, 1992).
Kellner, Hans, *Language and Historical Representation: Getting the Story Crooked* (Madison, Wisconsin: The University of Wisconsin Press, 1989).
Kenyon, Nicholas, ed., *Authenticity and Early Music* (Oxford: Oxford University Press, 1989).
Kidman, Joanna, Vincent O'Malley, Laina Macdonald, Tom Roa, and Keziah Wallis, eds., *Fragments From a Contested Past: Remembering, Denial and New Zealand History* (Wellington: BWB, 2022).
King, Thomas, *The Truth About Stories: A Native Narrative* (Toronto: House of Anansi Press, 2003).
Konte, Lamine, "The Griot, Singer and Chronicler of African Life." *The UNESCO Courier* 4 (1986), 21–25.
Kostova, Elizabeth, *The Historian: A Novel* (New York and Boston: Little, Brown and Company, 2005).
Leyenberger, Arthur, "Interviewing Dan Bunten." *Antic* 3, no. 9 (1985). https://www.atarimagazines.com/v3n9/profiles.html.
Li, Na. "Performing History in China: Cultural Memory in the Present." *International Public History* 5, no. 2 (2022), 127–41.
Logge, Thorsten, Eva Schöck-Quinteros, and Nils Steffan, eds., *Geschichte im Rampenlicht. Inszenierungen historischer Quellen im Theater* (Berlin: De Gruyter Oldenbourg, 2021).
Lowenthal, David, *The Past is a Foreign Country* (Cambridge: Cambridge University Press, 1985).
Loxley, James, *Performativity* (New York and London: Routledge, 2006).
Macdonald, Sharon, *Memorylands: Heritage and Identity in Europe Today* (London and New York: Routledge, 2013).
Magel, Emil A., "The Role of the *Gewel* in Wolof Society: The Professional Image of Lamin Jeng." *Journal of Anthropological Research* 37, no. 2 (1981), 183–91.
Magelssen, Scott, "'This is Drama. You Are Characters.' The Tourist as Fugitive Slave in Conner Prairie's 'Follow the North Star.'" *Theatre Topics* 16, no. 1 (2006), 19–34.
Magelssen, Scott, *Living History Museums: Undoing History Through Performance* (Lanham, MA: The Scarecrow Press, 2007).
Martin, Carol, ed., *Dramaturgy of the Real on the World Stage* (Basingstoke, Hants: Palgrave Macmillan, 2010).
Mattos, Hebe, "Memórias Do Cativeiro: Narrativas E Etnotexto." *História Oral* 8, no. 1 (2009), 54–55.
Mattos, Hebe, and Martha Abreu, "'Remanescentes das Comunidades dos Quilombos': memória do cativeiro, patrimônio cultural e direito à reparação." *Iberoamericana* 11 (2014), 145–58.
Mattos, Renata, "O Jongo: Voz, Ritmo, Memória e Transmissão." *Psicanálise & Barroco em revista* 18, no. 2 (2020), 34–37.
McCalman, Iain, and Paul A. Pickering, eds., *Historical Reenactment: From Realism to the Affective Turn* (Basingstoke, Hants: Palgrave Macmillan, 2010).
Mendes, Ricardo, "Jongo: Atlantic Crossings and Ritual Return to Aruanda." *Letrônica* 15, no. 1 (2022), 1–11.
Meringolo, Denise M., *Museums, Monuments and National Parks: Towards a New Genealogy of Public History* (Amherst and Boston: University of Massachusetts Press, 2012).
Meyer, Leonard B., *Emotion and Meaning in Music* (Chicago: University of Chicago Press, 1956).

Mills, Sandra, "Theatre for Transformation and Empowerment: A Case Study of Jana Sanskriti Theatre of the Oppressed." *Development in Practice* 19, nos. 4–5 (2009), 550–59.
Mrázek, Jan, ed., *Puppet Theater in Contemporary Indonesia: Nee Approaches to Performance Events* (Ann Arbor, MI: University of Michigan, 2002).
Mrázek, Jan, *Phenomenology of a Puppet Theatre: Contemplations on the Art of Javanese wayang kulit* (Leiden: KITLV Press, 2005).
Munslow, Alun, *Narrative and History* (Basingstoke: Palgrave Macmillan, 2007).
Murata, Margaret, "The Recitative Soliloquy." *Journal of the American Musicological Society* 32, no. 1 (1979), 45–49.
Murphy, Joe, and Joe Robertson, *The Jungle* (London: Faber & Faber, 2017).
National Theatre (London), *Danton's Death Program* (August 2010).
Nichols, Bill, *Introduction to Documentary* (2nd ed., Bloomington, IN: Indiana University Press, 2010).
Nielsen, Holly, "Reductive, Superficial, Beautiful – A Historian's View of Assassin's Creed: Syndicate." *The Guardian*, December 9, 2015. https://www.theguardian.com/technology/2015/dec/09/assassins-creed-syndicate-historian-ubisoft.
Novick, Peter, *That Noble Dream: The 'Objectivity Question' and the American Historical Profession* (Cambridge: Cambridge University Press, 1988).
O'Falt, Chris, "How Robert Eggers Used Real Historical Accounts to Create His Horror Sensation the Witch." *IndieWire*, February 19, 2016. http://www.indiewire.com/2016/02/how-robert-eggers-used-real-historical-accounts-to-create-his-horror-sensation-the-witch-67882/.
Okeowo, Alexis, "How Saidiya Hartman Retells the History of Black Life." *The New Yorker*, October 19, 2020.
Okeowo, Alexis, "Secret Histories." *The New Yorker*, October 26, 2020.
Olsen, Bjørnar, and Þóra Pétursdóttir, "Unruly Heritage: Tracing Legacies in the Anthropocene." *Arkæologisk Forum* 35 (2016). http://www.archaeology.dk/upl/16170/AF3508BjrnarOlsenraPtursdttirSRTRYK.pdf.
O'Malley, Sarah, "Witches in Space: An Introduction." *Early Theatre* 26, no. 2 (2023), 131–45.
Ong, Walter S., "African Talking Drums and Oral Noeties." *New Literary History* 8, no. 3 (1977), 411–29.
Parks, Suzan-Lori, *The America Play and Other Works* (New York: Theatre Communications Group, 1995).
Parr, Joy, "Notes for a More Sensuous History of Twentieth-Century Canada: The Timely, the Tacit, and the Material Body." *Canadian Historical Review* 84, no. 4 (2001), 720–45.
Pavis, Patrice, *Dictionary of the Theatre: Terms, Concepts, and Analysis* (Toronto: University of Toronto Press, 1998).
Phillips, Mark Salber, *Society and Sentiment: Genres of Historical Writing in Britain, 1740–1820* (Princeton: Princeton University Press, 2000).
Phillips, Mark Salber, *On Historical Distance* (New Haven and London: Yale University Press, 2013).
Phillips, Mark Salber, Barbara Caine, and Julia Adeney Thomas, eds., *Rethinking Historical Distance* (Basingstoke, Hants: Palgrave Macmillan, 2013).
Pigoń, Jakub, ed., *The Children of Herodotus: Greek and Roman Historiography and Related* (Newcastle Upon Tyne: Cambridge Scholars Publishing, 2008).
Playhouse Theatre (London), *The Jungle Program*, October 2018.
Pojmann, Wendy, Barbar Reeves-Ellington, and Karen Ward Mahar, *Doing History: An Introduction to the Historian's Craft* (Oxford: Oxford University Press, 2015).

Portelli, Allessandro, *The Death of Luigi Trastulli and Other Stories: Form and Meaning in Oral History* (Albany, NY: State University of New York Press, 1991).
Posner, Dassia N., Claudia Orenstein, and John Ball, eds., *The Routledge Companion to Puppetry and Material Performance* (New York and London: Routledge, 2015).
Price, Tanya Y., "Rhythms of Culture: Djembe and African Memory in African-American Cultural Traditions." *Black Music Research Journal* 33, no. 2 (2013), 227–47.
Proot, Goran, "Miracles Latey Vvrovght: The Use of 'vv' for 'w' in 17th-Century Titles." https://www.folger.edu/blogs/collation/miracles-lately-vvrovght-the-use-of-vv-for-w-in-17th-century-titles/.
Revnov, Michael, ed., *Theorizing Documentary* (London and New York: Routledge, 1993).
Ricoeur, Paul, *Time and Narrative*, Vol. 3 (Chicago and London: The University of Chicago Press, 1985).
Roach, Joseph, *Cities of the Dead: Circum-Atlantic Performance* (New York, NY: Columbia University Press, 1996).
Robinson, Dylan, Wal'aks Keane Tait, and Goothl Ts'imilx Mike Dangeli, "The Nisga'a History of the 'Kuyas' Aria." *Canadian Opera Company, Louis Riel/Tosca Program* (Spring 2017), 15.
Rokem, Freddie, *Performing History: Theatrical Representations of the Past in Contemporary Theatre* (Iowa City: Iowa University Press, 2000).
Rosenzweig, Roy, and David Thelen, *The Presence of the Past: Popular Uses of History in American Life* (New York: Columbia University Press, 1998).
Rosmus, Anna, "From Reality to Fiction: Anna Rosmus as the 'Nasty Girl.'" *Religion and the Arts* 4, no. 1 (2000), 113–43.
Roulston, Keith, "On the Farm Show." *The Rural Voice*, Monday, August 15, 2022. ruralvoice.ca/the-farm-show-a-foundational-moment-in-theatre-by-keith-rouston.
Sachs, Albie, *The Soft Vengeance of a Freedom Fighter* (Oakland: University of California Press, 2014).
Sajnani, Nisha, "Coming into Presence: Discoverint the Ethics and Aesthetics of Performing Histories Within the Montreal Life Stories Project." *Alt. Theatre: Cultural Diversity and the Stage* 9, no. 1 (2011), 40–49.
Salas, Jo, *Improvising Real Life: Personal Story in Playback Theatre* (New Platz, NY: Tusitala Publishing, 2013).
Salevouris, Michael J., and Conal Furay, *The Methods and Skills of History: A Practical Guide* (New York: Wiley Blackwell, 1988).
Samuel, Raphael, *Theatres of Memory, Volume 1: Past and Present in Contemporary Culture* (London: Verso, 1994).
Saxton, Laura, "A True Story: Defining Accuracy and Authenticity in Historical Fiction." *Rethinking History* 24, no. 2 (2020), 127–44.
Schechner, Richard, *Between Theater and Anthropology* (Philadelphia: University of Pennsylvannia Press, 1985).
Schechner, Richard, *Performance Studies: An Introduction* (2nd ed., New York: Routledge, 2002).
Schlehe, Judith, Michiko Uike-Bormann, Carolyn Oesterle, and Wolfgang Hochbruck, *Staging the Past: Themed Environments in Transcultural Perspectives* (Bielefeld: Transkript, 2002).
Schneider, R., *Performing Remains: Art and War in Times of Theatrical Reenactment* (New York and London: Routledge, 2011).

Schulz, Dorothea, "Praise Without Enchantment: Griots, Broadcast Media, and the Politics of Tradition in Mali." *Africa Today* 44, no. 4 (1997), 443–64.
Scott, Joan, "Storytelling." *History and Theory* 50, no. 2 (2011), 203–9.
Shaw, Adrienne, "The Tyranny of Realism: Historical Accuracy and Politics of Representation in Assassin's Creed III." *The Journal of the Canadian Game Studies Association* 9, no. 14 (2015), 4–24.
Smith, Mark M., *Sensing the Past: Seeing, Hearing, Smelling, Tasting, and Touching in History* (Berkeley and Los Angeles: University of California Press, 2007).
Smith, Shawn Michelle, *Photography on the Color Line. W.E.B. Du Bois, Race, and Visual Culture* (Durham, NC and London: Duke University Press, 2004).
Snow, Stephen Eddy, *Performing the Pilgrims: A Study of Ethnohistorical Role-Playing at Plimoth Plantation* (Jackson, MS: University of Mississippi Press, 1993).
Somers, Harry, *Louis Riel: An Opera in Three Acts* (s.l., s.n., c.1967).
Sousanis, Nick, *Unflattening* (Cambridge, MA: Harvard University Press, 2015).
Soutar, Annabel, "Reality as Poetic Narrative." *Alt. Theatre* 9, no. 1 (2011), 21–32.
Steblin, Rita, *A History of Key Characteristics in the Eighteenth and Early Nineteenth Centuries* (Ann Arbor: UMI Research Press, 1983).
Steedman, Carolyn, *Dust: The Archive and Cultural History* (New Brunswick, NJ: Rutgers University Press, 2002).
Stern, Fritz, *The Varieties of History: From Voltaire to the Present* (2nd ed., New York: Vintage, 1973).
Stoler, Ann Laura, *Along the Archival Grain: Epistemic Anxieties and Colonial Common Sense* (Princeton: Princeton University Press, 2009).
Taylor, Diana, *The Archive and the Repertoire: Performing Cultural Memory in the Americas* (Durham, NC and London: Duke University Press, 2003).
Theatre Pass Muraille, *The Farm Show* (Toronto: The Coach House Press, 1976).
Thompson, E. P., *The Making of the English Working Class* (Harmondsworth, UK: Penguin, 1968).
Tivedi, Saam, *Imagination, Music, and the Emotions: A Philosophical Study* (Albany, NY: State University of New York Press, 2017).
Torre, Giovanni, "New Zealand Divided as Replica of Captain Cook's Endeavour Marks 250th Anniversary Landing." *The Daily Telegraph*, October 8, 2019. Accessed March 23, 2024. https://www.telegraph.co.uk/news/2019/10/08/new-zealand-divided-replica-captain-cooks-endeavour-marks-250th/.
Trouillot, Michel-Rolph, *Silencing the Past: Power and the Production of History* (Massachuetts: Beacon Press, 1995).
Tyson, Amy M., *The Wages of History: Emotional Labor on Public History's Front Lines* (Amherst and Boston: University of Massachusetts Press, 2013).
Van Groenendael, Victoria M. Clara, *The Dalang Behind the Wayang* (Dordrecht: Foric Publications, 1985).
Varutti, Marzia, "The Affective Turn in Museums and the Rise of Affective Curatorship." *Museum Management and Curatorship* 38, no. 1 (2022), 61–75.
Verstraten, Peter, *Film Narratology* (Toronto: University of Toronto Press, 2009).
Weintraub, Andrew N., *Power Plays: Wayang Golek Puppet Theatre of West Java* (Athens: Ohio University Research in International Studies, 2004).
Weiss, Peter, "The Material and the Models: Notes Towards a Definition of Documentary Theatre." *Theatre Quarterly* 1, no. 1 (1971), 41–43.
Weld, Kirsten, *Paper Cadavers: The Archives of Dictatorship in Guatemala* (Durham and London: Duke University Press, 2014).
White, Hayden, *The Content of the Form: Narrative Discourse and Historical Representation* (Baltimore, MD: Johns Hopkins University Press, 1987).

White, Hayden, "Historiography and Historiophoty." *American Historical Review* 92, no. 5 (1988), 1193–99.
White, Hayden, "Introduction: Historical Fiction, Fictional History, and Historical Reality." *Rethinking History* 9, nos. 2/3 (2005), 147–57.
Wind, Tony Leigh, *Black Women's Literature of the Americas: Griots and Goddesses* (London and New York: Routledge, 2023).
Winton, Dean, "The Performance of Recitative in Late Baroque Opera." *Music & Letters* 58, no. 4 (1977), 389–91.
Worthen, W. B., *Shakespeare Performance Studies* (Cambridge: Cambridge University Press, 2014).
Woydon, Joanna, and Dorota Wiśniewska, eds., *Public in Public History* (New York and London: Routledge, 2021).
Yates, David, "Orange Order Was Once Clinton's Most Popular Fraternal Organization." *Goderich Signal-Star*, July 2, 2020. https://www.goderichsignalstar.com/opinion/columnists/orange-order was-once-clintons-most-popular-fraternal-organization-2.
Zembrzycki, Stacey, *According to Baba: A Collaborative Oral History of Sudbury's Ukrainian Community* (Vancouver: University of British Colombia Press, 2014).

Unpublished

Adamek, Anna, "Multi-Object Acquisition Proposal" Document Re: Goldcorp Canada Ltd., February 21, 2018, Canada Museum of Science and Technology.
Boschmann, Kathryn, "Capturing Oma and Opa: A Reflection," (Paper Submitted for HIST 5702X Narrativity and Performance in Public History, April, 2014).
Chiblow, Liane, "My Cat Ate the Bannock" & the Story of Verna Patronella Johnston: A Reflection," (Paper Submitted for HIST 5702X Narrativity and Performance in Public History, April, 2018).
Cox, Fiona Sinead, "The Farm Show Show," (Script Submitted for HIST 5702X Narrativity and Performance in Public History, April, 2014).
Davis, Natalie Zemon, Personal Communication, June 1, 2010, Post Round-Table on "Theatre, History, Storytelling" with Natalie Zemon Davis, David Fennario, Edward (Ted) little, and David Dean, Canadian Historical Association Annual Conference, Concordia University, Montreal, Canada.
Duthie, Rick, "'One Day Stronger': A Public History Theatrical Experiment About Remembered Sudbury Strikes, 1958–2010." PhD Thesis, Carleton University, 2021.
English Theatre, National Arts Centre (Ottawa, Canada), *King Lear* Script (2012). In author's possession.
Gallupe-Paton, Meranda, "Memories of Mechanicsville: A Personal Public History." (Major Research Essay for the MA in Public History with Specialization in Digital Humanities, Carleton University, 2022).
Germain, Rowen, "The Letter." (Paper Submitted for HIST 5702X Narrativity and Performance in Public History, April 2018).
Hinton, Peter, Email to the National Art Centre's English Theatre Company performing King Lear, February 21, 2012 (Author's Possession).
Lee, Suki, "Lunatic Asylums as Factories: A Nineteenth-Century Narrativity and Performance Study Based on Stories of Annie May Pernet, Emma Copper, Mary Huestis Pengully, and Elizabeth Packard" (Paper Submitted for HIST 5702X Narrativity and Performance in Public History, May 2014).

MacDonald, Amy, "Come Ceilidh on Cape Breton Island: A Reflection," (Paper Submitted for HIST 5702X Narrativity and Performance in Public History, April 2014).
MacDonald, Amy, "'Time Crossing Liaisons': Interpreter/Character Relationships at the Fortress of Louisbourg National History Site." M.A. Research Essay, Carleton University, 2015.
Mahoney, Jacqueline, "Something Great or Noble: Performing the Life of Johanna Van Gogh Bonger." MA Research Essay, Carleton University, 2023.
Nixon, Sara, "Layers: Performing Community Within Grimsby, Ontario's Main Street." https://www.youtube.com/watch?v=yLoGGEgnaIs.
Siebert, David, "Unruly Remains: Heritage Values and the Afterlives of CFS Carp," (Presentation Performed and Submitted for HIST 5707 Narrativity and Performance in Public History, April 2020).
Smith, Allison Margot, "Eighty Years of History in Sixteen Lines," (Paper Submitted for HIST 5702X Narrativity and Performance in Public History, April 2014).
Zapf, Donna, and Anne Doris, "Singing History, Performing Race: An Analysis of Three Canadian Operas: *Beatrice Chancy*, *Elsewhereness*, and *Louis Riel*." PhD Dissertation, University of Victoria, 2004.
Zinck, Andrew Michael, "Music and Dramatic Structure in the Operas of Harry Somers," PhD Dissertation, University of Toronto, 1996.

Media and Websites

"Assassin's Creed," https://www.ubisoft.com/en-ca/game/assassins-creed/assassins-creed.
"The 100 Best History Books of All Time," https://www.listmuse.com/100-best-history-books-time.php.
"Blood Harmony," Written by Tyler Bryant, Rebecca Lovell, Kevin-John McGowan 2022, Performed by Larkin Poe, https://www.azlyrics.com/lyrics/larkinpoe/bloodharmony.html.
Bowie, Geoff, dir., *The Universal Clock – The Resistance of Peter Watkins* (National Film Board of Canada, 2001, 76 mins).
Canadian Museum of History, "View the Morning Star – Gambeh Then' Interpretive Platform," https://www.historymuseum.ca/cmc/exhibitions/tresors/treasure/283eng.html.
Carleton Centre for Public History, Danielle Mahon interviews Allison Margot Smith, https://carleton.ca/ccph/cu-videos/interview-with-allison-margot-smith-1-2/.
Cohen, g, "On Writing" (National Jewish Theatre, 2014) *Digital Theatre +* (2021).
Dewa Ruci [The Resplendent God] 2008, Contemporary Wayang Archive, https://cwa-web.org/en/DewaRuci.
Dosse, Jeanne, dir., *Jana Sanskriti: A Theatre on the Field* (Jeanne Dosse, 2005, 53 mins) *Digital Theatre+* (2021).
Durand, Maxime, "From Dreams to Realities: Performing History in the Assassin's Creed@Video Game Series," Shannon Lecture, October 23, 2015, Carleton University, Ottawa.
Fernandez, Guilerme, and Isabel Castro, dirs., *Memórias do Cativerior* (LABHOI, 2005, 41'), YouTube, https://www.youtube.com/watch?v=JEw4k8Wpofw.
Hartman Saidiya, and Arthur Jafa in Conversation, Recorded Hammer Museum June 6, 2019, Hammer Channel, https://channel.hammer.ucla.edu/video/601/saidiya-hartman-arthur-jafa-in-conversation.
Ingenium, "Uncovering History through the Dome Mine Doors," YouTube (2021), https://www.youtube.com/watch?v=Cen1ECYE98Q.

Kouyaté, Dani, dir., *Keita! L'heritage du griot* (1994), https://youtu.be/yzqbaFH14CQ?feature=shared).
"Let's Play! Svoboda 1945 – Liberation," https://koerber-stiftung.de/en/projects/ecommemoration/ecommemoration-convention-2021/.
Mattos, Hebe, and Martha Abreu, dirs., *Jongos Calangos e Folias, Música Negra, memória e poesia* (LABHOI, 2011, 48 mins), YouTube, https://www.youtube.com/watch?v=DB_AHH3xXYQ&ab_channel=Resist%C3%AAnciaSambadeRaiz.
McVinnie, Sophie, "'Anyone Who Has Siblings Knows How Occasionally Fraught the Relationship Can Get' Larkin Poe on Why Their New Album is More of a Family Affair Than Ever," November 10, 2022, https://guitar.com/features/interviews/larkin-poe-new-ep-blood-harmony/.
Merriam-Webster, "Word of the Year 2023," https://www.merriam-webster.com/wordplay/word-of-the-year.
Mittlemann, Arnold, dir., *The Soap Myth* (National Jewish Theatre, 2012, 80 mins). *Digital Theatre+* (2020).
National Council on Public History, "What is Public History?" https://ncph.org/what-is-public-history/about-the-field/.
Ondaatje, Michael, dir., *The Clinton Special: A Film About the Farm Show* (1974, 79 mins).
Radio New Zealand, "Protest and hope as Cook's Endeavour Replica Lands in Gisborne," October 8, 2019, https://www.youtube.com/watch?v=NtYHjBvRVFs, at 7:51.
"The Seven Cities of Gold," http://www.c64sets.com/seven_cities_of_gold.html.
Smith, Allison Margot, "Film: Mary Ann Shadd Revisited: Echoes From an Old House," https://activehistory.ca/blog/2016/03/08/film-mary-ann-shadd-revisited-echoes-from-an-old-house.
"Svoboda 1945 Liberation Website," https://store.steampowered.com/app/1076620/Svoboda_1945_Liberation/.
Toffolo, Matthew, "Interview with Costume Designer Linda Muir (The Witch, Bitten)," https://matthewtoffolo.com/2016/02/21/interview-with-costume-designer-linda-muir-the-witch-bitten/.
Watkins, Peter, dir., *Culloden* (BBC, 1964, 73 mins).
"What Are the First Documentaries in History? The Lumière Brothers," March 29, 2022, https://guidedoc.tv/blog/first-documentary-films-lumiere-brothers/.
"The Witch," https://en.wikipedia.org/wiki/The_Witch_(2015_film).
"The Witch: A New-England Folktale," https://www.imdb.com/title/tt4263482/awards/.
Zembrzycki, Stacey, "Sharing Authority with Baba," https://www.sudburyukrainians.ca/sharing-authority.

INDEX

Note: Numbers in *italic* indicate a figure on the given page number.

accuracy 65, 103, 108–9, 117–18, 126; *see also* historical accuracy
actants 120
affect 3–5, 9–10, 16, 59, 80–2, 86–7, 140, 146, 154, 159–61; in theatre 88–90, 137
Afghanistan, war in 18
Africa 24, 45, 48; *see also* Central Africa; North Africa; West Africa
African American: music 136; pasts 1
Aids crisis 61
Algeria 112
Algonquin Anishnaabe 105
alienation 112; effect 34
American revolutionary period 65–6
anachronisms 108–9
Ancestry 44
Angola 46
antisemitism 38
Aotearoa 25–6
apartheid 90, 115
"Arabism" 71
archives 4–5, 11–14, 19, 22, 26, 30–50, 65, 74, 88–9, 119, 127, 129–30, 134, 136, 138, 141n2, 144–7, 150–2, 154; archival engagements 48–50; challenging 40–4; intangible 5, 44–8; interactive 66; living 45, 49, 72; making

archives perform 132–4; memory 97; performance 9; performing in 31–3, 133
archivists 5, 31, 34, 44, 56, 154
artificial intelligence (AI): -generated plagiarism 151; -generated text 151
asceticism 13
Assassin's Creed (AC) series 63–7, 164
audience(s) 8–9, 13–15, 17–19, 26, 39–40, 44, 46, 49, 56, 58–62, 66, 68–74, 82–3, 85–6, 89–94, 98, 103, 105–10, 114–17, 119–20, 125, 128, 132, 134–8, 140–1, 141n3, 148, 151–2, 154–5, 159, 161; and authenticity 108–9
augmented reality 10; virtual AR 56
Australia 15, 23, 74
authenticity 5, 9, 23, 72, 103, 107–8m 111, 114, 117–18, 120, 125–6, 134, 137, 150; and audience 108–9; *see also* historical authenticity

backstories 139–41
bannock 125, 128
Barbados 42
Barthes, Roland 5, 55–6
Benjamin, Walter 128
Bennett, Alan 114; *The Madness of George III* 114

Berry, Danielle Bunten 132–3; M.U.L.E. 132; *The Seven Cities of Gold* 132
Bhabha, Homi 97, 155
Blair, Tony 58
Bloom, Harold 8
blueprints 1–2
Boal, Augusto 5, 19, 25, 89–91; *see also* Theatre of the Oppressed
Boleyn, Anne 114, 133–4; Book of Hours 133–4
Bonnie Prince Charlie 54
Bossuet 56
Branigan, Tania 3
Bratayuda 67, 77n42
Brazil 5, 19, 46–8; *see also quilombo*
Brecht, Bertolt 18–19, 34, 55, 136, 155; *Street Scene* 18; *see also Mother Courage*
Britain 55, 83, 87, 98, 110–11, 134; ancient 105; early modern 1, 9, 102, 159; Tudor 14
British empiricist tradition 4
British Rail 61
Broken Umbrella Theatre, A 159–60
Büchner, Georg 57–8; *Danton's Death* 58
"Buried Alive Stories" 96, 97
Bury, John 10–11, 14, 21
Butler, Judith 19

Callow, Simon 114
Calvinism 133
Cambodian genocide 89
Canada 15, 44, 60, 62, 80, 83, 94, 98, 105–8, 124, 130, 134, 138, 141, 152, 161; Atlantic 94; Cape Breton, northern Nova Scotia 94–5, 117, 137–8; centenary of 82–3; Manitoba 83, 85; Montreal 58, 64, 83, 88–9; National Art Centre (NAC) 105; New Brunswick 83; Nova Scotia 83, 94, 117, 137; Ontario 60–1, 83, 85, 131, 134, 137–8; Quebec 64, 83; Truth and Reconciliation Commission 83, 107; *see also* Diefenbunker; *Farm Show, The*; New France
Canada Science and Technology Museum 129, 138, *139*, 142n8
Canadian Museum of History (Canadian Museum of Civilization) 124, 152; Haida Gwaii Salon 124

Canadian Opera Company 83
Canadian War Museum 164
Cardinal, Douglas 124
Caribbean 24, 65
Carlyle, Thomas 13
Catholic church 95
ceilidh 137–8
Central Africa 46
Champlain, Samuel de 106
Charles Games 144, *145*
Chernobyl disaster 87–8; Chernobyl exclusion zone 87
Chiblow, Liane 124–5, 128
China 3; Cultural Revolution 3; Imperial 64
Christmas Carol, A 9
Christophe, Henry 86–7
Cifuentes, Edeliberto 30
cinéma vérité ('truth cinema') 57
civil war 67; American 119; Guatemalan 30
Cohen, Jeff 37–40; *see also Soap Myth, The*
collectivization 145–6
Collingwood, R.G. 21–2, 104, 133
colonialism 1, 12, 26, 42, 45, 72, 83, 86; anti- 24; settler 25
Commanda, William 124
communism 145
Congo 46
context 13, 22–4, 26, 37, 56, 65, 104, 106–8, 136, 140; cultural 56; economic 56; emotional 114; historical 146; personal 56; political 56; public history 95; social 56
Cook, Captain James 25–6, 105
Corado, Ana 30
Coras, Jean de 36–7
Coulter, John 83; *Riel* 83
creation story 124
creativity 150, 158
Cree (language) 83–4, 99n14
critical fabulation 11, 42
Cuban Revolution 24
cultural genocide 83, 106–7
cultural heritage 46
curators 5, 38, 44, 127, 129, 138, 141, 154
Curran, San Francisco *110*
Cusack, Peter 87–8, 131; *Sounds from Dangerous Places* 87–8

Index

Dahl, Roald 33; *Charlie and the Chocolate Factory* 33
dance 17–18, 45–7, 50, 90, 118, 126–7, 137
David, Jacques-Louis 114
Davis, Natalie Zemon 11, 36–7, 40, 42, 109
de Certeau, Michel 31, 36, 136
democracy 8
Dening, Greg 3, 17, 20, 32, 50, 126, 133, 136
Derrida, Jacques 43, 49
Dewa Ruci 69–74
Diefenbunker: Canada's Cold War Museum 130–1
Dome Mine door, Ingenium Conservation Lab, Canada Science and Technology 139
Donizetti, Gaetano 14
dowry 91–2
dramaturgy 58–9, 105
Durand, Maxime 64–5, 76n34, 164; see also Assassin's Creed (AC) series
Duthie, Rick 60–1, 148; *One Day Stronger* 60–1
Dvořák, Antonin 117; "Going Home" theme 116; New World Symphony 117

Eakins, Thomas 41
Edgar, David 115–16; *The Jail Diaries of Albie Sachs* 115–16
Eggers, Robert 102–3; see also *VVitch, The: A New England Folktale*
Eisenstein, Sergei 24
Elizabethan culture 12–13
embroidery 96–7, 96; "Buried Alive Stories" 96, 97
emotions 4–5, 9–10, 13, 25, 30–1, 35, 39–40, 47, 49, 66, 68, 80–2, 85, 87–8, 92–5, 97–8, 103, 114, 117, 120, 125, 129–31, 136–8, 140, 145–6, 150, 159, 165; in theatre 88–90
empiricism 4, 11, 15, 20–1, 81
England; early modern 4, 107; Elizabethan/Jacobean 105; London 24, 58, 63–5, 76n32, 111, 116; see also Britain
English Theatre Company 7
Enlightenment 13
Europe 11–13, 17–18, 45, 58, 94, 106, 110, 118, 145

Facebook 44
fact vs. fiction 13, 35, 134
family 15, 25, 31, 33–6, 43–5, 60, 62, 68–9, 80, 92, 102–3, 108, 115–16, 120, 125–6, 137–8, 140, 146, 153–4; performing 134–6
Farm Show, The 61–3, 76n30, 134–5
fascism 8
fiction 2–3, 8, 12–13, 21–2, 24, 35–6, 40, 42, 55, 57, 61, 64, 113, 134, 145, 150–1, 164; fact vs. 13, 35, 134, 164; historical 13, 22, 36, 75n2, 108, 133–4; vs. non-fiction 3, 55, 150; science 132; see also non-fiction
film: documentary 5, 35–6, 55*7, 92, 111, 113, 126–7, 135, 137, 141, 164; fiction 35; fictional 57; historical feature 18, 54–5, 57, 103, 109; historical fiction 36
filmmakers 35–6, 56–7, 127
Finlay, Robert 11, 36–7, 40
First Nations 83; Kitigan Zibi 105, 124; Kitigàn-zìbì Anishinàbeg 105; Mi'kmaq 137; Nisga'a 99n14
First World War 39, 76n32
Flaubert, Gustave 56; *Madame Bovary* 56
Fortress Louisbourg, Cape Breton, Nova Scotia 94, 117
Foucault, Michel 43, 117
Four Nations Exchange 107
fourth wall 18, 69, 73, 90
France 12, 56, 83; Calais 110–11; early modern 109; Paris 111–13; revolutionary 148; see also French Revolution; New France; Paris Commune
Franciscan rule 13
Francis of Assisi 105
Frederick the Great, Prussian king 87
French Revolution 58, 64, 114
Freud, Sigmund 43, 49–50, 113

Gambia, the 44–5
Ganguly, Sanjoy 90–4
genocide: Cambodian 89; Rwandan 89; see also cultural genocide
Germany 146; unification of 12; see also Nazi Germany
gewel (Wolof) 44–5
global south 5

Goeth, Amon 82
Goffman, Erving 17
Grace, Fraser 115; *Breakfast with Mugabe* 115
graphic novels 10, 16, 21, 126, 145–6, 164
Grierson, John 56–7
griot (French) 44–6
Guatemala 5, 30–1; National Civil Police (PNC) 30
Guerre, Bertrande de Rols 36–7, 109
Guerre, Martin 36–7, 109
Guevara, Che 93
Guinea 45
Guinea-Bissau 45
Gurindji of Daguragu and Kalkarindji 23

Haiti 86–7, 89, 98; Haitian revolution 24, 86–7
Hall, Edward 57; *Chronicle* 57
Hamlet 18–19
Hare, David 61; *The Permanent Way* 61
Hartman, Saidiya 11, 41–3, 75n8
hedonism 82
Heinlein, Robert 132
Hemings, Sally 147–8
Henry VIII 133, 160
Herodotus 1, 10, 13, 27n5, 56, 65
Herschel, Sir John 2
Hester, Sam 148, *149*
Hinduism 70, 72
Hinton, Peter 8, 84, 106, 139
historical accuracy 104–5, 108, 114, 117–19
historical authenticity 104–5
historical distance 4, 25, 32, 94, 109, 112, 118–20, 132, 147
historical meaning 80, 129, 141n3; affective music and 82
historical narratives 3, 47, 86, 114, 133
historical performance movement 104
historical re-enactments 6, 25, 104, 117
historical thinking 2
historical writing 2, 11, 136
Historic Fort Snelling, Minnesota 94–5, 118, 120
historiography 1–3, 12–13, 23–4, 74, 80, 154

history 10–13; affective 16, 81, 154, 160; from below 25, 154; Black 16, 137; constitutional 16; cultural 16, 31, 44, 80, 164; as drama 23–5; embodied 81; of the everyday 16; of experience 81; LGBTQIA+ 16; living 6, 9, 19, 80–1, 89, 94–5, 104, 117–20, 127, 134; method and practice 11, 22–3, 147; playing history privately 146–7; political 16; "pop" 15; postmodern 16; sensory 16; settler 25; social 16, 32; theory 2, 23; wars 2; women's 16; work 14, 16, 19, 26, 44, 72, 85, 88, 150; *see also* historiography; history-telling; living history; oral history; public history
history-telling 97, 155
Hokari, Minoru 23, 74
Holocaust 37, 39–40, 89
hot-seating 114–15
Hudson's Bay Company 83
Huizinga, Johan 80–1, 164; *Autumn of the Middle Ages* 81; *Homo Ludens* 81, 164

idealism 11, 21, 37
Idle No More movement 107
imagination 2, 5, 10, 13, 21–2, 33, 42, 54, 67, 82, 88, 114, 119, 132–3, 146, 150
India 5, 43, 67–8, 80, 90, 98
Indian National Congress 43
Indigeneity 105, 125, 128; *see also* First Nations; Indigenous culture; Indigenous freedoms; Indigenous peoples; Indigenous rights; Indigenous sovereignty; Métis
Indigenous culture 26, 124
Indigenous freedoms 83
Indigenous peoples 26, 83, 125, 132; *see also* First Nations
Indigenous rights 26, 83
Indigenous sovereignty 107
Indonesia 5, 67, 70–2; *see also* Wayang figures
Instagram 44
interdisciplinarity 81, 127, 152
interpretation 11, 15, 86, 90, 103–4, 117, 119, 147, 159, 161; first-person 80, 118–20; historical

14, 104; second-person 120; third-person 119–20
interpreters 94–5, 117, 119–20; first-person 118, 120; historical 94; living history 94, 117, 119; third-person 119
invention(s) 11, 35–7, 58, 67, 134, 141, 147, 162, 164; mindful 28–41, 138–41
Iron Age 105
Isikhumbuzo Applied History Unit 90
Islam 70–1
Italy 12, 14, 64

jali (Mande) 44–5
James, C.L.R. 23–5; *The Black Jacobins* 23–4
James I 7; *Demonology* 7
Jana Sanskriti 5, 80, 90–5, 91; *see also* Theatre of the Oppressed
Janvier, Alex 124
Jashuva, Gurram 72
Java 67, 70–1, 74; *see also* Indonesia
Jefferson, Thomas 147–8; Declaration of Independence 147; *see also* Hemings, Sally
Johns, Ted 61–2; *see also Farm Show, The*
Johnston, Verna 124–5
jongo (*caxambu*) 46–8
Jungle, The 110, 111, 120

Kapur, Shekhar 103; *Elizabeth* 103
Kennedy, John F. 139–40
Kennedy, Robert F. 138, 140
King, Martin Luther, Jr. 138, 140
King Lear 9, 104–8
kino-pravda ("film truth") 57
Kostova, Elizabeth 22; *The Historian: A Novel* 22
Kubrick, Stanley 18; *Spartacus* 18
Ku Klux Klan 136–7
Kyrgyzstan 93

La Commune – Paris, 1871 111–13
Lacoste, Raphaël 63, 64
Languirand, Jacques 82–3
Larkin Poe (rock band) 49
Latin America 31, 90
living heritage sites 94
Living Histories Ensemble 88–9
living history/histories 95, 117–20; interpreters 94, 117, 119; museums and programmes 81, 104; performances 6, 19, 95, 117–18, 127, 134; performers 80, 117; sites 9; re-enactments 104, 119–20
"London Mood" 63
Louis Riel 5, 82–6
L'Ouverture, Toussaint 23–4
Lumiére brothers 56

Macbeth 7–10, 108
Macdonald, Sir John A. 84–5
Machiavelli 56
Mahabharata 67, 70, 72
Mahoney, Jackie 148, 151
Mali 44–5
Māori 25–6
Marat, Jean-Paul 114
marginalization 43, 86, 93, 112
Marx, Karl 65
Marxism 24
McKellen, Ian 114
memory 5, 31, 35–6, 44–5, 86–7, 113, 116, 126, 129, 139; archives 97, 152; collective 48–9; community 154; novel 43; palaces 150; private 37–40; theatres of 96–8; work 40
Métis 80, 83–6, 99n14, 106, 108
Michelet, Jules 21, 49, 56
Michif (language) 84
Middle Ages 105
Middle Passage 24
mimicry 46, 69, 71, 97
Montreal Life Stories 89
Moore, Mavor 82–3
Mother Courage 9, 18
Mozart 82, 114; *La Nozze de Figaro* 114
Mugabe, Robert 115
Muir, Linda 103
music 5, 17–18, 45, 47, 55, 72, 76–7n41, 80, 84–5, 88–90, 102, 104, 118, 126–7, 145; affective 82; African American 136; baroque religious 84; Celtic 137; country 85; gospel 85; house 90; live 137; symphonic 99n10; *see also* dance; opera
myth 11, 21, 137

narrative(s) 12, 21, 25–6, 32, 42, 46, 48–9, 56, 59, 65, 70, 125, 131, 133, 136, 138, 145, 154, 165; archival 41; Cold War 131; conventional 48,

Index **185**

66; counter- 41; dramatic 59, 85; first-person 86; game 164; historical 3, 47, 86, 114, 133; national 87
narrativity 6, 9, 138, 140, 155, 157, 159, 164; teaching of, in public history 125–9
National Council on Public History 15, 72, 159
Nazi Germany 144; Third Reich 33
Nazis 38
Nazism 33
Neo-Nazis 34
New Caledonia 112
New France 95
New Zealand 25–6, 161–2; see also Aotearoa
Nicaragua 108
non-fiction 3, 55, 63, 150; vs. fiction 3, 55, 150
North Africa 85, 111
North America 14–15, 17, 64, 68, 105–6, 134
Nuremberg trials 38–9

objectivity 22, 89, 98, 150, 152–4, 159
Oceania 50
Ojigkwanong Indigenous Student Centre, Carleton University 124–5
Olivier, Sir Laurence 18
Ondaatje, Michael 76n29, 135; see also *Farm Show, The*
operas 5, 9–10, 14, 20, 80, 82–6, 99n14, 103, 159; see also *Louis Riel*
oral history 5, 13, 23, 57, 89, 117, 128, 145, 147, 152, 155, 157; and performance 96–8
oral traditions 23, 74, 128
original research 2
Oscar Mayer 141
Other, the/otherness 21, 50
Out of Joint 114; *Talking to Terrorists* 114
Ozark Software 132

pantsula 90
Paris Commune 6, 111, 113; see also *La Commune – Paris, 1871*
Parks, Suzan-Lori 1–3, 147; see also *Sally and Tom*
Parr, Queen Katherine 133
Past, the 1, 3–5, 9–23, 26, 34–5, 40–5, 47–50, 55–7, 65–6, 73, 79–98, 104–5, 108–9, 113, 115, 117–20, 127, 131, 133, 146–8, 150, 152–4; affect and emotion in theatre 88–90; affect, emotions, and the senses 80–2; affective labour and reliving the Past 94–5; affective music and historical meaning 82; animating 117; documenting 55, 59; embodying 4, 117, 119, 136–8; feeling 5, 79–98; gaming 164–5; interpreting 94; inventing 36–7; narrating 108; narrativizing 24; otherness of 50; performing 9, 37, 94–5, 104, 128, 141n3, 150; playing 66; preserving 5; reconstructing 22, 55; recording 65; re-creating 95; re-enacting 115; re-living 94–5, 98; re-presenting 19, 95, 113, 132; re-staging 63; re-storying 117; re-telling 98; silencing/sounds of silence 86–8; staging 1, 85; storying 74; theatres of memory 96–8; witnessing 85; writing 13, 20–1, 25–6, 48, 50, 90, 126; see also *Louis Riel*; Theatre of the Oppressed
Pearson, Lester B. 140
performance 17–20; archive 9; in archives 31–3, 133; artist 114; aural 88; authentic 102–20; authenticity and audience 108–9; elements 19; embodied 80; family 134–6; first-person 138; *gewel* 45; historical 5, 103–4; historical accuracy and authenticity 104–5; Indigenous *King Lear* 105–8; *jongo* 47–8; of living histories 6, 19, 95, 117–20, 127, 134; musical 104; oral storytelling 46; oratorical 45; original 9; of the Past 9, 37, 94–5, 104, 128, 141n3, 150; performing real people 113–17; performing the Real 109–11; playback 89, 134; of public history 9, 43, 80–1, 85, 144–50; puppet 68–9; re- 59, 104; reality-based 92; staged 126, 141; strategies 111, 119; studies 4–5, 9–10, 17, 19–20, 126, 152, 155; teaching of, in public history 125–9; theatre 89; theatrical 126; traditional 69, 72; *wayang* 67–9, 73, 76–7n41; see also *La Commune – Paris, 1871*

photographs 38–9, 41, 43–4, 56, 97, 113, 117, 130–2, 136, 144, 146–7, 153
Plimouth Patuxet Plantation 118
poetry/poems 44, 59, 61, 87, 94, 117, 126
Popular Uses of History in American Life 15
positionality 3, 22, 26, 33, 127, 136, 147, 150, 152
positivism 1, 11, 81
Prairie, Connor 80, 120
Presentation of the Self in Everyday Life, The 17
primary sources 2–3, 11, 21, 23, 34, 44, 55–6, 68, 102–4, 111, 126, 135–6, 151
Protestantism 36, 76n27, 84–5
psychological gesture 114
Public Historian, The 15
public historians 1, 4, 9, 15–16, 44, 94, 104, 127
public history 1, 4–6, 10, 13–17, 60–1, 66, 72, 74, 94–5, 98, 124, 134, *139*, 151–2; performing 9, 43, 80–1, 85, 144–50; as popular history 14; private memory and 37–40; teaching narrativity and performance in 6, 9, 125–9, 155, 157, 159, 164; work 13–17, 19, 37–40, 72, 85, 88, 144–50; *see also* public historians
puppetry 10, 72, 76–7n41; shadow 5, 55; *see also* puppets; Wayang
puppets 67, 69, 72, 136; hand 67; paper 136; shadow 67; tree 70; *see also* Wayang
puritanism 102–3
Puritan New England 102, 105

Quakers 79–80
quilombo 46, 48; Quilombo São José festival 47
Quran 70

Rāmayana 67–8
Ranke, Leopold von 11, 81
Read, Mary 65
Real, the 2, 5, 19, 35–6, 54–74, 111, 115, 137, 145, 150; capturing the Real in film 55–7; nuancing the Real 67–74; performing 109–11; storying the Past 74; theatres of 57–63; *see also* Assassin's Creed (AC) series; *Dewa Ruci*; *Farm Show, The*; *wayang kulit* (shadow puppets)
realism 65–6, 145
reality effects 5, 55–7, 64–7, 73, 133, 136
re-enactment 9, 16, 18–19, 22, 25–6, 49, 56, 81, 103–5, 112, 115, 118, 120, 126–7; living history 104, 119–20; *see also* historical re-enactments
re-enactors 82, 103, 105, 118–20
residential school system 83, 107
Return of Martin Guerre, The 109
Rice, Condoleezza 157
Ricoeur, Paul 50, 55
Riel, Louis 5, 80, 83–5, 155; *see also* Louis Riel
Robeson, Paul 24
Rokem, Freddie 19, 115, 135, 155
Romeo and Juliet 9, 12, 109, 139
Rosenzweig, Roy 15; *Popular Uses of History in American Life* 15
Rosmus, Anya 35
Rouch, Jean 57
Russia 38–9, 57, 138
Rwandan genocide 89

Sachs, Albie 115–16
Salas, Jo 89, 157
Sally and Tom 147–8
Sandinistas 108
Sans Souci, Colonel Jean-Baptiste 86–7
Schechner, Richard 17–19, 155; "twice-restored behaviour" 155
Schindler, Oskar 82
Schrecklicke Mädchen, Das (The Nasty Girl) 33–6
Scotland 7
Scott, Sir Walter 13
secondary sources 2–3, 113, 119, 134
Second World War 94, 105, 112, 145
seeing and doing, ways of 20–3
Senegal 5, 44–5, 48
Senegambia 45; *see also* Gambia, the; Guinea; Guinea-Bissau; Mali; Senegal; Sierre Leone
senses 4–5, 10, 13, 21, 49, 80–2, 93–4, 125, 140, 150, 153, 159

Seven Grandfather teachings 107
Shadd, Mary Ann 137
Shakespeare, William 6, 7–9, 13, 18, 57, 104–8
Shiloh, battle of 105
Shironi, Hema 96, 97; "Buried Alive Stories" 96, 97
Shonar Meye (Golden Girl) 91–2, *91*
Sidney, Angela 74
Siebert, David 130–1, *130*
Sierre Leone 45
slavery 24, 41, 46–8, 80, 147–8; abolition of 47, 137
Soap Myth, The 37–40
Somers, Harry 82–6, 99n14; *see also* Louis Riel
Somoza 108
sonic journalism 87
Sousanis, Nick 21; *Unflattening* 21
South Africa 90, 98, 116
space and place 130–2; home 129–30
"spect-actors" 19, 90
speculation 2, 5, 10, 12, 22, 37, 39–40, 42, 132, 141, 147, 164
Spielberg, Steven 82; *Schindler's List* 82
Spitzer, Morris 40
Sri Lanka 97–8; Sinhalese-dominated government 97; Tamil separatists 97
Steedman, Carolyn 31–2, 49–50, 133
Stewart-Verger, Ruth 155
storytellers 23, 89, 117, 124, 128, 154–5
storytelling 24, 44–6, 57, 74, 97–8, 117, 124, 126–8, 136, 152, 155–6; hi- 24, 57, 74; Indigenous 128
subjectivity 22, 127, 147, 152
Suharto 69; Golkar party 69; New Order government 69
Sukarno 71
Susmono, Enthus 69; *see also* Dewa Ruci
Svetlana, Tsalko 87
Svoboda 1945 Liberation 6, 144–7, *145*
Syria 110

Tagore, Rabindranath 94
Te Maro 26
theatre(s): affect and emotion in 88–90; documentary 57–9, 61–2, 151, 155, 157; epic 18–19, 25, 58; grass roots 62; of memory 96–8; "naturalist" 58; "newspaper" 58; playback 62–3, 80, 88–9, 117, 155, 157; post-dramatic 109; of the Real 57–63; site-specific 63; theatrical pasts 148–50; tribunal 58; verbatim 58–62, 157; *see also* Theatre of the Oppressed
Theatre of the Oppressed 5, 19, 25, 80, 89–94, 111, 155
theatricality 20, 32, 58, 85, 116
"Theatrical Pasts" 148–50, *149*
Thelen, David 15; *Popular Uses of History in American Life* 15
Thirty Years' War 18
Thompson, Paul 61–2, 135; *see also* Farm Show, The
Three Stooges 68
Thucydides 1, 10, 13, 27n5
TikTok 44
Tilh, Arnaud du 36, 109
Touré, Sékou 45–6
Toussaint Louverture 24
"tragic flaw" 24
Trevelyan, G. M. 10, 14, 21
Trouillot, Michel-Rolph 86–7; *Silencing the Past* 86
truth and reconciliation 31, 83, 107
truth claims 3
Twitter 44

Ubisoft 64–6, 164; *see also* Assassin's Creed (AC) series
Ukraine 98
Ukraine Soviet Socialist Republic 87
Underground Railroad 80
UNESCO 131
United States (USA) 14, 24, 94, 98, 108, *110*, 133, 141, 147, 157, 159
"Unruly Remains" *130*

Van Gogh, Vincent 151
Van Gogh-Bonger, Johanna 151
Verhoeven, Michael 33–6; *see also* Schrecklicke Mädchen, Das (The Nasty Girl)
Vertov, Dziga 57
video games 5–6, 9–10, 16, 55–6, 64–5, 81–2, 103, 132, 144, 146–7, 159, 164; first-person shooter (FPS) games 82; *see also* Assassin's

Creed (AC) series; *Svoboda 1945 Liberation*
Vimy 9
Vlad the Impaler 22
VVitch, The: A New England Folktale 102–3

Wahid, Abdurrahman 71
Walker, William 108; *Walker: A True Story* 108
Watkins, Peter 54–, 111–13; *Culloden* 54–5; see also *La Commune – Paris, 1871*
Wayang 73; see also *wayang golek*; *wayang kontemporer*; *wayang kulit*; *wayang perjuangam*; *wayang wong*
wayang golek (wooden hand puppets) 67, 69, 77n45

wayang kontemporer (modern wayang) 70
wayang kulit (shadow puppets) 5, 67–9, 76–7n41
wayang perjuangam (struggle puppet) 72
wayang wong (human shadow puppets) 67–9
Web 2.0 44
Weiss, Peter 58
West Africa 44
Wiccan 8
Williams, John 82, 99n10
witchcraft 8, 102–3, 159–60
witches 7–10, 102
Woolley, Joseph 32–3

YouTube 44–5

For Product Safety Concerns and Information please contact our
EU representative GPSR@taylorandfrancis.com Taylor & Francis
Verlag GmbH, Kaufingerstraße 24, 80331 München, Germany